P9-DOH-843

LANDSCAPE PAINTING

LANDSCAPE PAINTING

Patricia Monahan

**Eagle
Editions**

A QUANTUM BOOK

Published by Eagle Editions Ltd
11 Heathfield
Royston
Hertfordshire SG8 5BW

Copyright © MCMLXXXV
Quarto Publishing plc

This edition printed 2004

All rights reserved.
This book is protected by copyright. No part
of it may be reproduced, stored in a retrieval
system, or transmitted in any form or by any
means, without the prior permission in writing
of the Publisher, nor be otherwise circulated in
any form of binding or cover other than that in
which it is published and without a similar
condition including this condition being
imposed on the subsequent publisher.

ISBN 1-86160-883-7

QUMMLP

This book is produced by
Quantum Publishing
6 Blundell Street
London N7 9BH

Printed in China by
SNP Leefung Printers Ltd

CONTENTS

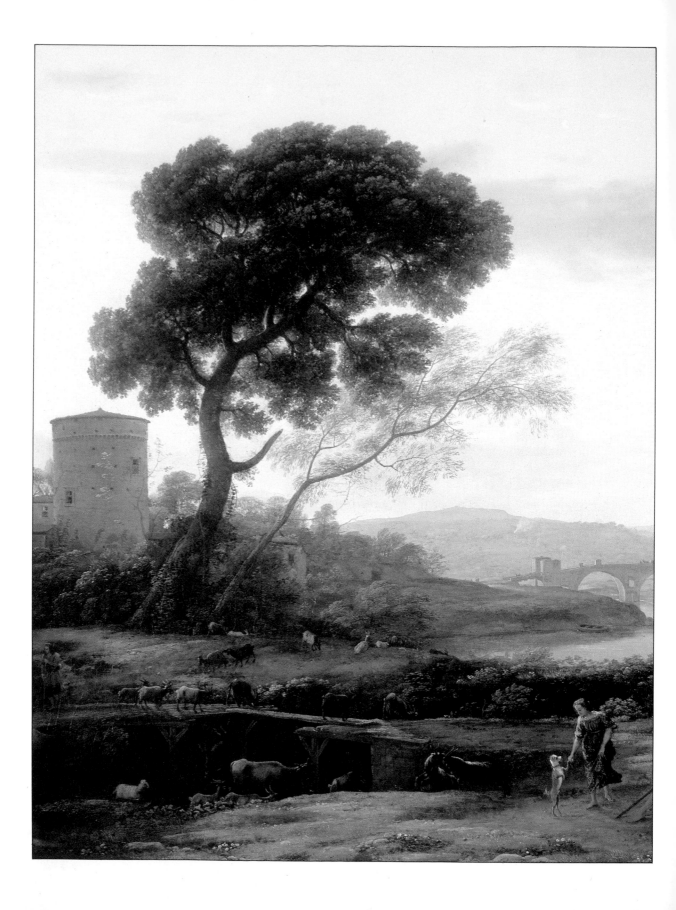

NATURE IN ART

The urge to record the world around us in paint is deeply embedded in the human psyche. For thousands of years artists have struggled to depict the animals, flowers, streams and hills which form the backcloth to our everyday lives, but it is only in fairly recent times that these disparate elements have been recognized as part of a whole which we now refer to as 'landscape'.

Pastoral Landscape with Ponte Molle, Rome by Claude Lorraine (1600-82) *detail*. Claude painted poetic landscapes suffused with a warm golden light.

Civilizations have come and gone, and each has evolved an art that reflects both the concerns and achievements of the society which produced it. Thus, in primitive art, objects are rarely produced for contemplation, but have a practical or ritual use, often as sympathetic magic to make the event depicted happen – a successful hunt for example. For three thousand years the Ancient Egyptians were concerned with preparations for the next life. Their artists painted images which recorded the necessities of life, so that the Pharaoh or nobleman who employed them would be well provided for in the afterlife. Greek art was almost completely absorbed in glorifying the human form, and it was only in Hellenistic and Roman times that landscape painting began to emerge. In China, on the other hand, the long tradition of landscape painting reflects that society's absorption with, and respect for, the beauties of nature, which were seen as a manifestation of cosmic forces. As in the Hellenistic and Roman world, landscape painting was closely associated with poetry. In the medieval world, landscape provided a decorative background to human activities. It was a Christian art and every picture was imbued with several layers of rich and complex symbolism. Our tradition of painting goes back only five hundred years and reflects the profound change in attitude during the period we call the Renaissance, when artists, scientists and others began to look at the natural world with a newly inquiring eye.

Four million years ago our ancestors first stood upright and walked the Earth on two feet. Two million years later, in the period known as the palaeolithic or Old Stone Age, we find the first traces of toolmaking and, 35,000 years ago, in the last stages of the palaeolithic age, we find evidence of artistic activity. The last Ice Age was coming to an end and in the flat plains of western Europe, where the ice had begun to recede, bands of hunters roamed, following the plentiful herds of reindeer, mammoth and bison, on which they relied for food and clothing. These nomadic peoples lived in naturally occurring rock caves and it is in these, in France and Spain, that we find evidence of their artistic skills. Some of the most astonishing images can be seen in a cave in Altamira in northern Spain. Here the artists of the late Stone Age depicted the animals with which they shared the Earth, and with a verve and confidence born of knowledge and close observation. The drawing is both subtle and vigorous, with fluid outlines that convey both strength and a sense of movement. The cave paintings at Lascaux in the Dordogne

are equally vivid – there, herds of bison, cattle, horses and deer career across the rockface chased by huntsmen with weapons raised to strike. The artists have worked with the unevenness of the rock surface, incorporating stains and watermarks. Some of the images are rendered in outline, others have been colored with brightly colored earth pigments. Fingers, twigs, feathers and bits of fur were their tools, but their chief asset was their power of observation, that same power so essential to the successful huntsman. At this distance in time we can only speculate about the motives which drove our ancestors to spend time and energy creating these images. Perhaps they had a magical significance and were painted in the hope that the event depicted would come to pass, that by creating an image of an object they could in some way achieve control over it.

As the European ice sheets retreated between 12,000 and 6,000 years ago, North Africa and the Middle East became more arid. Groups of people began to settle near rivers, to cultivate crops and domesticate animals, and so we have the beginning of agriculture. Paradoxically, the birth of agriculture gave rise to the city, for farming practices allowed a society to produce surpluses. More food could be produced by fewer people and the people released from activity on the land were then available for other functions. It was this specialization which gave rise to urban living. More complex societies required more complicated methods of organization and thus it is in this part of the world that we also find some of the oldest and most successful civilizations. The way in which the people of different cultures perceive themselves and their relationship to the natural world has dictated the way in which they have depicted the world in their art forms. So by studying some of these relationships we may shed light on some of the works of art that they have left, and which we can see in museums and galleries throughout the world.

ANCIENT EGYPT – THE LONG ROAD TO THE GRAVE

For the origins of our own attitudes to the natural world we must look to the civilization of Ancient Egypt. On the banks of the River Nile there evolved a civilization of great richness and magnificence which lasted for thousands of years. Their kings were regarded as divine beings and as such had absolute authority. Their wealth and power is demonstrated by the monuments they left. Thousands of workers and slaves were mobilized to work year in year out

quarrying stone and conveying it, with the most primitive means possible, to building sites. Then, with feats of engineering which still cannot be fully understood, enormous tombs, called pyramids, constructed of mounds of stone, were erected. All this was to ensure that at the end of his life the ruler could ascend back to the gods from whom he came. For the Egyptian, life was a long preparation for the afterlife. It was essential that the body of the dead person be preserved if his spirit was to live on in the world beyond – this explains the elaborate embalming and binding of the body. The mummy of the king was laid in the center of the tomb and to make doubly sure that his spirit survived, his image was sculpted in granite.

Initially these rites were reserved for kings, but soon the smaller tombs of nobles of the royal household were grouped around the king's mound. Gradually every self-respecting person began to make provision for the afterlife, by ordering a costly grave that would house his mummy and his likeness, as a kind of life insurance for the afterlife.

What we know of Egyptian art is derived from the reliefs and paintings which adorned the walls of the tombs – paintings that were never meant to be seen except by the dead, that were not meant to be enjoyed but were meant to 'keep alive'. Originally, an important man would have been buried surrounded by his servants and slaves, who were sacrificed to ensure that he entered the afterlife accompanied by a suitable entourage. Later, images of the retinue were substituted for the real thing. The pictures and models found in Egyptian tombs fulfilled this function – providing the soul of the dead king with sufficient victuals and company for the afterlife – rather like the preparations for a long journey.

These reliefs and wallpaintings provide us with an extraordinarily vivid picture of everyday life in Egypt thousands of years ago and yet, in order to understand them fully, we must also understand Egyptian conventions for the representation of real life. Egyptian art had a very special purpose – the artist was required to produce a complete and accurate image, so that everything was clearly seen and would be preserved permanently, and completely, in the afterlife. He was not concerned with beauty nor with representing nature as it appeared from any one particular position. He approached his subjects rather like a map maker, drawing objects from their most characteristic viewpoint. A tree seen from above would not be easily

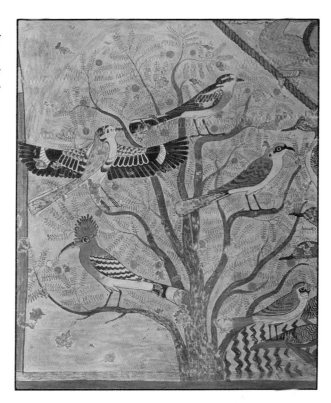

Birds in an Acacia Tree. This Egyptian wall painting comes from the tomb of Khnemhopte, a Pharaoh of the 12th dynasty. Egyptian murals were executed in watercolor and reflect a close observation of nature.

recognized – so it was drawn as seen from the side. Birds and animals were drawn in profile, a pond was seen from above, and the waters of the Nile were also seen from above as on a map. The artist did not draw what he saw but what he knew to be there. Convention also dictated that the most important person in the picture was drawn larger than others. In these wall paintings the objects are rarely seen as a picture as we understand it but as a series of elements in a sequential story. Only in some smaller-scale works, such as a chest found in the tomb of Tutankhamun, do we see forms set against a landscape background. The painted chest shows the young king in battle and out hunting. The animals

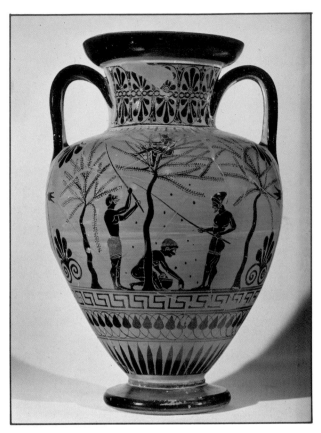

Athenian black-figure vase
showing olives being gathered.
The vase dates from *c.* 520 BC
and is by the Antimenes
painter. Most of our
knowledge of Greek art is
gleaned from vase painting.

than women. He did not seek originality and the most admired artist was the one who could reproduce exactly the statues and paintings of the past. Thus in three thousand years Egyptian art changed hardly at all.

Other great civilizations existed in the Middle East, in the lands between the Rivers Tigris and Euphrates, but the art of the Babylonian and Assyrian Empires is less well known and preserved than the tomb art of Egypt which was designed to survive forever.

THE ART OF ANCIENT GREECE

Greek art is in many ways very accessible to us for it is part of our tradition and we feel an empathy with its art forms. Our knowledge of Greek art is gained from three sources: from its monuments, mostly building and sculpture; from Roman copies; and from what the Greeks themselves had to say about their artists – they were the first people in history to write at any length about their own artists.

Greek art is characterized by a striving towards naturalism combined with an acute sense of order and beauty. Very few Greek paintings have come down to us – there are a few fragments on walls and no panel painting – so most of what we know of the art is deduced from painted pottery. This shows the Greek artist slowly beginning to experiment and investigate, trying out new ideas and new ways of representing the human form. The great revolutions in Greek art occurred in the fifth century BC in what is known as the Classical period (480-323 BC). Artists attempted foreshortening and began to imply pictorial depth by moving figures at a distance further up the picture plane – the distant figures were, however, not reduced in size. Greek art appears to have been primarily concerned with the depiction of the human figure. We have little information about how they handled scenery but this may be because the only real source of paintings are their vases. The vase painters used a very limited range of colors and this may explain the absence of scenery and distant views.

LANDSCAPE IN THE HELLENISTIC AND ROMAN WORLD

What we know of painting in the Roman world has been gained from the murals preserved in the Italian towns of Pompeii, Herculaneum and Stabiae which were buried under ash when Vesuvius erupted in AD 79. Many of these paintings are believed to be based on themes from Greek art and much of the work was carried out by Greek artists.

are rendered with great skill and liveliness, but the king and his horse-drawn chariot remain frozen against the usual blank background filled with hieroglyphics.

Egyptian art is characterized by a rigid geometry combined with a keen observation of nature. The artist began by setting out a grid of lines along which the figures were distributed in a carefully considered and harmonious way. Plants, animals and birds are rendered with such accuracy that scientists can identify the species. The Egyptian artist was bound by a strict set of rules – seated statues always had their hands on their knees and men always had darker skin

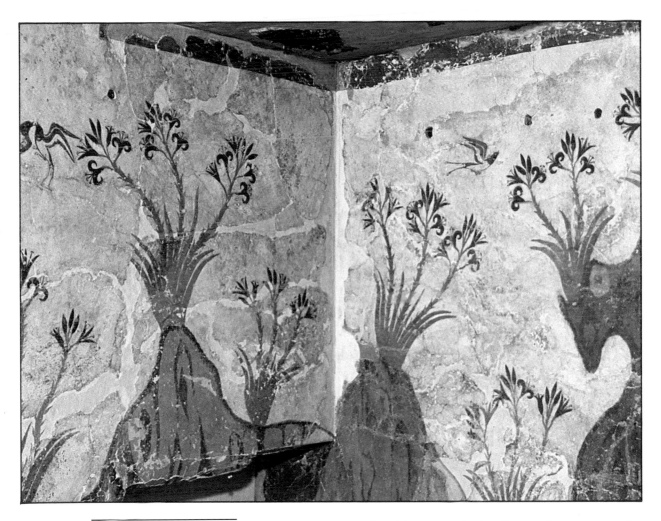

This delightful fresco depicting a fantastic landscape with lilies and birds is from the Greek island of Santorini and dates from about 1500 BC. An acute sense of pattern is combined with precise knowledge of the subject.

The paintings show an interest in landscape either as a background to anecdotal subjects or as a subject in itself. It was another sixteen hundred years before landscape was again treated as an important subject in its own right in European art. These paintings are rendered with a rapid sketchiness reminiscent of the work of the Impressionists. The clarity of outline favoured by the Egyptians and Greeks is replaced by atmospheric effects, soft contours and a subtle use of light and shade. These artists often used a plunging, bird's-eye view, and assumed that the landscape began right at the viewer's feet so that he or she was plummeted into the scene. The picture area is deep and the rendering is illusionistic.

During Roman times Pompeii became a favorite watering place of wealthy Romans. They took thermal cures in the hot springs and sought a respite from the metropolis with its busy, narrow streets and alleys, flanked by high buildings, where the inhabitants rarely caught a glimpse of the sun. Just as today, the shores of the Gulf of Naples attracted the rich and not so rich. Tiberius had a summer residence on Capri, Caligula on Ischia, and the whole shoreline was dotted with magnificent villas. Anyone who has visited either of the sites at Pompeii or Herculaneum will know just

how small and poky these town houses were. These claustrophobic spaces were visually enlarged by paintings, which did not merely decorate the walls, but removed them and brought the countryside of the Campagna into the rooms of the town dwellers. Those wealthy enough had villas in the countryside to which they returned when the summer heat made the town unbearable. But while they were in town they wanted their homes to imitate the countryside. With a clever use of empirical perspective the artists created the illusionistic vistas which stretched through vineyards, gardens, fields and woods. Without a precise knowledge of the laws of perspective as we know them, the artist nonetheless conquered space – objects diminish in size as they recede towards the horizon, the colors in the distance are blurred and impressionistically rendered to further the illusion of depth. The scenes are often glimpsed through painted marble columns and porticoes which again serve to imply depth, dividing the painting into areas and creating a sharp contrast between objects close to the viewer and those far away. This interest in painting the landscape went hand in hand with poetry and the same compulsion which drove Virgil (70-19 BC) to write his great pastoral poems the *Georgics* and *Bucolics*, inspired the wall painters of Pompeii.

LANDSCAPE IN CHINESE ART

Landscape became a subject of Chinese art at a very early stage, and can be seen in bronzes and pottery of the Han dynasty (206 BC-AD 220). The Chinese approach to space and distance in landscape compositions was not based on a scientific approach to perspective. They took a high bird's-eye view of the subject, and by a skilful arrangement of objects, persuaded the viewer to 'read' the painting – moving down towering mountains and along meandering streams. By the eleventh century Chinese artists had mastered the art of what they called the 'far and near' and by the time of the T'ang dynasty (AD 618-906) the landscapes used as backgrounds to figure groups were painted with bright colors and lively, free brushwork. The works of a few celebrated masters remain to give us an idea of the richness and vitality of this period. The poet and painter Wang Wei (AD 698-759) was the first artist to paint pure landscapes, several centuries before a similar development in Europe. He was undoubtedly influenced by Taoism which advocated the contemplation of nature and inspired the Chinese

interest in poetry and landscape painting. Wild scenery, mountains and rushing torrents were recurring themes in both poetry and painting. The painter was concerned not just with the visual reality of the scenery but with the mood it conveyed, and the spirituality which it induced. The Sung (960-1278) and Yüan (1260-1368) dynasties are usually considered to be the greatest age of Chinese painting. The artists of this period, who regarded Wang Wei as their precursor, also sought to imbue the landscape with the emotion of a poem. Landscape paintings were not required to be topographically accurate – artists took elements from the actual scene and organized them in a way which expressed their own vision and heightened the emotional content of their pictures. Chinese artists worked on a small scale – silk, paper, ink and watercolors were their favored materials.

LANDSCAPE AS SYMBOL

Medieval art was a Christian art. The Church allowed only an allegorical appreciation of nature, so the decorative landscapes in Gothic paintings and tapestries can be encompassed by Kenneth Clark's phrase 'the landscape of symbols'. The paintings of the period are full of a rich iconography – objects from nature were seen as both delightful in themselves and also as manifestations of a powerful God. An art based on symbolism rather than realism is bound to acquire a decorative quality, as the artist becomes immersed in the details of the individual elements rather than the whole.

Much painting in the Middle Ages took the form of miniatures and can be seen in the illuminated manuscripts that have survived. Books of Hours were intended for private devotion, but by the end of the fourteenth century they were also valued as precious works of art. Jean, Duc de Berry, brother of Charles V of France, commissioned a series of Books of Hours in the last decade of the fourteenth century and the first decades of the fifteenth, each more lavish than the last. The series culminated in the *Très Riches Heures* which he commissioned from the Limburg Brothers. The devotional texts are illustrated by twelve calendar scenes rich in decoration and symbolism. These illustrations are small but exquisite and some are believed to be the first accurate landscapes in northern European art.

Numerous secular texts were also illustrated, including books on science, herbals, astronomy and other subjects.

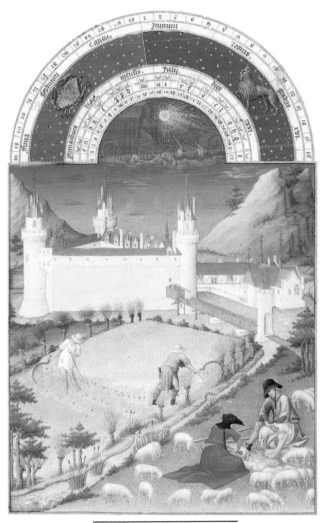

July from *Les Très Riches Heures du Duc de Berry*, the masterpiece by the Limburg brothers who painted miniatures in the early part of the 15th century. Here the landscape becomes an important part of the painting and the artists try to create depth within the picture space.

Tapestries were another art form in which the artists of the period demonstrated the pleasure taken in things natural and the decorative heights to which these motifs could be taken. In all these paintings and tapestries nature is closely and accurately observed, but with a great sense of pattern and design, and a feel for the detail rather than the whole.

These Gothic landscapes are characterized by carpets of flowers, little woods, fantastic rocks, formalized trees, all gathered together with an eye for pattern and a wish to delight the eye.

In Italy we must go to Sienna to find that concern with nature which was to evolve into the landscape painting of later years. There, the sensuous enjoyment of nature and its decorative qualities was typified by the work of Simone Martini (active 1315, died 1344) and the Lorenzetti brothers (Ambrogio, active 1319, died c 1348, Pietro active 1320, died c 1348).

TOWARDS REALITY

In landscape painting it is the quality of the light that floods the picture which creates a sense of unity and reality. This quality was first evidenced in the landscapes depicted in the miniatures in medieval manuscripts, for it is easier to achieve this sense of unity in small scale works. The *Hours of Turin*, painted between 1414 and 1417 for the Count of Holland, demonstrates a subtlety in the handling of landscape not seen again until the nineteenth century.

At this time very few artists had been concerned with precise topographical detail. In 1494 the German artist, Dürer, made a series of slavishly accurate drawings of the landscape. In 1505-6 he visited Venice and on his travels painted watercolors which are unique in their choice of subject and medium and seem to have been made in a spirit of inquiry and as a personal record rather than as a study for a larger work.

A common theme in all landscape painting at this time was a concern with space – this appeared simultaneously in Flemish and Italian art, but though it produced a similar result it was different in means and intention. In Jan van Eyck it is based on his perception of light, and throughout Flemish painting it remained empirical.

In the *Adoration of the Lamb* panel in the Ghent Altarpiece we again see pale distances suffused with light. It has a low viewpoint and we proceed smoothly from foreground to background. At that time many painters dealt with these transitions by dividing the scene into sections.

THE RENAISSANCE

The word 'Renaissance', meaning rebirth, is generally applied to an intellectual movement which started in the fourteenth century and reached its culmination in the

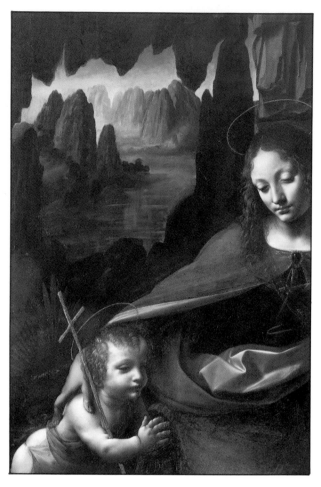

The Virgin of the Rocks by Leonardo da Vinci (1452-1519). In this detail we see the wild, rocky landscape which Leonardo favored as backgrounds for many of his paintings. He took a scientific interest in geology and rock formation.

Church as the center of life towards an absorbing pre-occupation with humanity and with the natural world. The art of the medieval world had been an art dedicated to the glory of God and the power of the Church. Its iconography and its system of symbols, made use of stylized forms in what was largely a conceptual art form. The Renaissance shifted the focus of attention to man and, supported by the developments of philosophy and science, brought a new analytical and perceptual discipline to bear on the representation of form and space.

The artists who were inspired by this ferment of ideas began to break away from the more stylized concepts of medieval art and strove to bring an increased naturalism into their treatment of religious themes. Figures acquired a greater sense of volume and plasticity and were placed in settings in which three-dimensional space was increasingly clearly defined. Working directly from human models and the environment in which they lived, artists began to transcribe what they saw rather than rely on handed-down conventions. The study of anatomy and perspective became part of the artist's discipline, enabling artists to produce accurate representations of what they saw.

Leonardo da Vinci (1452-1519) in many ways typifies the attitudes of the Renaissance. He was a master of painting, sculpture and drawing and combined this with an insatiable curiosity about the world around him. He studied nature in all its manifestations and made a deep study of anatomy. In one of his most famous paintings, the *Madonna of the Rocks*, of which there are two versions, one in London and one in Paris, he created a strange and moving picture in which the dark and gloomy background is a wilderness of jagged rocks glimpsed through the mouth of a cavern. The eye is led into mysterious vistas flanked by still more rocky pinnacles which rise from dimly seen watercourses, until they lose themselves in the half-light of misty distances. For Leonardo, wild, rocky landscapes like this were the only suitable background for his paintings. They represented the wildness of nature and the untamed background to human life. His landscapes resemble the precipitous rocky crags of Chinese painting and for the same reason – they too were interested in the contrast of man and his environment. But while the Chinese saw the landscape as symbolic, Leonardo was interested in the science behind what he saw. No matter how wild his landscapes, they are never artificial. A series of landscape drawings in the royal collection at

sixteenth century. It was a period of exploration and discovery in many fields, including the visual arts, philosophy and science. The reverberations of that period of intellectual reassessment and upheaval can still be felt today and many of the assumptions now prevalent in the visual arts can be traced back to that time.

One of the important aspects of the Renaissance was the movement away from the medieval concept of God and the

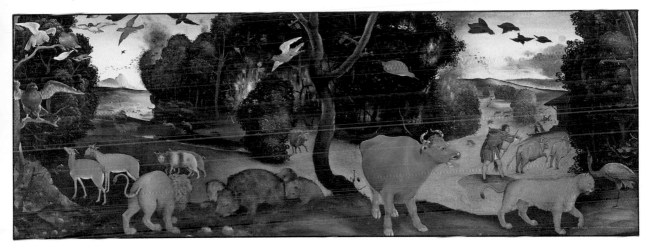

Forest Fire by Piero di Cosimo (1462-1521). Di Cosimo painted during the early part of the Renaissance in Italy but was always an idiosyncratic artist outside the mainstream.

Windsor Castle show Leonardo's studies from nature, including the background for the *Mona Lisa*.

The Florentine demand for a scientific approach to art led to the discovery of the mathematics of perspective – a system 'invented by Brunelleschi, first put into words by Leon Batista Alberti and given its fullest treatment by Piero della Francesca'.

The distinction between landscape with figures and figures in a landscape is difficult to define. For a long time the human content was the important element in the painting, with the landscape acting as a mere backcloth to the story being unfolded. The difficulty which artists experienced in placing figures in the landscape is illustrated by the *Martyrdom of St Sebastian* by the Pollaiuolo brothers (Antonio, c 1432-98; Piero, c 1441 before 1496) which dates from the 1470s; the figures in the foreground are seen from one viewpoint and the landscape beyond from another. Painters had many devices for dealing with this middle distance. In the *Baptism*, also in the National Gallery, London, Piero della Francesca (c 1410/20-92), one of the masters of perspective and the author of a book on the subject, handles the recession of the ground with ease, though the eye level of the picture is one-third of the way up, rather than at the base from which, as an altarpiece, it would

have been seen. In the difficult zone in the middle distance he fills the space between the ground and the foliage with high, Tuscan hills.

For the next major developments in the history of landscape painting we must move to Venice where Giovanni Bellini (c 1430-1516), Giorgione (1475-1510) and Titian (c 1487-1576) created moody, lyrical landscapes – pastoral scenes in which an ideal Arcadia was created. In Giorgione's painting, *Tempesta*, the details of the landscape and the figures are subordinated to the turbulent sky and the oppressive atmosphere which permeate the scene. He learned from his master, Giovanni Bellini, how to handle color and composition and managed to achieve a new unity between figures and their natural surroundings by means of color, atmosphere and proportion.

With the onset of the Reformation, many Flemish painters who had depended on the Church for work now found themselves deprived of their income. They began to concentrate on that aspect of their work for which they were famous throughout Europe, paintings in which meticulously executed landscapes dominate the background. Gradually the landscape proportion of the painting took over and there was soon a steady flood of landscape out of Antwerp to a ready market in Italian cities such as Venice. These were crowded fantastical scenes, painted to a fairly rigid formula. Among them, the work of Pieter Bruegel the Elder (c 1525-69) stands out for its originality. Artists like Joachim Patenier (before 1500-24) responded to this demand and created vast, fantastic panoramas as settings for such religious episodes as the Flight into Egypt. Patenier was the first Netherlandish painter to allow the landscape to

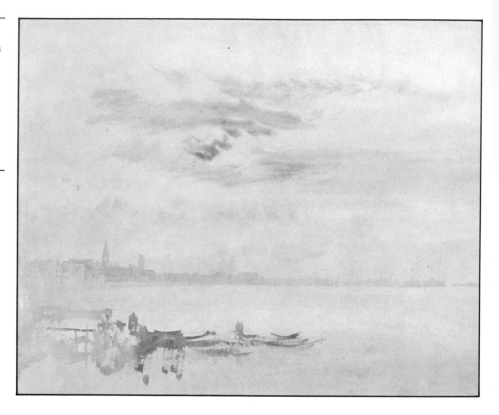

Venice from the Guidecca by J.M.W. Turner (1775-1851). In this economical watercolor Turner has captured the haunting beauty and special light of Venice. He was especially interested in light and the way space and atmosphere could be suggested within a painting.

dominate the narrative scene. His landscape is not the subject of the painting, but the craggy mountains and lush valleys dwarf the tiny figures. His landscape style is characterized by a threefold color scheme of warm browns in the foreground, shades of green in the middle distance, and a background of translucent blues.

Albrecht Altdorfer (*c* 1485-1538) worked in the German town of Regensburg. He was concerned with the integration of figures within a landscape space and is credited with being the first European artist to paint pure landscapes – miniatures painted during the last few years of his life.

DIVERGING PATHS

The seventeenth century was a time of great artistic excitement and it was in that century that landscape painting really came into its own. Once landscape painting had come of age and had developed as a subject in its own right, it took off in various directions, and artists created landscapes which were ideal, heroic, pastoral and naturalistic.

At this time Holland was an independent republic as a result of the war with Spain. There was no large scale courtly patronage and wealth was in the hands of the burghers.

They built fine new houses and wanted pictures to hang on their walls. They commissioned portraits, intimate indoor scenes and accurate paintings of the landscapes of their own country. The Dutch painters of the seventeenth century such as Jacob van Ruisdael (1628/9-82), Aelbert Cuyp (1620-91) and Hobbema (1638-1709) realized that scenes composed by nature were worthy of the painter's attention and they painted their own countryside accurately and naturalistically. Rubens (1577-1640) and Rembrandt (1606-69) also turned to studies of the landscape, but for purely personal reasons and as a means of expressing their own feelings and responses.

Rome at this time attracted a great many artists, including two of the greatest painters of landscape, Claude Lorraine (1600-82) and Nicolas Poussin (1593/4-1665). Claude, who was born in Lorraine in France, went to Rome as a pastry cook when he was about twelve and remained there for most of his life. Claude created lyrical pastoral landscapes based loosely on the landscape of the Campagna, the area around Rome, with its hills, lakes and distant mountains. He sketched in the open air, recording his experiences in notebooks, using pen and brush and dark-brown sepia

inks. Back in the studio these notes were used, but only as the basis, or the inspiration, of carefully designed compositions. In these idealized landscapes the positioning of each item, each classical building, was carefully considered so as to achieve an overall balance. These are dreamy, timeless landscapes – harmonious, balanced and immobile.

The rococo tastes of the eighteenth century favored a return to decorative, pastoral scenes and this trend is manifest in the work of Watteau (1684-1721) in France and Gainsborough (1727-88) in England. In the later years of the century the English painter Constable (1776-1837) turned away from these pastoral and picturesque concerns and looked back to the work of the Dutch realists, Hobbema and Ruisdael, for inspiration. J.M.W. Turner (1775-1851) originally painted landscapes in the Dutch manner, but influenced by the work of Claude, he gradually became interested in light – in the creation of luminous and atmospheric landscapes.

The Impressionists regarded the landscape as the most suitable subject for the painter. All the main figures of the movement, Pissarro, Manet, Degas, Cézanne, Monet and Renoir, were born between 1831 and 1841. Impressionism

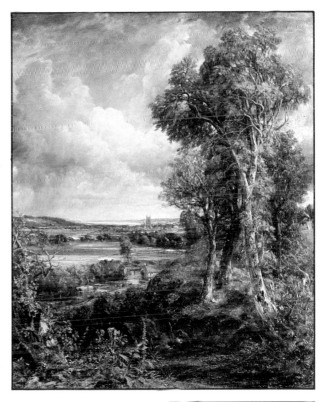

Dedham Vale by John Constable (1776-1837). He frequently painted the countryside of his childhood and this view is featured in many of his works.

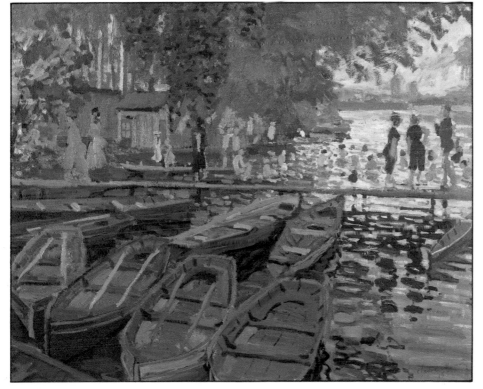

Bathing at La Grenouillère by Claude Monet (1840-1926). This painting was executed out of doors and the lively brushwork suggests the speed at which he worked in order to capture the transient effects of light.

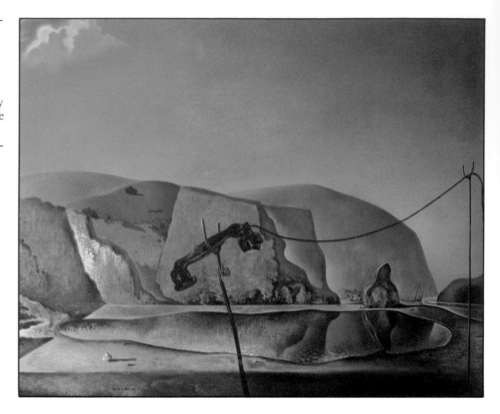

Mountain Lake by Salvador Dali (b1904). This painting typifies the alarming clarity with which the Surrealists created real landscapes and then upset our expectations by introducing strange dream-like images.

was not a homogeneous school but a loose association of gifted artists who banded together to discuss shared interests and to exhibit their work. Their aim was to achieve a greater naturalism by applying scientific principles to the analysis of color, tone and the way light is reflected from surfaces. This interest in color and light was partly derived from the researches of scientists such as Chevreul, who propounded the idea that any given color casts a shadow which is tinged with its complementary and this is one of the principal ways in which the Impressionists animated their picture surfaces. The Impressionists' brushwork, lack of firm outlines and high-keyed palettes were regarded as strange and revolutionary, and alienated the public. They painted in the open air producing rapid studies in free, sketchy brushwork which attempted to capture the fleeting effects of sunlight on mobile water. In seeking to free themselves from the conventional academic concerns with line, space and chiaroscuro, the Impressionist painters had to re-educate their eyes. They had to learn to 'see' the natural effect of light out-of-doors and reject the artificial eye of European painting. The Impressionists wanted to paint nature as it is seen and their quarrel with their more

conservative predecessors was not over their aim but over the means of achieving that aim. Their study of color and their experiments with brushwork were all designed to create an even more accurate visual impression.

After Impressionism many of the artists who had been concerned with it took the ideas evolved in their Impressionist period and developed them further. Beyond this, they had little in common, for each had different concerns and took Impressionism in a different direction.

THE TWENTIETH CENTURY

By the time of the twentieth century, artists had ceased to be concerned with the painting of facts and the imitation of natural appearance. The Cubists rejected single point perspective and sought to represent volume and solidity on a two-dimensional picture space without creating the illusion of a three-dimensional picture space. They represented real objects, but as they knew them, not as they appeared at one fortuitously chosen moment in time. The Cubists' chosen subject was still life, but landscape did figure in the work of such Surrealist painters as Dali (b 1904) and Magritte (1898-1967). These landscapes,

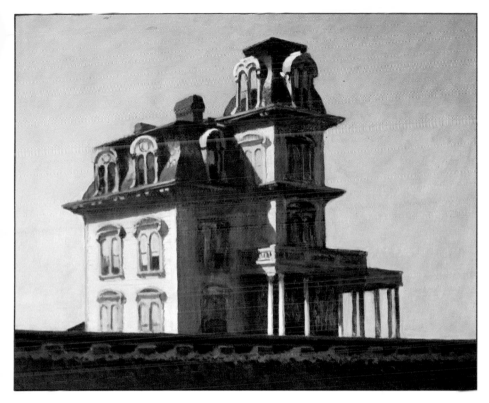

House by the Railroad by Edward Hopper (1882-1967). An American Realist painter, Hopper was concerned with formal precision. He modeled forms with tone, viewing his subject with a sharp, unrelenting eye.

which they depicted with such unsettling clarity, were gathered from the world of dreams in which the juxtaposition of strange and ambiguous images evokes obscure subconscious associations. Max Ernst (1891-1976) actually went to live in Arizona for a time because the real landscape there resembled the landscape of his surrealistic fantasies.

Landscape in the twentieth century has tended to survive in the form of national or regional schools of painting. In Britain, painters like Graham Sutherland (1903-80) and Paul Nash (1889-1946) have used the landscape as a way of exploring their own concerns. In America in the 1920s and 1930s the 'Regionalists' felt compelled by patriotism to create a genuinely American art. They glorified or at least recorded the rural, small town America which was rapidly being overtaken by the rapid urbanization of the country and the people. Grant Wood (1892-1942) was the most widely acclaimed member of the group. His tightly painted, detailed scenes are sometimes described as 'American Gothic'. Also loosely associated with the movement were such people as Edward Hopper (1882-1967), Andrew Wyeth (b 1917) and Ben Shahn (1898-1969).

Nowadays most people live in a largely industrial world.

In previous generations people lived much closer to the land, they were familiar with the natural world and their lives were ruled by the cycle of the seasons. The weather dictated the clothes they wore and the pattern of their work. We are increasingly insulated from the natural world, living and working in artificially heated concrete spaces. The changing seasons rarely impinge on our consciousness. Perhaps the 'land art' of the 1960s was a reaction against the way we were becoming submerged in our environment. In the past the land was used as a setting for works of art, but the land artists sculpted the land itself into an art form. The main practitioners were Karl Andre (b 1935), Robert Smithson (1938-72), Walter de Maria (b 1935) and Robert Morris (b 1931). The pyramids of Egypt, megaliths like Stonehenge and even the elaborately natural, but artificial, landscapes of gardens like Stourhead are precedents for this idea.

In this brief survey we have seen the way in which various societies have responded to nature. The way nature is depicted in painting is dictated by the kind of society, the way that society is organized, its interests, its philosophy and religion. We are part of a continuum and there is no reason to think that the subject is yet exhausted.

INTRODUCTION TO MATERIALS

If you find time to browse in your local art store, you will find yourself immersed in a world of exotically named materials and wondrous devices. This chapter is deliberately selective – it directs you to equipment which is particularly useful for the landscape painter.

The materials available to the landscape artist today are bewildering in their range. Experiment with as many as you can and always have painting and drawing equipment to hand.

ACRYLIC

Most people have painted or drawn at some time either during their school years or at evening classes. Often the first medium they use is the one they continue to work with. The choice may be quite fortuitous. It may be the medium made available by the school, probably poster color, the one favored by the teacher, or it may have been given as a present. It is sad that with so many exciting materials available many artists use, or have tried, only one or two media, and the one they use may not be the one that best suits their style, their approach or the subject. While change for its own sake is not necessarily a good motivating principle, it is important to explore the possibilities and make sure that what you use suits you, your pocket and the subject in which you are interested.

MATERIALS FOR SKETCHING

The artist's supply store can be a very daunting place for those unfamiliar with the range of materials, paints, brushes and painting surfaces displayed there. Many people end up using the same materials because they are intimidated and do not like to show their ignorance by asking questions. There is nothing to stop you having a good browse and asking questions – you will find the sales people very helpful and you will learn a great deal.

The first consideration with landscape painting is whether you intend to paint indoors or outdoors. The pros and cons of both approaches are discussed in the next chapter. In Chapters 6 to 10 a series of projects carried out in the main painting and drawing media are illustrated. Study the stages and the final paintings carefully and see which are the types of image that you might wish to achieve. You can learn a lot about the possibilities of the different media by studying the works of painters of the past and present in galleries and museums.

Another consideration to bear in mind when choosing your medium is the purpose of the drawing or painting. If you have little time, but want to make quick notes of something you have seen, you will probably want to work on a small scale, in a sketchbook. In that case you will probably use pencil, pen or watercolor, although anything that makes a mark can be used by an enterprising artist caught without materials – a burnt matchstick could be used in an emergency. Many artists use a couple of tubes of oil paint, a few sticks of oil pastel and a pencil, so that they have both line and color. The oil paint can be smudged on to

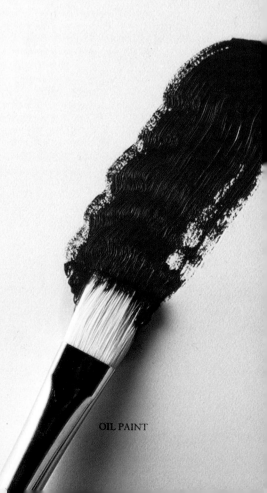

OIL PAINT

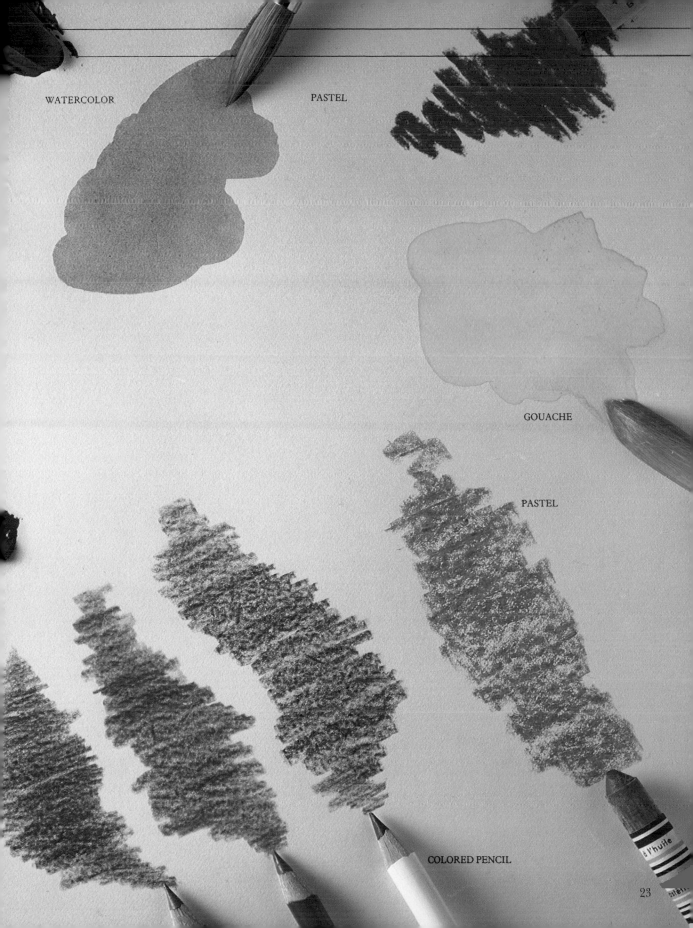

WATERCOLOR

PASTEL

GOUACHE

PASTEL

COLORED PENCIL

23

create a general form into which you can then work shapes, details and contours. If you feel bereft without color you could also use colored pencil or watercolor pencil in your sketchbook. Both media give you the advantage of line combined with color without the disadvantage of carrying cumbersome equipment around with you.

The size at which you wish to work is important, even in a sketchbook. Filling a large area with solid slabs of colored pencil is both time-consuming and tedious and you may not have the time to work up that amount of detail. If you feel that a larger scale is more appropriate you might prefer to work with watercolor or gouache or with a brisk medium like charcoal, which has a very responsive line.

Yet another factor to bear in mind is the relative cost of the materials available. Pencil, charcoal and fiber-tipped pens are obviously fairly cheap and will be within most people's budgets. Good watercolors on the other hand can be very expensive, particularly if you are buying a wide range of colors, although they do last for a very long time because they are used in such a dilute form.

You should also think about the intention of the painting or drawing. If it is for your own information only, as a means of investigating, learning, or recording, you will select different media and supports than if you want to produce a finished object for exhibition, as a gift or to hang on your own wall. This is not to imply that some media are necessarily more suitable for producing finished objects than others.

DRAWING MEDIA

Drawings can be made as investigative sketches, as personal records or as unique artistic offerings in their own right. The choice of tools available to the artist is immense. Charcoal is a particularly pleasing medium, with its flexible and fluid line, great tonal range, speed and expressive possibilities. It is, however, messy to work with and needs fixing if the work is to remain clean and is to last. Fixative is widely available in aerosol cans. Some artists use hair spray as a cheaper alternative.

Pencil is one of the cheapest and most flexible of drawing media – portable and available in a range of different lead qualities ranging from very hard to very soft. Colored pencils and watercolor pencils each have their own advantages and disadvantages, but above all they provide the artist with color.

Pen and ink is one of the most pleasing of all drawing media. The old-fashioned dip pen offers the artist a choice of nib types which can be used to create thick and thin lines; the artist can evoke brushwork by combining it with pleasing combinations of line and tone. Felt and fiber-tipped pens are new additions to the artist's armory and are both cheap and portable and definitely worth experimenting with. They too can be purchased in a range of colors.

Pastels can be used as both a drawing and a tinting medium and provide the artist with pigment in its least adulterated form. If you are excited by color you should experiment with both soft pastel and oil pastel. The vibrancy of their colors is a source of inspiration. Oil pastels are less messy than soft pastels and are particularly useful for sketching and working outdoors.

THE PAINTING MEDIA

The main painting media are oil, watercolor, gouache and acrylic. Oil paint is the most common and most popular painting medium. Its potential is tremendous and no two artists will use it in the same way. The paint can be used thickly or thinly, applied with brush or with a knife. The

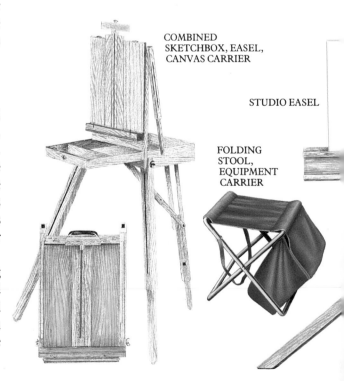

COMBINED
SKETCHBOX, EASEL,
CANVAS CARRIER

STUDIO EASEL

FOLDING
STOOL,
EQUIPMENT
CARRIER

painter unfamiliar with the medium must learn to control the color so that he or she can work wet-into-wet without slurring the colors so much that their purity is unintentionally lost. In many ways oil is a difficult medium but it repays time spent exploring its possibilities and coming to terms with its limitations. Many landscape painters prefer to work with other media, such as watercolor, pastel or acrylic, when they are working away from home, but use oil when they return to the studio. Others use acrylic to lay down the broad areas of the composition in the field. This dries quickly and can therefore be taken home without creating a mess. Oil paint can be worked over acrylic so the artist can complete the painting in oil when back in the studio. If you do want to work in oil outdoors you will have to plan your expeditions carefully and you will also need a good easel.

Acrylic is a relatively new medium. It contains the same pigments as the more traditional painting media, but while it has some of the qualities of oil and watercolor, it has other qualities entirely its own. It is seriously underestimated at the moment and suffers from unfair comparisons with the more traditional media. Its outstanding features are the speed with which it dries, and its excellent covering power. It is a flexible and useful medium and deserves to be explored for its own qualities.

Watercolor is a delightful medium. It too has suffered unfairly, having acquired a mystique which makes the self-taught or amateur painter shy away from it. Its techniques are thought to be difficult to master, and there is considered to be one 'correct' way to use it. Watercolor is, in fact, very flexible and is no more difficult to use than anything else. If you have been put off in the past, give it a try. Don't read a book on watercolor first, just buy some and paint. Then read books or ask people who use it to help you solve any problems that have arisen. Because it is light and the materials are simple, watercolor is particularly useful for working outdoors. You need water for mixing, diluting and cleaning and the paints, whether in tubes or pans, are very small.

EASELS

There are easels to suit almost every situation and pocket. Studio easels are large, easily adjustable and very sturdy. They take up a lot of space and are not collapsible so if space is at a premium you will probably prefer a radial easel. Radial easels can be folded down, tilted backward and forward and can support quite a large canvas. If you like to work sitting down you should consider the traditional artist's donkey which incorporates a bench. Again these easels take up quite a lot of space.

A table-top easel takes up little space and can be folded away when you are finished, but it can only support a small canvas or board.

There are a number of lightweight sketching easels which you will find very useful if you work outdoors. The ordinary small, sketching easel has telescopic legs which can be adjusted to an appropriate height. They are available in wood and lightweight tubular steel. The sketchbox easel consists of a box in which you can carry your painting equipment. When its legs are unfolded it becomes a very convenient and stable easel.

If you intend to paint outdoors you will need something in which to carry your materials. A sketchbox easel minimizes the items you have to carry. If you have an ordinary sketching easel you will need something in which to carry your paints and other equipment. Empty boxes for carrying oil paints are sold in art stores, or you can buy them complete with contents, but this is rather an expensive way to buy paint.

WOODEN SKETCHING EASEL

LIGHTWEIGHT ALUMINUM SKETCHING EASEL

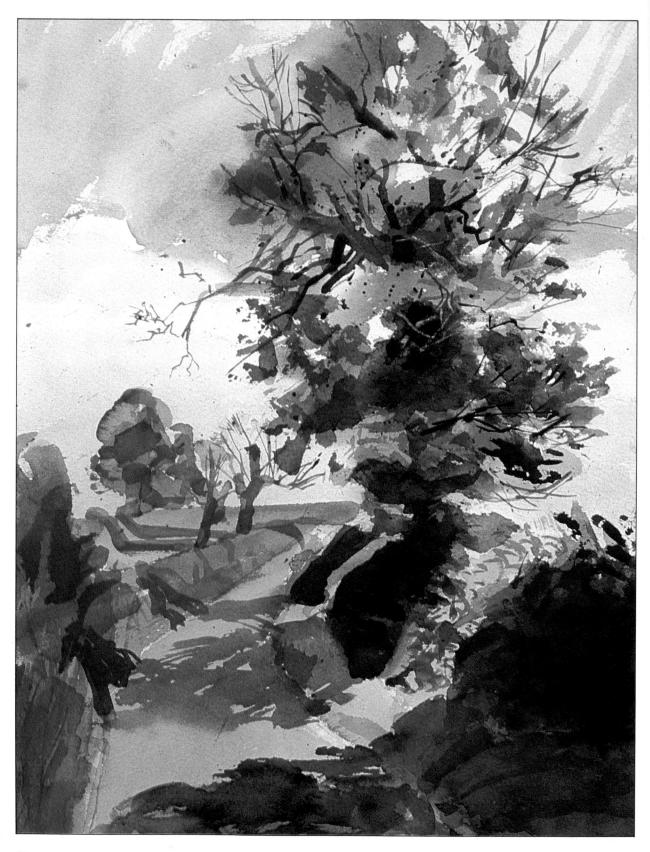

COMPOSING A PICTURE

One of the functions of the landscape painter is to encourage others to see the world with fresh eyes. In presenting this very personal vision, he or she will experience excitement and pleasure and should be able to convey this to the viewer. People who have never painted before often do not know where to start or what is a legitimate subject for a painting. The answer is that any subject can be the basis of a painting. What is important is how you organize the material you use.

The artist takes various objects, colors, patterns of light and dark and disperses them over the picture surface so that they work together, creating pleasing, thrilling, frightening or unsettling images.

THE GEOMETRY OF A PICTURE

One of the many elements that contribute to the success of a painting or drawing is the underlying grid, the scaffolding upon which it is built. The artists of Ancient Egypt divided the walls on which they were going to paint into a network of verticals and horizontals. The elements of the composition, including figures, were then disposed along these lines in a carefully considered and modulated way. By planning their paintings in this way they ensured the harmony, balance and sense of stability which they sought. Whatever the feeling you wish to establish you should be aware of this underlying geometry in your pictures. Leonardo da Vinci (1452-1519) was very aware of the underlying geometry which gave coherence and strength to a composition and used it in his own work. In his *Virgin of the Rocks* the elements of the painting are disposed around a triangle with the head of the Virgin at its apex.

RHYTHMS AND STRESSES WITHIN A PICTURE

Composition is a very important tool for the artist who wishes to harness and use the energy latent within his or her painting. The shape and size of the painting and the way these relate to the images within, all have a part to play. In some pictures the interest is focused in the center of the picture, and the corners and outer edges are bare and unoccupied. In other paintings the areas of activity are scattered over the picture surface. These different concentrations of activity set up a dynamic within the painting. In the first instance the eye constantly returns to the center of the painting, in the second the eye wanders ceaselessly over the picture surface. The artist who is aware of the energy which can be generated in this way, can harness it and exploit it for his or her own ends. The artist can set up disharmonies, forcing the viewer to look exactly where he or she, the artist, wishes. These rhythms can be set up in many ways. An asymmetrical design, for example, can be used to imply a gesture or a direction of movement. Tensions can be very easily created, thus a profile portrait will require more space between the front of the face and the edge of the painting than between the back of the head and the edge of the painting.

Dramatic impact within a composition can also be created by a variation of scale. If a large image such as a head occupies the foreground, the eye of the head seen in close-up may be the same size as a whole figure seen only a short distance behind it.

The artist may also draw attention to the rhythms and stresses within a work by the kind of line he or she uses, by stressing the direction of the structural, by the quality of the line used and by the way in which images are contained within the picture frame. These rhythms may be obvious, as in the case of kinetic artists, or they may be undercurrents.

CREATING A SENSE OF MOVEMENT

The way a figure or an object is placed on the canvas can radically affect its importance in the painting. The center

In both these paintings *above* and *left* the artist has contrasted an empty area with a detailed area. Empty spaces can be made to 'work' by drawing attention to an important feature or giving the eye a place to rest.

foreground is usually the dominant place, so moving the subject further up the picture may create the impression that it is farther away, even if it is painted the same size on the canvas. Placing a figure on the extreme left of a painting and facing that way will create the illusion that it is moving off and out of the painting. The same figure facing the other way will create a sense of movement into the painting, implying that the figure is stepping, or has just stepped, into the painting.

A clever artist manipulates the viewer, persuading him or her to follow a direction that the artist intends by tricking the eye into following a path around and even off the painting. Compositions can only really exist when the area of the picture is clearly defined, for this forces the artist to make decisions about how to work within limited parameters. The cave painters of palaeolithic times were untrammeled by such decisions, and were limited only by the size of the rock face, which had no clearly defined borders. However, people have a great ability to make a virtue of a necessity and so it is with the limited area of the canvas. Suppose you decided to paint one single figure on a canvas, and that the size of the canvas was specified – you would still be left with an incredible range of choices and could create many different pictures depending on how you positioned the image.

It could, for instance, be positioned centrally – both vertically and horizontally. This would create a feeling of isolation, loneliness and stillness. Move the figure down

toward the bottom of the painting and it will appear to move nearer. Move it further down, so that it is cut by the frame, and you will imply that it is even nearer and behind something. Move the figure down so that only the head shows over the frame and you will create an image which is both strange and amusing. By moving the figure further up the picture you create the illusion that it is farther away.

By introducing another image into the composition you create a new set of variables. The way the figures are placed relative to each other sets up tensions and movements. Move them in relationship to each other, overlap them and you once again imply distance. The composition becomes even more complex when you start changing the size of the components and the way they fill the space – change their relative size and the picture changes yet again. Like so many things in painting these considerations are important, but you should not let them worry you. Most people are unaware of these aspects of composition until they are pointed out to them, but once you do become aware of them file them away for reference. These are things which you should be aware of at a subconscious level and apply automatically.

USING EMPTY SPACES IN PAINTINGS

An important aspect of any painting is the way in which the artist disposes the elements around the picture surface, and also the number of elements, whether they be objects or colors. A painting consisting of many small objects evenly

In these paintings *above* and *right* the artists have spread the areas of interest throughout the paintings. There is no obvious place for the eye to rest and the paintings have an underlying tension.

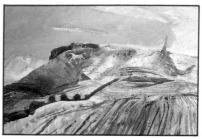

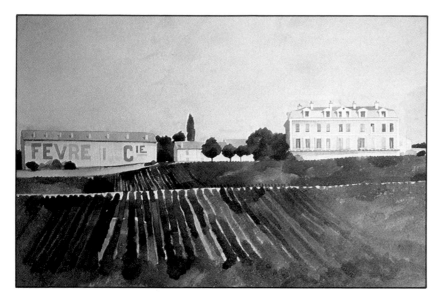

Both artists *above* and *left* have employed converging lines to lead the viewer's eye into the painting. In this way they emphasize both the foreground and the background and thus the space between.

dispersed over the picture surface creates a kind of visual tension, as there is no place for the eye to rest. In other words it is a 'busy' painting. If, however, the artist intersperses the busy areas with relatively uncluttered areas, these will act like punctuation points in the composition, allowing the eye a place to rest and yet, at the same time, enhancing the brightness and excitement of the more busily articulated areas. You could even have a painting in which a single small object is placed within a large field. None of these compositions is 'correct', none is better than the other. But the important point is that they are all different and these strong visual forces are there for you to exploit to your own ends.

In landscape painting artists often use this device by contrasting a busy foreground with a simple, flat background. The artist may change the level of the horizon, moving it up and down the picture so that at one extreme no sky at all is shown and at the other the sky occupies the major area of the painting.

SPACE IN LANDSCAPE PAINTING

An artist painting from nature is faced with the problem of representing three-dimensional form in space, on the flat surface of the canvas. In order to do so the artist is forced to distort what he or she has seen. Mathematical or linear perspective is one convention which can be used to help present images in a way that will be meaningful to the viewer. It is important to remember that the laws of

perspective are not necessarily the rules of painting – artists can produce pleasing images without any knowledge of perspective, or they can, if they choose, ignore or distort those rules.

Linear perspective is based on a horizontal picture surface, from which lines recede at right-angles to a vanishing point. The origins of this system can be traced to the late thirteenth and early fourteenth centuries in Italy, when artists such as Giotto began to take a new interest in the natural world. This led them to search for an empirical way of representing solid objects realistically. Brunelleschi (1377-1460) developed a geometry to make possible the perspectival representation of three-dimensional space on a flat surface. Alberti (1404-97) described and publicized the system in his *Della Pittura*, 1436.

In order to deal with the concept of linear perspective, it is first necessary to grasp the idea of the picture plane. The best way to visualize the picture plane is to imagine that you are holding an empty picture frame, or a piece of glass, vertically in front of you, between you and the scene that you are painting. It must be at right-angles to your line of vision and it must stay in one position. If the viewpoint is altered while you are painting, you will create an inconsistent perspective. The concept of the picture plane is also useful to check the angles of lines observed in the landscape which can be 'read' against the horizontals and verticals of the frame.

Next you must establish the vanishing point. When you

are standing, your eye-level is exactly the same distance from the ground as your eye. If someone the same height as you is standing on the horizon, that person's eye-level and yours are the same distance from the ground. His or her eye-level establishes the horizon line and the vanishing point is somewhere on that line. The vanishing point is the point at which right-angles to the picture plane appear to converge. The vanishing point need not necessarily be within the picture plane, but it will be somewhere along the horizon line.

Perspective works in all dimensions. An avenue of trees recedes according to the laws of perspective. If the trees are planted in a straight line, are of the same height, and if the road does not undulate, both the bases of the trees and the tops of the crowns will lie along lines which will converge on the same point.

The angles that the walls of buildings make with the picture plane are also important. If a row of houses is set along an avenue, the sides of the houses looking on to the avenue would be at right-angles to the picture plane and the ground line and roof line would converge to the same vanishing point as the line of trees. If, on the other hand, you were looking straight at the side of the wall of a building, the wall would be parallel to the picture plane, its base and top would be horizontal and its side would be vertical. In single-point perspective one side of a cube remains undistorted and parallel to the picture plane. If you were very close to the base of the wall and looked up, its sides would appear to converge. All objects can be treated in this way – trees, clouds, mountains. The important thing to remember is that while perspective can be used to create illusions of reality, illusionism is not the concern of all artists.

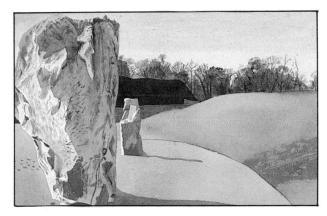

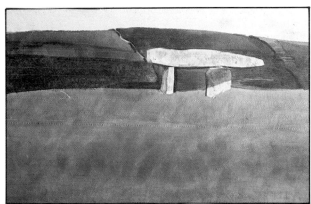

In this group of landscape paintings the artists have made different decisions about where the horizon should fall in relation to the picture frame. Notice the way this affects the sense of space within the paintings.

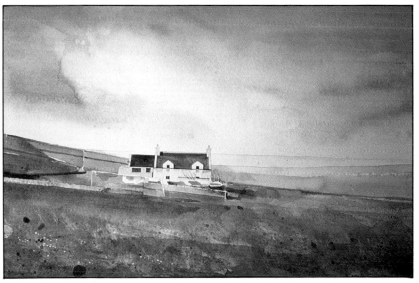

Aerial perspective is an alternative method of representing the appearance of depth or recession in a picture. The term was invented by Leonardo da Vinci (1452–1519) to distinguish it from the linear methods of creating the same illusion, then also in use. In atmospheric perspective another spatial dimension is added by the use of tone and color. All colors are perceived through the atmosphere. Dust and droplets of moisture cause scattering of light as it passes through the atmosphere.

This affects our perceptions of colors which appear to change according to the distance from our eyes. Objects in the distance appear less distinct and take on a bluish tinge. In the far distance only the broad shape of objects can be observed and they appear pure blue. The first example of aerial or empirical perspective can be seen in the wall paintings at Pompeii and Herculaneum. The artists drew and painted what they saw, creating paintings in which the illusion of reality, of depth and distance is convincingly depicted. However, it is not possible to locate every single object in space. The viewer trying to thread a path in and around the objects will get lost.

Aerial perspective also depends on reducing the contrast between light and dark in the distance. A tree which has light playing on one side, will have one dark side and one light side. If the tree is close to the picture plane, the contrasts between those light and dark sides will be fairly strong. But as the distance between the tree and the picture plane increases, the contrast will be reduced. From a distance, the darker side seems lighter because the atmosphere itself is illuminated. The shadow on the tree will appear progressively lighter the farther away it is, the lighter side will become slightly darker according to the density of the atmosphere, but to a lesser degree than the shadow gets lighter.

In painting, contrasts of tone and color make objects appear closer. It is important to be able to compare the tonal values in what you see. When composing a picture it is often useful to pick out the lightest and the darkest tones in the scene and place everything in its appropriate place within this tonal scale.

TONE IN PAINTING

A painting can be analyzed by looking for the underlying geometry and for the directional lines. However, this underlying structure is overlaid by other aspects which may work to emphasize the basic structure, or may work against it, creating an interesting dynamic. The way in which the areas of tone are disposed across the picture surface is an important underlying current in the composition. One of the best ways to identify these areas of light and dark is to squint at the painting through half-closed eyes. You will see the painting reduced to its very simple components – almost an abstract. Some paintings will be divided into a few areas of light and dark, creating strong simple images and a feeling of stillness and calm. Other paintings are a mass of small elements leading the eye in a more agitated way

In both these paintings *above* and *left* the artist has allowed the tree trunks to break the picture frame at top and bottom. This brings the image up to the picture frame, creating a sense of recession by contrast.

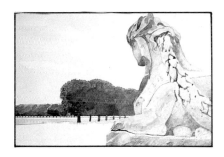

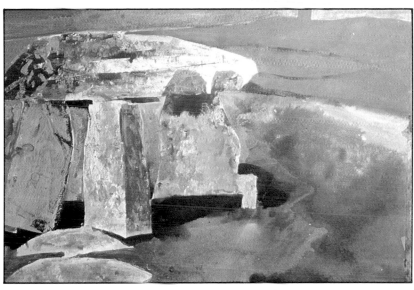

These paintings illustrate the effect of warm and cool colors within a painting. *Above* the tones are predominantly cool and *right* the artist has introduced a passage of warm, brick red.

around and across the picture surface. You can investigate the tonal masses of a painting by making a sketch of the basic forms, then blocking in the tones to see if they relate to, or counteract, the underlying geometry.

COLORS AND THEIR EFFECT

The study of color is a fascinating subject and psychologists, physiologists, physicists, artists and interior decorators have applied their minds to it over the years. Colors can evoke moods and feelings, and certain colors acquire a particular significance in different cultures. In our culture, for example, white is regarded as the color of purity and brides marry in white, but to the Chinese, it symbolizes death and is appropriate to mourning. Colors have been found to have a profound effect on how the body functions.

Red has a dramatic effect – it has been found to increase the rate at which we breathe, speed up the heartbeat and raise the blood pressure. Blue, on the other hand, has the opposite effect – it slows respiration and heartbeat and lowers temperature. Color has also been found to have an effect on the way we experience environmental temperatures. In an experiment it was found that people in a room painted blue-green 'felt' the room temperature of 59°F was cold, whereas a red-orange room was not 'felt' to be cold until the temperature actually dropped to 52°-54°F, a difference of 5°-7°F. This is as a result of the influences on the circulation and respiration.

An artist uses color for expressive purposes – it is yet another means of communicating what he or she feels. The artist may use a low-key palette in which the tones are muted and there are no bright colors. The artist might use such a deliberately restrained palette in order to convey a feeling of peace and calm, or it might be appropriate for describing the leaden sky and drained color of a winter's afternoon. A high-keyed palette would be used to describe the bright vibrant colors of a Mediterranean landscape bathed in summer sun.

Color systems and science may seem remote to the artist, with his or her paints and ideas, but it is important for the artist, no matter how inexperienced, to experiment with different pigments and colored grounds – to get to know how color works in practice. It is difficult to be objective about color but constant experiment, and analysis of the results, will help you to develop a knowledge of, and skill with, color. What you learn will be of value throughout your painting career.

The ability to put colors together skilfully will enable you to exploit the language of color; the greater your knowledge, the larger your color vocabulary, the freer you will be to translate the images in your mind into paint on the canvas. There are no 'right' or 'wrong' color combinations, but if you know what makes cetain colors 'scream', you can either exploit the effect, or avoid it, as you wish. Colors combined and interact in a variety of ways. For example, yellow on a white background appears very different from yellow on a black background.

34

CHOOSING A SUBJECT

We all have an attachment to our native landscape – it exerts a profound influence on the way we live and on our view of life. The artist quite naturally responds to this feeling for place. By paying attention to the features that normally form the background to our everyday lives, he or she encourages others to look more intensely at their surroundings.

Artists differ in the extent to which they need the subject in front of them as they paint. For some it is essential all the time, the direct visual response being their primary concern.

Most landscape painters have a profound love of the countryside – they are fascinated by the atmospheric effects of changing light in the open air, the movement of clouds across the sky and the shifting and flickering of weather. For them there is nothing to beat the pleasure and excitement of working *en plein air* (outdoors) before the subject. But if you have not tried to work in this way before, you should not underestimate the problems. The countryside spreads out around you in all directions and, depending on where you have positioned yourself and the nature of the topography, the view extends for miles and miles, right to the horizon. The scale and range is daunting. There may be trees, rivers, mountains, hills, buildings, people, ploughed fields, animals, water and reflections, and above it all the huge dome of the sky, flecked with clouds. All this complexity will be suffused with a light which may change from moment to moment, casting shadows and creating pools of brightness. And there will be constant movement, the movement of clouds across the sky, and the wind in the trees rustling the leaves so that one moment they are dark green and the next silver. How can you possibly cope with all this? Where should you start? What will make a 'good' picture?

The way you tackle the problem will depend on your personality – you will probably approach the problem in much the same way as any other. The thoughtful, careful person will select the 'ideal' spot, by considering all the possibilities, making sketches, and analyzing the compositional problems. Finally, he or she will set up the easel and start to work in an organized and orderly way. A more impetuous person will just want to get started, will set up the easel and paint what is there after only cursory consideration of the alternatives.

Having selected a spot, you will have to decide what to include and what to leave out. The choice ranges from a detailed painting or drawing of the grasses growing at your feet to a vast panorama which includes everything you can see without moving. Selection is one of the important creative processes; you could put a dozen artists in the countryside at the same spot and no two would choose the same subject. One might paint a scene glimpsed through a gap in a hedge, concentrating on the sense of depth created by overlapping images. Another painter might concentrate on the sky, another on the grasses and wild flowers, another, interested in the human form, might use the other painters as models for a painting of figures in a landscape.

Yet another might concentrate on an architecturally interesting building. You will have your own interests and concerns which will change from time to time and these will be reflected in your work.

One very useful way of reducing the vastness of the countryside to manageable proportions is to cut yourself a window in a piece of cardboard. As you peer through it you will mask off areas of the scene and this will help you concentrate. By holding the window close to your eye you will frame a large portion of the view; by holding it far away you can highlight a small area. If you have not got a frame you can use your hands as a mask and, by peering through them with one eye closed, concentrate on certain areas. Ideally your frame should have the same proportions as your canvas, and by turning it around you can decide what shape your picture should be.

SUPPORTS: SIZE AND SHAPE

The shape of a picture is an important, but often disregarded, element of the final composition. Pictures have been painted with circles, semicircles and polygons, but the most usual shape is the rectangle. The reason for the supremacy of the rectangle has more to do with economics

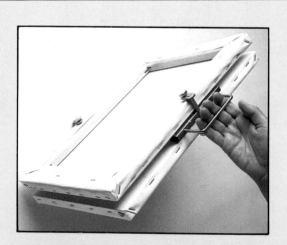

Carrying wet canvases home is one of the problems which the landscape artist has to grapple with. This canvas-carrying device *above* clamps two canvases together, wet side to wet side. The canvases are held apart from one another and the handle makes them easy to carry. Take two canvases the same size with you, even if you don't use both.

and efficiency than with the way we perceive things. In fact, a circle or a semicircle is more closely related to our field of vision than a rectangle. The rectangle evolved as soon as painters began to work on panels rather than on walls, for it became apparent that if pictures were to hang alongside one another some harmonization would be necessary, and the rectangle emerged as the ideal shape. A vertical rectangle is referred to as portrait and a horizontal rectangle is called landscape. These terms should not be confused with areas of work, Constable (1776-1837), for instance, painted many landscapes on vertical canvases and Degas (1834-1917) painted portraits on horizontal canvases.

Different shapes and sizes evoke different responses from the viewer. A landscape shape is said to create a feeling of calm and stability while a square is stable and solid. And think how you are affected by the size of an object. A small painting, for example, feels intimate and domestic. A large one, like Turner's *Snowstorm: Hannibal and his Army Crossing the Alps,* in the Tate Gallery in London, which is 52½ x 93 inches emphasizes not the intimate lyrical aspect of the countryside, but the immensity and awfulness of nature. The size at which you work will depend on habit, on the subject and on the medium you are using. Some painters always work on a small scale, others always paint on a large scale and others are more flexible and respond to the demands of the subject.

OUTDOORS *vs* STUDIO

Apart from the obvious pleasures of being out in the fresh air in a beautiful part of the countryside, there are many aspects of painting outdoors which cannot be reproduced in the studio. When you are painting *en plein air* you are part of the scene with your subject all around you. You are not painting at one remove but you are there, and can capture the sense of the moment. You can choose between the micro and the macro scale, between the subject right at your feet or the vistas far away on the horizon. You are aware of smells and movement, and are sensitive to subtle color changes as clouds scud across the sky, now hiding, now revealing the sun. You have an acute awareness of scale, of size, of space, for you can see and feel them. Photographs may flatten and distort, but when you are actually on the spot you can record just how impressive particular hills appeared to you at the time. Using color and descriptive brushwork you can convey that sense of height which might be lost in a photograph. Texture is revealed by light as it

Selecting a subject to paint can be difficult, especially when faced with the broad expanse of the countryside. A frame helps you to see parts of the scene in isolation. Here the artist isolates different parts of a sketch to see how they would work as paintings.

bounces off incidental surfaces. It is an important aspect of any painting. This is highlighted outdoors where the changing light flickers across surfaces, revealing first one aspect and then another. You are very aware of surfaces, of the feel of substances, of the difference between brick and stone, the smoothness of glass and roughness of bark and of the contribution that each makes to the overall impact of the scene. Working in the studio all this sense of immediacy is lost and the subject can become sanitized.

Another great advantage is that you can maneuver yourself until you find the view that appeals to you most. You can turn through 360 degrees and can shift your position so as to remove objects from your line of vision or include others. There are, of course, some disadvantages. Not everyone has access to the countryside or even to an appropriate area in the city. Access can be a problem and unless you have motorized transport it can be difficult to convey all the paraphernalia necessary, for say, an oil painting. The weather can be a deterrent and, certainly in some localities, there are several months of the year during which it would be a hazard to health to spend any length of time immobile outdoors.

The studio has much to recommend it. There is the comfort and convenience, and protection from the elements. Materials are close to hand, and heavy easels and

equipment don't have to be wrapped and carried around. In the studio you are not generally so pressed for time and can be more considered and selective. You can afford to experiment with different ideas and compositions. Using material gathered in the field as a jumping-off point, you can deliberately distort and highlight. Because you are removed from the scene you may feel freer to adapt the material, to select and reject. By distancing yourself from the subject, you give yourself scope to experiment, to be creative, to make something very personal and unique.

THE 'IDEAL' SUBJECT

In many ways the best subject is the one closest to hand. Sometimes looking for the 'ideal' subject can be a kind of displacement activity, where you are subconsciously putting off the moment when you actually get down to painting. So look around your home and check the views from your windows. Is there a painting there? You are not necessarily looking for something pretty. What you want is something which elicits a response in you and which has interesting features that you can exploit. Are there unusual blocks of color, for example an odd perspective problem or an enclosed space which opens out into a broader vista? Look for texture, for light and shadow. The real interest of the painting will lie, not in the subject, but in what you make of

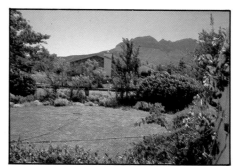

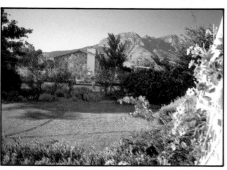

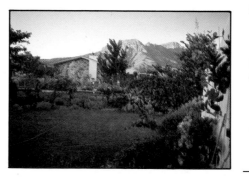

This series of photographs was taken from the same spot on the same day. The first *top left* was taken at 8.30 am, the second *top right* was taken at 1.00 pm, the third *bottom left* at 6.20 pm and the last in the series *bottom right* at 7.10 pm. As the sun rises, passes overhead and sinks, different areas of the scene are illuminated. Notice the way the flowers start to catch the light in the middle of the day and the contrast between the dark foreground and the mountains catching the evening sun in the last picture. The way the light changes during the day is something you must allow for or accommodate in your work when painting outdoors.

it. Looked at in this way, absolutely any subject can make a painting.

However, if you really do not feel inspired by the view from your window, have you got a garden, a terrace or a patio which you could paint? Or is there a park, a river or an area of open land nearby? At first you will feel uncomfortable about working where people can see you but you can always find some corner where you can tuck yourself away and people will not notice you.

A 'VISUAL DIARY'

Another method of working is to collect material for your painting in a sketchbook. Use watercolor, colored pencil, oil, or pastel – any medium with which you feel happy and can work quickly. Make a series of sketches. Some can be rapid, but if you are going to work up a painting you should also make some detailed drawings or paintings. This performs two functions. First it will ensure that you have the information you need to make a painting in your studio, but even more important it will concentrate your mind and force you really to look at what is there. In much the same way, people who take notes at lectures will sometimes look back at the information they have recorded, but often the exercise of jotting down the information is sufficient to imprint it on their minds, so that they do not need to refer to the notes they have made.

A sketchbook is probably the artist's most important tool and you should never be without one, no matter how small. It can be used in many ways. It is like a visual diary, a record of day-to-day events. It can also be used to try out ideas. If you are attracted by a particular view, for example you can make rapid notes in which you consider different formats and analyse various compositions. You can move about and see how the elements of the subject fall within a particular format when viewed from different angles. Do you want that particular tree on the left or right of the painting? How would the view look if you stepped back so that it was framed by two trees? These notes need not be large and can be very sketchy.

With a colored medium such as watercolor or colored pencil, you should have plenty of information about the color of the subject. If, however, you use pencil or black fiber-tipped pen, you may wish to annotate the drawing with remarks about colors and the fall of light. You can also add dabs of color to the painting as an

In the sketch *above* the artist has briefly noted the colors by putting down small areas of paint. He has supplemented this information with handwritten notes.

aide-mémoire.

You can supplement the material you have gathered in this way by taking photographs. Unless you are a skilled photographer, you may be surprised to find just how a photograph can flatten its subject, so that a scene which you remember as quite spectacular will appear rather boring and unimpressive. Your sketches will capture the differences of scale and will highlight those features which you found interesting, while the camera will be rather unselective, treating each element in the landsape with the same degree of attention.

WORKING FROM PHOTOGRAPHS

Photographs and pictures taken from newspapers, calendars and magazines, can be used as reference material to create exciting compositions. Do not copy them slavishly as the resulting pictures will have all the faults of the originals, and will lack creativity. Instead you can exaggerate, highlight and distort what you see in order to 'create' your own image.

If you take photographs with the intention of using them in the studio, take a series including detailed shots.

Photographs can supplement information in a sketchbook and jog the memory. They can be specially taken as the basis for a painting. Photographs from magazines are a source of ideas, although they need not be literally interpreted.

Keep scrap books of photographs, newspaper cuttings and anything which stimulates your imagination – in that way you need never be at a loss for a subject. Even the flaws in this sort of material can be exploited and may set you off on a new line of investigation.

If you find it difficult to work freely in this way you might try working from photographs at one remove. You could, for example, start by making a collage of the subject. You could then make a painting from the collage and you will thus avoid the trap of slavish copying.

Black-and-white newspaper photographs are another fascinating source of inspiration. The grainy, rather coarse effect created by the screening of the picture for reproduction and the absorbent nature of the paper give the image the unresolved qualities of a rapid charcoal sketch.

TOPICS

A great many subjects and approaches are encompassed by the term landscape. You may, for example, be concerned with making an accurate record of an area which you find attractive, or to which you have an emotional attachment.

You may, on the other hand, be interested in the subject merely as a vehicle for an investigation of the effects of light, of the use of color to create mood, of structure and space. The range of subjects is endless and you can return to the same one again and again, looking at new angles, or tackling a new problem. Monet was fascinated by light and the way it affected the color harmonies of the subject. He made several series of paintings in which he painted the same subject under different light conditions and at different seasons. The most famous of these are *Poplars*, *Haystacks* and *Rouen Cathedral*. He painted the poplars on the banks of the River Epte in different lights and at different times of day. His paintings of haystacks captured the way light changed with the seasons. He would take up to thirty canvases into the field, moving from one to another as the light conditions changed.

You may approach landscape through the figures in the landscape, or you may be interested in the way buildings and other artificial structures add interest to a landscape. These features need not occupy large parts of the painting, but they can act as a focal point with the surrounding landscape providing atmosphere and setting. For example, a building in a landscape can provide an interesting change of tone and form – a basic rectangular shape surrounded by softer, more natural forms. The contrast of the hard edges of artificial structures can enhance rather than detract from the soft sinuous forms of nature.

The urban landscape provides the artist with a wealth of stimulating material. Architectural subjects make simple, almost abstract compositions. Look, for example, at the smooth lines and flat simple surfaces of modern buildings. In the city you will find complex and exciting arrangements of pattern and tone, and color as intricate as anything to be found in nature.

TOWARDS ABSTRACTION

One of the fascinations of painting is that you can make of it what you will. For many painters, the figure, the landscape or the still life is merely a starting point for their paintings, and once finished the origins of the idea are difficult or impossible to find. The difference between what is figurative and what is abstract is sometimes rather fine, especially as we find it very difficult to look at any image without 'interpreting' it, without giving it an identity which relates to something we already know. Think how easy it is to read

shapes in clouds, a face on the moon, and form in blots and stains on the ceiling. All paintings, even representational paintings, rely on a degree of selectivity. Painters do not include everything they see, they distort and adjust in order to make a moving, three-dimensional world fit on to a static, two-dimensional picture surface. The infinite colors of the visible world have to be reproduced with a limited range of pigments. This unconscious abstraction is inherent in all painting, and conscious abstraction merely takes the process a stage further. An abstract painting strips away layers of surface decoration to reveal the bare bones of the subject, the underlying organization and geometry which appeals to our aesthetic and intellectual senses. The rise of abstract art in the twentieth century can be traced back to the introduction of the camera, which liberated the artist from the role of recorder of events and commentator on society. It was at the same time a reaction against the Impressionists' obsession with naturalism. Artists began to concentrate on the formal values of their paintings – on the structure, composition and on color. This led them to Cubism, Constructivism and other increasingly abstract art forms. Eventually some artists moved away from the representation of the real world altogether – in truly abstract work no part of the painting represents or symbolizes anything in the real world.

Many very exciting landscape paintings veer towards abstraction, as the artist's delight with color of form leads to a gradual break-down of the image, and the viewer is teased as the images constantly dissolve and resolve into familiar forms.

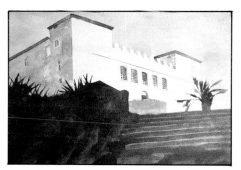

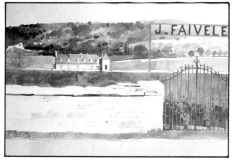

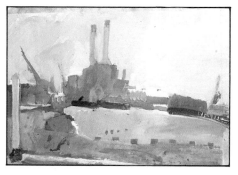

The pictures illustrated here show some of the range of subjects available to the landscape artist and the way they can be handled. In the first painting, for example, *top left* a single structure dominates the picture. In the second *top right* a building is again featured but it is integrated into the surrounding landscape. *Center left* the artist has chosen an urban subject which contrasts with the rural scene beside it *center right*. The two paintings *bottom left* and *bottom right* are of images abstracted from nature.

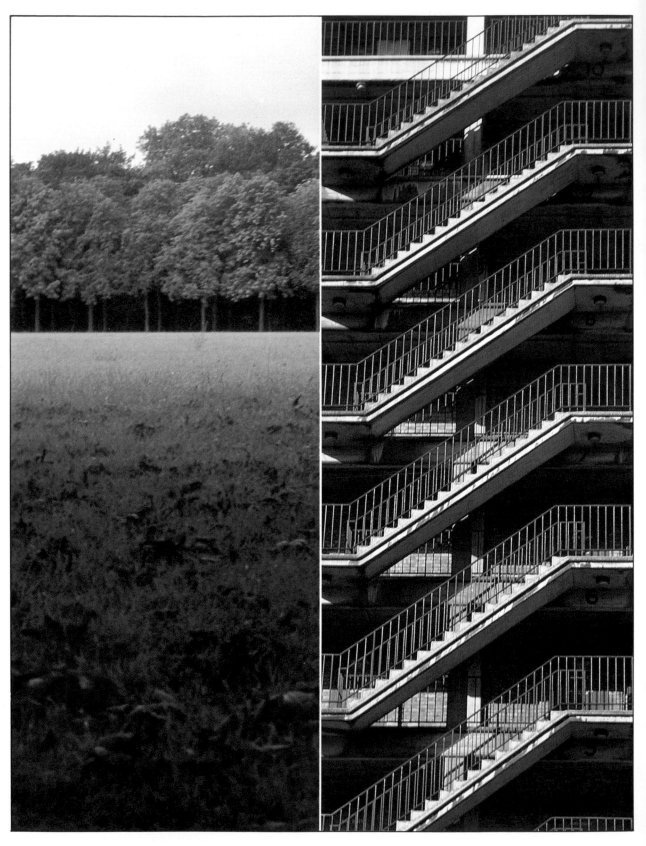

LOOKING AT LANDSCAPE

The painting of landscape for its own sake is a fairly recent development in the history of art and was more or less unknown before the late eighteenth century. Landscape has been included as an incidental part of the background of paintings since earliest times, although the landscape was not seen as a unified whole, but as a collection of quite separate things. Only when artists learned to 'see' all these disparate elements as a 'scene' did landscape as a theme of painting become possible. This chapter makes a visual survey of the elements of which the landscape is composed.

The urban scene is now an important part of our visual environment and landscape artists are increasingly turning to the cities for their inspiration.

Looking at Landscape

Here we see just some of the disparate elements which make up the landscape. The landscape provides the artist with an almost limitless source of inspiration. It is a subject full of richness and variety, from the varied forms of the earth's surface, to the sky which covers it. It is important to remove all preconceptions from your mind each time you approach your subject. Always survey the scene as if it were new and unknown. In that way your work will always be fresh and you will always be learning. Let your subject teach you rather than trying to impose preconceived ideas.

A landscape is made up of several features – the skeleton, the sky and clouds, the trees and, sometimes, water. The topography of a landscape is dictated by its underlying geology. The rocks which lie under the surface are the skeleton over which the surface details are laid. The sky is an important part of any landscape and can set the mood of a painting. It may be clear and blue, dotted with low scudding clouds, veiled with high haze or lowering and stormy. Once you start to look at a tree with an artist's inquiring eye, you realize how much trees vary from species to species and through the seasons. Water in a landscape can be difficult to handle because it has no structure. It also tends to be lighter than the sky, because an expanse of water reflects the sky. Objects such as ships, islands or headlands can be used to suggest space. Landscape is a challenging and rewarding subject. In order to master it you must study it whenever you can, learning to look and see.

Oil

'A most beautiful invention and a great convenience to the art of Painting' – that is how Vasari described the discovery of coloring in oil. The Flemish painter, Jan van Eyck is usually credited with discovering the technique at the beginning of the fifteenth century, but though he was undoubtedly responsible for innovations in the field of painting, oil had actually been used as a medium in the Middle Ages, long before his time. Whatever the circumstances, it is certain that from the fifteenth century onward painting in oil developed rapidly. The new medium liberated artists from the constraints of tempera. Now they could produce deep, richly saturated colors which glowed with an inner light, and with its greater range of lights and darks, oil paint allowed them to model form more naturally and easily than ever before. It is these qualities which have ensured that for the past four hundred years oil has been the favored medium among artists. It is flexible, responsive and can be used in a great variety of techniques. Diluted it can be used to create thin, subtly tinted layers of glazes. Used straight from the tube it produces thick, fresh impastos, in which the texture of the paint and the mark of the brush become an important component of the finished painting.

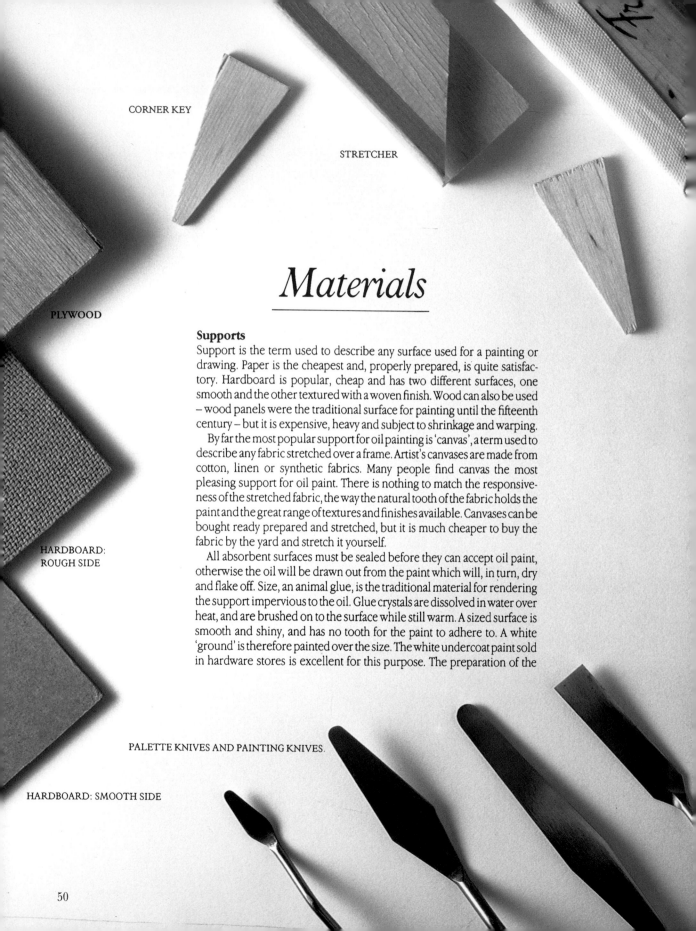

CORNER KEY

STRETCHER

PLYWOOD

HARDBOARD:
ROUGH SIDE

Materials

Supports

Support is the term used to describe any surface used for a painting or drawing. Paper is the cheapest and, properly prepared, is quite satisfactory. Hardboard is popular, cheap and has two different surfaces, one smooth and the other textured with a woven finish. Wood can also be used – wood panels were the traditional surface for painting until the fifteenth century – but it is expensive, heavy and subject to shrinkage and warping.

By far the most popular support for oil painting is 'canvas', a term used to describe any fabric stretched over a frame. Artist's canvases are made from cotton, linen or synthetic fabrics. Many people find canvas the most pleasing support for oil paint. There is nothing to match the responsiveness of the stretched fabric, the way the natural tooth of the fabric holds the paint and the great range of textures and finishes available. Canvases can be bought ready prepared and stretched, but it is much cheaper to buy the fabric by the yard and stretch it yourself.

All absorbent surfaces must be sealed before they can accept oil paint, otherwise the oil will be drawn out from the paint which will, in turn, dry and flake off. Size, an animal glue, is the traditional material for rendering the support impervious to the oil. Glue crystals are dissolved in water over heat, and are brushed on to the surface while still warm. A sized surface is smooth and shiny, and has no tooth for the paint to adhere to. A white 'ground' is therefore painted over the size. The white undercoat paint sold in hardware stores is excellent for this purpose. The preparation of the

PALETTE KNIVES AND PAINTING KNIVES.

HARDBOARD: SMOOTH SIDE

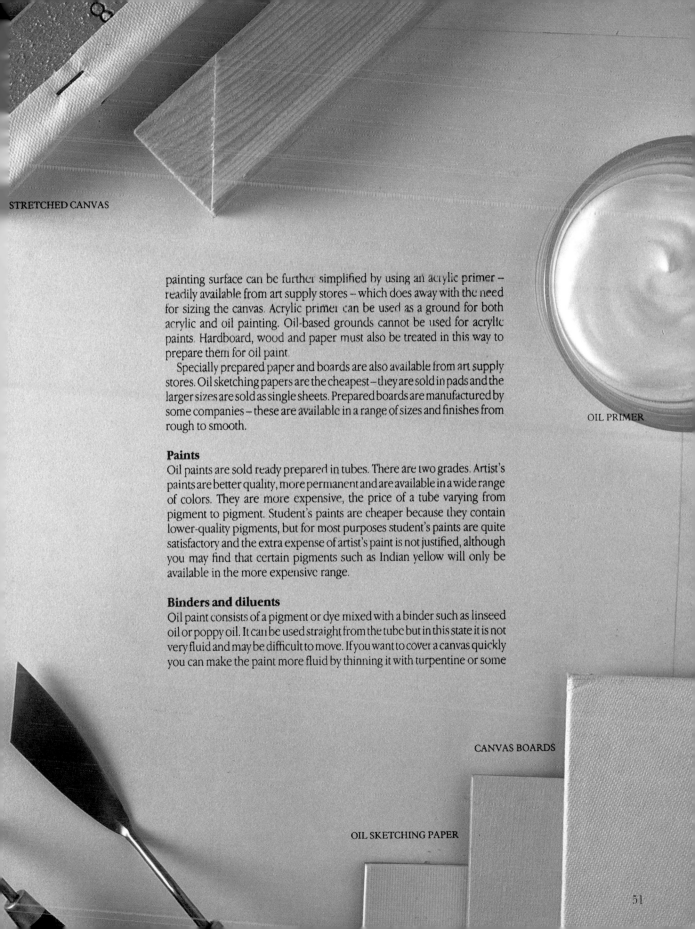

STRETCHED CANVAS

OIL PRIMER

painting surface can be further simplified by using an acrylic primer – readily available from art supply stores – which does away with the need for sizing the canvas. Acrylic primer can be used as a ground for both acrylic and oil painting. Oil-based grounds cannot be used for acrylic paints. Hardboard, wood and paper must also be treated in this way to prepare them for oil paint.

Specially prepared paper and boards are also available from art supply stores. Oil sketching papers are the cheapest – they are sold in pads and the larger sizes are sold as single sheets. Prepared boards are manufactured by some companies – these are available in a range of sizes and finishes from rough to smooth.

Paints

Oil paints are sold ready prepared in tubes. There are two grades. Artist's paints are better quality, more permanent and are available in a wide range of colors. They are more expensive, the price of a tube varying from pigment to pigment. Student's paints are cheaper because they contain lower-quality pigments, but for most purposes student's paints are quite satisfactory and the extra expense of artist's paint is not justified, although you may find that certain pigments such as Indian yellow will only be available in the more expensive range.

Binders and diluents

Oil paint consists of a pigment or dye mixed with a binder such as linseed oil or poppy oil. It can be used straight from the tube but in this state it is not very fluid and may be difficult to move. If you want to cover a canvas quickly you can make the paint more fluid by thinning it with turpentine or some

CANVAS BOARDS

OIL SKETCHING PAPER

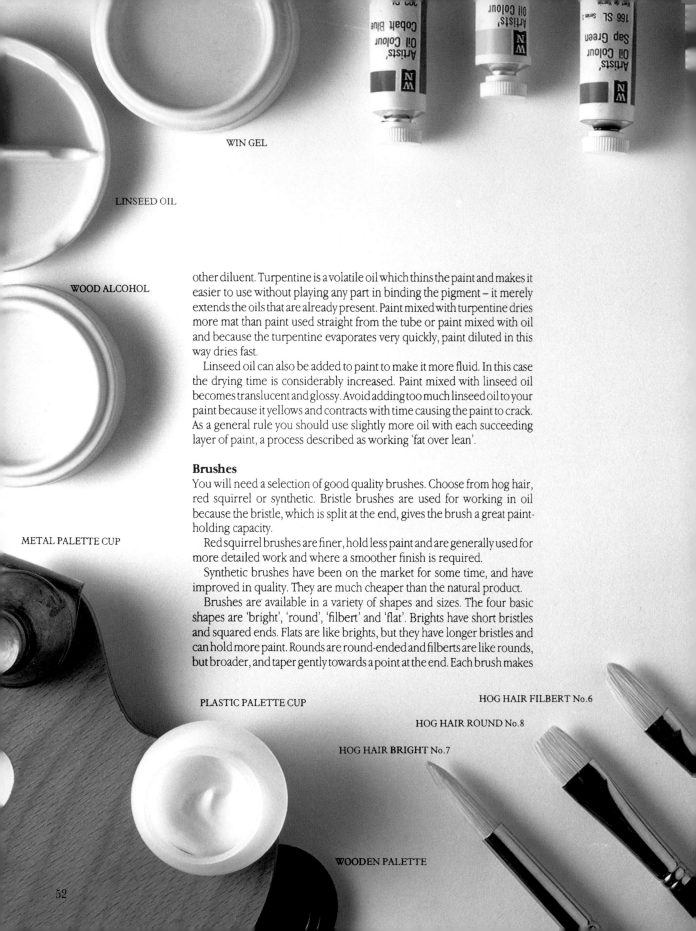

WIN GEL

LINSEED OIL

WOOD ALCOHOL

METAL PALETTE CUP

other diluent. Turpentine is a volatile oil which thins the paint and makes it easier to use without playing any part in binding the pigment – it merely extends the oils that are already present. Paint mixed with turpentine dries more mat than paint used straight from the tube or paint mixed with oil and because the turpentine evaporates very quickly, paint diluted in this way dries fast.

Linseed oil can also be added to paint to make it more fluid. In this case the drying time is considerably increased. Paint mixed with linseed oil becomes translucent and glossy. Avoid adding too much linseed oil to your paint because it yellows and contracts with time causing the paint to crack. As a general rule you should use slightly more oil with each succeeding layer of paint, a process described as working 'fat over lean'.

Brushes

You will need a selection of good quality brushes. Choose from hog hair, red squirrel or synthetic. Bristle brushes are used for working in oil because the bristle, which is split at the end, gives the brush a great paint-holding capacity.

Red squirrel brushes are finer, hold less paint and are generally used for more detailed work and where a smoother finish is required.

Synthetic brushes have been on the market for some time, and have improved in quality. They are much cheaper than the natural product.

Brushes are available in a variety of shapes and sizes. The four basic shapes are 'bright', 'round', 'filbert' and 'flat'. Brights have short bristles and squared ends. Flats are like brights, but they have longer bristles and can hold more paint. Rounds are round-ended and filberts are like rounds, but broader, and taper gently towards a point at the end. Each brush makes

PLASTIC PALETTE CUP

HOG HAIR FILBERT No.6

HOG HAIR ROUND No.8

HOG HAIR BRIGHT No.7

WOODEN PALETTE

PAPER PALETTE

ARTIST'S OIL COLORS

its own distinctive mark. All these shapes are available in a range of sizes from No. 1 which is the smallest to No. 12 which is the largest. Extra-large brushes are available in numbers up to 36.

Good brushes are expensive and should be well looked after. Always clean your brushes after use or at the end of each day's work. To clean them, rinse them in turpentine or wood alcohol and wipe them dry with a cloth. Do not leave them to soak because the hairs will come loose and fall out. When the paint has been removed from the brushes they should be washed in warm water with strong household soap, rinsed carefully in running water, dried and the bristles molded into shape. Store them – bristle end up – in a jar.

Other equipment

Paint is mixed on a palette, which is available in a variety of sizes and shapes and is usually made of wood. Palette-knives, made from smooth flexible steel, are used to clean the palette, to mix paint and can also be used to apply paint to the canvas. Painting knives have thin delicate blades with long, cranked handles – this ensures that your fingers are kept clear of the paint surface. You will need containers for oil and turpentine. Metal containers called palette cups can be clipped on to the side of the palette, but you will also need a large jar of turpentine or wood alcohol.

A mahlstick is a cane with a chamois tip. If you are right-handed hold the mahlstick in your left hand and rest the tip on the canvas, if it is dry, or on the edge of the stretcher. You can then steady your painting arm on the cane.

The list of equipment described here may sound daunting, but remember that all you really need is a support, some tubes of paint, a few brushes, some white spirit and a subject.

SYNTHETIC BRIGHT No.14

SYNTHETIC FAN-SHAPED
BLENDER No.6

SABLE BRIGHT No.8

SABLE ROUND No.4

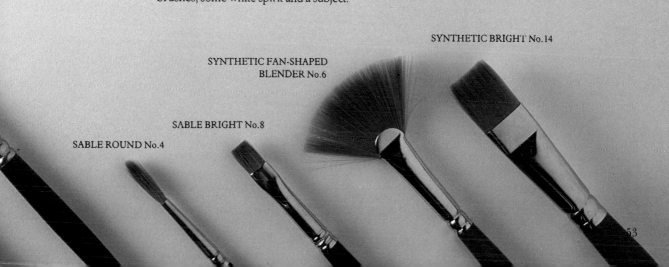

A Village in Derbyshire

Derbyshire is an area of limestone upland at the southern end of the Pennines, the chain of hills which forms the spine of England. The caves and springs typical of limestone scenery occur throughout the region, but the highest areas are capped by gritstone outcrops, which provide much more rugged scenery, with bold, rocky escarpments, sometimes called edges. The geology of an area dictates the outward appearance of a landscape in much the same way as the bone structure of a skull dictates the facial characteristics of an individual.

The artist was born and brought up in this part of the country and has a natural affinity and liking for the landscape which constantly recurs in his work. He likes the change in level between the peaks and dales, the undulating topography and the constantly changing angles. He is attracted by the greyness of the naturally occurring gritstone and limestone which is used in the construction of the dwellings and walls of the region – even the roofs are often made from stone slabs rather than tiles.

This oil painting evolved from a series of sketches made on one of his many visits to the area and was painted in his studio when he returned. He was particularly concerned with the way the elements of the composition balance and with the feeling of movement into the picture and around the objects. In this composition there is a constant change of direction as the eye is led down the street and around and among the houses before being brought up short against the hilly area in the background.

Using his sketches for reference, the artist made a detailed drawing on a piece of prepared hardboard. He likes to create a sense of structure in his compositions and to feel that the objects are convincingly placed in space. He also likes the linear feel of a drawing and sometimes uses quite heavily drawn lines in his paintings, often projecting the lines beyond the object in order to create a feeling of continuity. His brushwork is descriptive – for the road, the direction of the brushstrokes follows the tire marks of the traffic, for the plasterwork of the walls he applies light and dark paint with small stabbing strokes which change direction, to imitate the way in which light reflects accidental forms. Where he wants to add detail, he waits until the paint is dry and works into the area with a small brush.

1 The series of sketches *right* was made by the artist during several visits to the area. He used a felt-tip pen – his favorite sketching tool. The color notes proved useful when he started work in the studio.

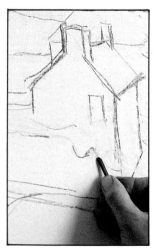

2 Working on the smooth side of a piece of primed hardboard *left* the artist starts to lay in the broad outlines of the composition. He uses willow charcoal, a very responsive medium which is easily corrected.

3 At this stage *right* the artist considers all the different elements of the composition carefully and makes any adjustments necessary. Having completed the initial drawing he then 'knocks it back' by flicking it with a duster.

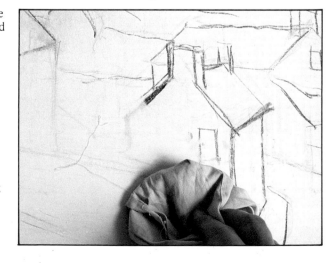

BRUSHMARKS

Each brush is capable of making a particular set of
marks which depend on its shape and size. By trial
and practice you will learn just what each brush is
capable of, which one suits your style, and which one
is appropriate for a given purpose. Every now and
then you should experiment with a brush to see just
how many different kinds of mark you can make
with it. Here we show a set of six marks, one set
made with a No. 7 flat and the other with a No. 7
round. Some of the marks are similar to each other.
The straight lines and the dashes could have been
made with the same brush, although those made
with the round are smaller. Other marks are more
obviously different.

NO. 7 FLAT

NO. 7 ROUND

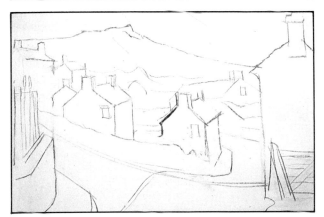

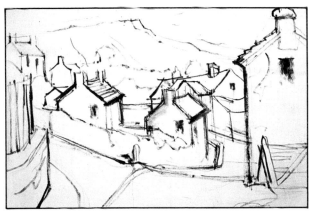

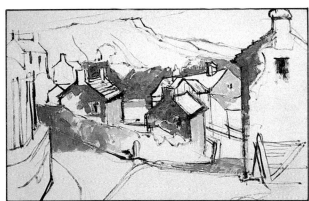

4 We see the faint outlines of
the charcoal drawing *top left*.
Notice the way the eye is led
into the picture by the road
which sweeps from the
foreground into the distance.

5 The artist reinforces the
lines of the charcoal drawing
by tracing over them with a
fine brush and black paint
thinly diluted with turpentine
top right.

6 The artist starts to lay in
color *above left* working
briskly with a loaded brush. He
does not concentrate on one
area but moves over the entire
picture surface.

7 The artist is able to judge
the effect of each color on its
neighbor *above right*. A
color which looks 'right' on
the palette may not look 'right'
on the canvas.

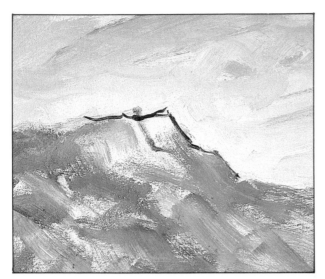

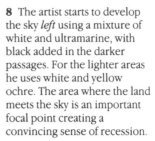

8 The artist starts to develop the sky *left* using a mixture of white and ultramarine, with black added in the darker passages. For the lighter areas he uses white and yellow ochre. The area where the land meets the sky is an important focal point creating a convincing sense of recession.

9 In the detail *right* we see how the artist's loose handling of the paint allows the underlying color to show through adding sparkle to succeeding layers. On the sunny facade of the cottage, warm ochers are overlaid with cool grays.

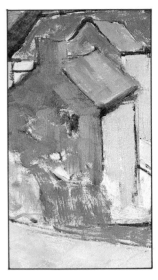

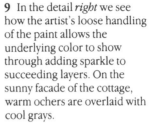

10 The marks of the brush are an important part of the painting *left*. They vary with the subject – short, square strokes for the masonry, long sweeping strokes for the road.

11 *Below* a fine brush and thinly diluted black paint are used to draw in the details of the thick stone roofing slabs. These will be knocked back later.

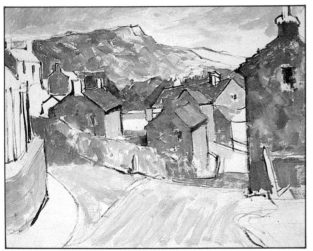

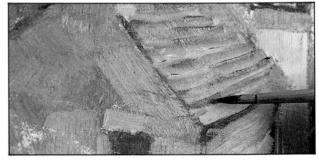

12 The forms of the stones on the wall *left* are simply indicated using a fine brush. In these areas the artist varies both the direction of the brushstrokes and the color to avoid areas of flat color and to reflect the way light catches accidental forms.

13 The picture is almost complete *right*. Notice how the brushstrokes in the foreground follow the direction of the tire marks. The red of the chimney pots has now become an important element of the overall color scheme.

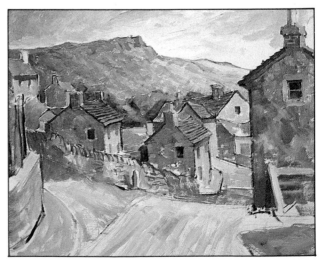

What the artist used

The artist used a piece of hardboard 24 x 36 inches. He used the smooth side of the board, which he abraded slightly with sandpaper before applying an acrylic primer. He made his initial drawing with willow charcoal, removed the surplus dust with a rag and then traced the lines of the charcoal drawing using ivory black diluted with turpentine, and a No. 6 synthetic brush. He used a selection of flat bristle brushes ranging from Nos. 3 to 11. He used a large kidney-shaped wooden palette.

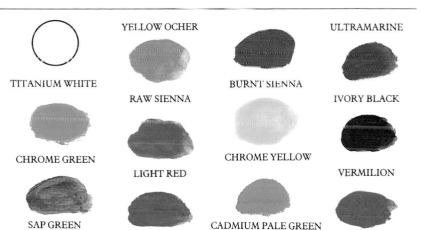

TITANIUM WHITE

YELLOW OCHER

RAW SIENNA

BURNT SIENNA

ULTRAMARINE

IVORY BLACK

CHROME GREEN

CHROME YELLOW

LIGHT RED

VERMILION

SAP GREEN

CADMIUM PALE GREEN

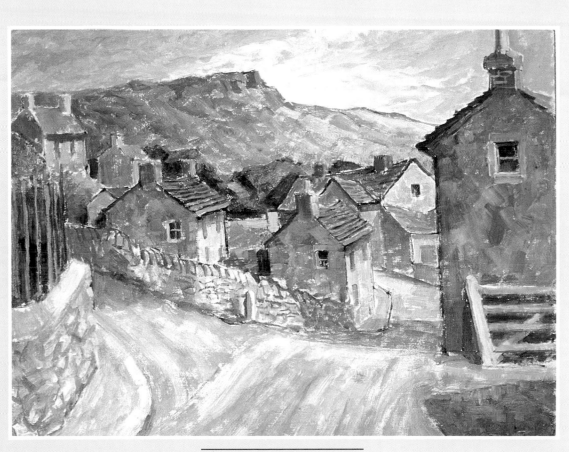

A Village in Derbyshire

Autumn Mists

This landscape was painted on an overcast day in autumn. The artist has captured the dullness of the leaden sky and the special, flattening quality of the light. The entire scene is evenly illuminated with no strongly contrasting lights and darks, and no strong shadows. The flatness of the light has the effect of reducing the difference between the distant objects and those in the foreground. This difference is, of course, the basis of aerial perspective and the artist had to overcome the tendency for the background to advance. He did so by cropping in close to the image, by bringing the track right up to the foreground, and by carefully controlling his brushstrokes, using larger, more clearly defined strokes to describe the foreground area, and smaller, smoother brushwork to describe the trees and the cottage in the distance.

The composition hangs on the strong horizontal established by the base of the treeline. From here the vertical line of the trees rises into the wintry sky. These verticals and horizontals are counterbalanced by the sweeping diagonals of the pathway which divide the foreground into a series of triangles.

The artist started with a very simple sketchy drawing, using diluted cobalt blue paint. He worked briskly, laying in broad areas – light gray for the sky and ochry tones for the field in the foreground. With a complex subject such as this there is a temptation to become distracted by the details of the painting – to draw every tree, for example. Try to establish the broad areas, seeing the subject as a series of large, interlocking patches of color. Once these are established you have something against which to key your subsequent colors. A very complicated visual process takes place when we look at a pattern of colors. The individual colors do not operate as independent units. Thus the color that looks absolutely 'right' on the palette may be subtly or very 'wrong' on the canvas when judged against the other colors. When you have finished blocking in, you should reappraise the color balance, judge each color against its neighbor, assess the part it plays in the whole, decide whether the color scheme reflects the mood of the subject and make any adjustments.

1 The artist starts *right* by laying in the broad outlines of the subject, using thinly diluted cobalt paint and a No. 4 sable brush.

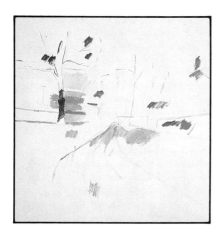

2 This painting depends for its effect on colors and masses, so the artist does not make a detailed underdrawing but lays in areas of color almost immediately *above*. This direct approach requires confidence and therefore suits some people better than others.

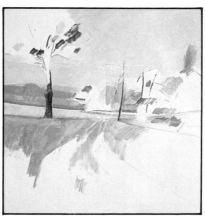

3 The artist blocks in broad areas of warm and cool colors *above*: browns and ochers and blues and grays. These loosely brushed areas give him a key against which he can develop tone and local color, which are very difficult to assess in isolation.

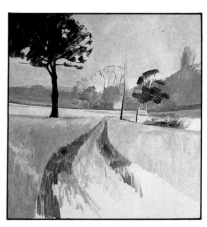

4 The artist now lays in areas of local color *above*: the green of the path and the dark brown masses of the tree which dominates the middle distance. In order to suggest a sense of space and recession the artist works pale blues, grays and mauves into the area along the horizon.

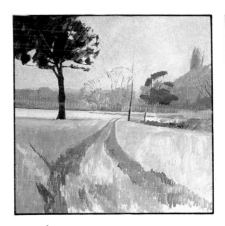

5 *Above* and in the final picture *below right* the sense of space is enhanced by warm colors and richly textured paint in the foreground. A fine sable brush is used to touch in the details of the distant trees.

TREES: DIFFERENT APPROACHES

These details illustrate some of the techniques which the artist has used. The tall tree in the foreground has been described using loosely handled, fluid paint, applied with busy, rather spiky brushstrokes, but the skeletal outlines of the elms silhouetted against the gray sky have been drawn with a fine brush in thin paint. The hazy shapes of the poplar and ash have been scrubbed in with loose directional strokes. The painting is colorful, with even the most distant trees being seen as drifts of pearly grays and blues.

What the artist used

The artist used a fine-grained canvas 30 x 30 inches which he stretched and prepared with rabbit skin glue size and an oil ground. He used a selection of bristle brushes, Nos. 2 to 8 flats and rounds, and turpentine, linseed oil and a large wooden palette. He used a No. 4 sable for the initial drawing.

RAW UMBER

COBALT BLUE

LEMON YELLOW

YELLOW OCHER

FLAKE

BURNT SIENNA

ALIZARIN CRIMSON

VIRIDIAN GREEN

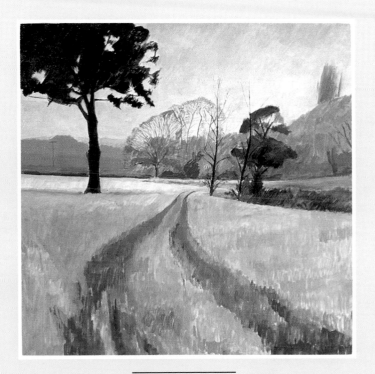

Autumn Mists

Landscape with Palm Trees

Several features attracted the artist to this subject. He was moved by the strong, simple shapes, and by the way in which the vertical columns of the cypresses contrast with the exuberant spikiness of the palm trees. He was also fascinated by the sense of depth. He enhanced the feeling of recession by emphasizing the foreground elements, allowing the strong verticals to break the picture frame at top and bottom, thus advancing the image on to the picture plane. He used vigorous, textured brushstrokes in the foreground, while the hills on the horizon were less fully described, using pastel colors, laid in with thin washes. The feeling of recession created in this way is known as aerial perspective. It is based on the idea that objects in the distance look hazier and more blue than those in the foreground – the contrast between light and dark, between shadow and sunlight, will be strongest close to you and will diminish with increasing distance.

The artist has handled the paint with great freedom and inventiveness. There are as many approaches to paint and painting as there are artists, and oil paint is a particularly versatile medium. The great Flemish masters applied paint in thin layers in order to create highly detailed and realistic paintings, with smooth, untextured surfaces. Nowadays, however, many artists exploit the mark-retaining qualities of oil to create textured paint surfaces. They use paint straight from the tube in order to achieve a thick impasto which holds the mark of the brush or painting knife. The raised areas of paint throw shadows and scatter light in a way that imitates nature. With a light, rapid brushstroke you can create a rough broken texture which allows the underlying colors to shine through, creating a lively surface which resembles the flickering quality of light. Paint may be applied more thickly in one area of the painting than in others, creating an interesting contrast which can be used to emphasize the different qualities of various substances – a thin transparent film for the sky and thick impasto dabs for foliage, for example. Where the paint is applied thickly it is possible to inscribe it. You can do this with any tool: the end of a brush, the edge of your palette knife or even your fingers will do. Paint can be scratched away from larger areas to reveal the underlying color.

1 For the artist no subject is without interest – each presents its own particular charms and challenges. This view *right* presented a range of simple shapes and a sense of space and recession.

2 The artist starts *above* by making a very sketchy pencil drawing directly on to the ready-primed canvas board. Initially the paint is applied in a very fluid form working over the entire picture surface with great verve. His excitement is reflected in the way the paint is applied.

3 By contrast the paint *left* is applied quite thickly. The artist describes the general outline of the cypress tree with thinly diluted green and then works into the wet paint with undiluted yellow so that both colors mingle on the support and both are picked up by the brush.

4 By using paint thinly diluted with a mixture of turpentine and linseed oil *left* the artist is able to work at speed and with considerable freedom. This is particularly useful when working outdoors where the light or the weather is liable to change at any moment.

5 Working in this rapid and direct way the broad outlines of the painting are very quickly established. In Step 4 the main areas of the painting were blocked in. *Above* the artist has reworked the sky, the foreground and even the cypress tree.

6 In this painting the paint and the paint surface are very important. The artist uses the side of a painting knife *above* to flick on calligraphic marks which describe the texture of the tree trunk and also provide a pleasing decorative detail.

CREATING TEXTURE IN OIL PAINT

Oil paint offers the artist, even the novice, considerable freedom. It can be used to build up thick impastos as well as thin transparent glazes. Thick paint retains the mark of the brush, and by using different sizes and shapes you can create marks to represent the texture of leaves, grasses, stems or tree trunks, for example. In the first detail the artist is using his finger to create a softly smudged area of color. In the second, he is using a knife to scratch into the wet paint – a technique known as *graffito*.

7 This detail *above* shows just how exciting paint can be. The paint is applied thickly and thinly, with colors in discrete layers or slurred into one another. Here the artist uses the handle of the brush to scratch textures into the wet paint.

8 The foliage at the top of the painting is briefly but expressively described *right* using a painting knife to flick color on to the dry and textured surface of the sky.

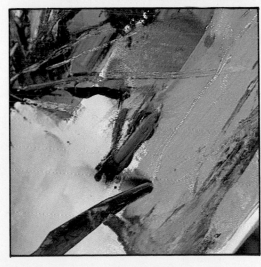

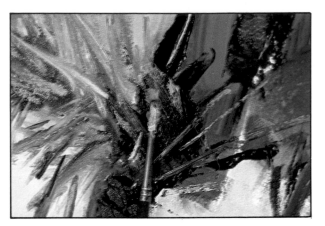

9 Using a loaded brush the artist works into the crown of the tree in the foreground *left*. Bits of color are picked up by accident and carried from one area to another giving the color scheme an underlying coherence.

10 *Right* the artist uses a small sable brush to pick out details on the trunk of the same tree. This detail provides an interesting contrast to the more broadly rendered areas.

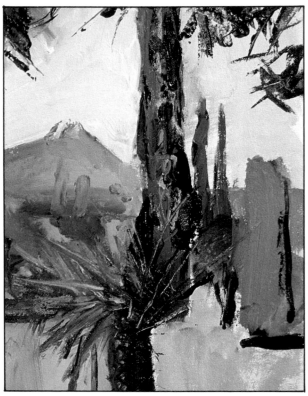

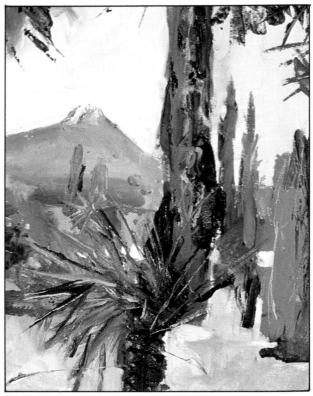

11 The artist adds texture to the tall tree which dominates the painting *above*. At the same time he works pale, broken grays over the mountain on the horizon. By doing so he increases the sense of recession because pale, cool colors take the horizon away from the picture plane while the textured surface advances.

12 *Above right* he adds more detail in the middle distance. This, together with the visible brushstrokes in the foreground, brings that area nearer to the picture plane. By deliberately pushing back the horizon and bringing the foreground up to the picture plane the artist creates a gently plunging picture space.

13 By adding this detail the artist balances the trees on the right-hand side and at the same time firmly establishes the middle ground *right*. In the final picture *opposite* you can see how the strong verticals are balanced by a broad horizontal band. The two central tree trunks break the frame at the top and bottom.

What the artist used

The artist used a proprietary canvas board 30 × 24 inches. These are available in a range of standard sizes and are ready-primed for oil. You can choose between a rough or a fine textured surface. He used a range of hog hair brushes Nos.6 to 12 flats and rounds. He also used some synthetic soft fibered brushes which are ideal for handling thinly diluted oil paint. He used a medium-sized painting knife. A painting knife has a cranked handle so that your hand does not come into contact with the paint surface. He also used linseed oil and turpentine.

ALIZARIN

BLACK

YELLOW OCHER

RAW UMBER

PRUSSIAN BLUE

HOOKERS GREEN

WHITE

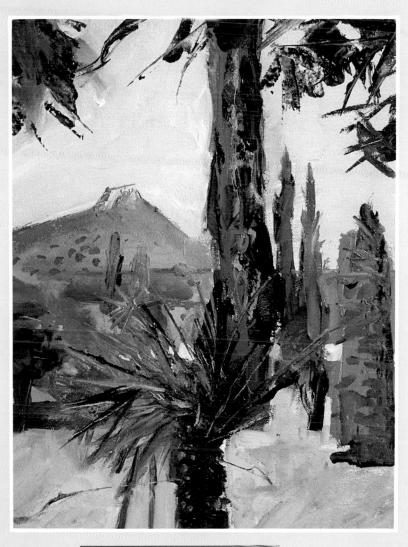

Landscape with Palm Trees

Greek Village

This is a studio painting, but the artist has captured the feel of the place, the warmth of the Mediterranean sun and the special clarity of light characteristic of that part of the world. The artist often visits Greece and one summer spent several weeks sketching in and around this village. He was attracted by the unusual aspect offered by the high viewpoint (a window of the house in which he was staying). He made a series of sketches, annotating them with remarks about colors and the effects of light. He supplemented the information in his sketchbook with photographs, so that when he started to develop the composition in his studio, several months later, he had plenty of material to work from. This method of working – assembling information and then using it to work up a composition in the studio – has several advantages. You have time to plan and develop the composition and may discard several designs before making your final decision. It also means that you will have plenty of subjects to work on during the dark winter months when the weather and lack of light keep you indoors.

The artist worked quickly and freely, blocking in the general forms and areas of color with thin paint diluted with turpentine. Turpentine evaporates quickly so the underpainting was soon dry and the artist was then able to start working over the sketchy underpainting in thick, rich impastos. With this thicker paint, the marks of the brush take on a new importance, describing and following form, and indicating the texture of particular areas. Look, for instance, at the way in which the brushmarks have been used to suggest the clusters of needles on the tree in the foreground, and the leafiness of the rows of vegetables in the lower right-hand corner.

The artist developed all the areas of the painting at the same rate, moving from one part of the painting to another. Inevitably color is taken from one area to another and these recurring color notes give the painting an underlying coherence which pulls otherwise disparate elements together and results in a pleasing whole.

Although he worked in two stages, thin underpainting followed by a thicker impasto, the painting was completed in one day. The speed and directness with which he worked counteracted the tendency inherent in studio work to become contrived and stilted. The painting has all the energy and spontaneity of a painting made directly from the subject.

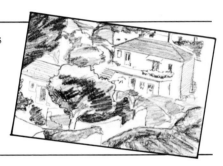

1 The sketch *right* is one of a series. The artist used a 3B pencil in a small sketch book 10 x 7 inches of good quality cartridge paper.

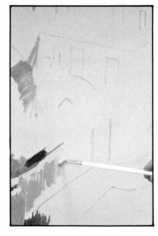

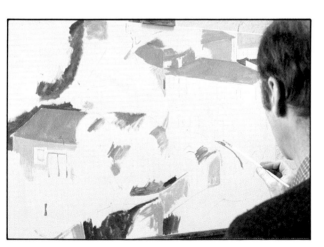

2 *Above* the artist draws the broad outlines of the subject on to the support using a fine brush and cobalt blue thinly diluted with turpentine. He then blocks in the mid-tones.

3 The subject is a complex jumble of architecture and foliage, and there are sharp tonal contrasts between the shadows and sunlit surfaces. The artist works across the painting *above* establishing solid areas of mid-tones – roofs, trees and walls in shadow. He can then work up to the lighter tones and down to the darker tones.

4 In the detail *above* the artist draws the curve of a small bridge. In order to keep his hand steady he rests his drawing hand on a mahlstick which is held in the left hand.

5 Having established the mid-tones with thin, freely applied paint, the artist moves from the general to the particular and starts to draw architectural details *above*.

6 In the detail *left* we can see how thinly the paint has been applied in the early stages. Here the artist is using a small hog hair brush to add detail to the roof.

7 The broad outlines of the final picture begin to emerge *below*. At this stage the artist scrutinizes the painting through half-closed eyes.

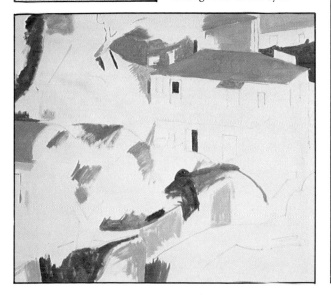

CANVAS TEXTURE

The texture of the support can be a very important element of any painting. Below we show three different types and quality of canvas. What you use will depend on personal taste, painting technique and how much you want to spend. For this painting the artist used a fairly finely woven canvas and the details below show how the canvas accepts thick impasto paint and thinly diluted paint. With a coarser canvas the paint would sit on top of the raised areas of the weave.

8 The artist begins to develop the tonal contrasts of the painting *left*. In this detail he uses a mixture of viridian and umber to establish the darkest areas of the shrub on the very edge of the painting. He keeps the entire painting moving.

9 Using a long-handled hog hair brush the artist draws in the small figures near the center of the painting *right*. He uses a medium-sized, round brush. This gives him sufficient detail without the risk of getting too fussy, which might happen with a smaller brush. The long handle allows him to work away from the painting while the stiff bristles hold oil paint well and add texture to the paint surface.

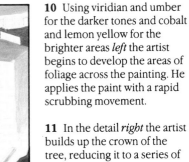

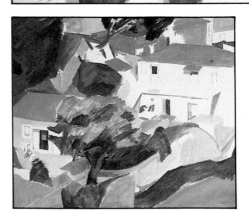

10 Using viridian and umber for the darker tones and cobalt and lemon yellow for the brighter areas *left* the artist begins to develop the areas of foliage across the painting. He applies the paint with a rapid scrubbing movement.

11 In the detail *right* the artist builds up the crown of the tree, reducing it to a series of simple forms. If you think of vegetation in terms of twigs, stems and leaves, you will very quickly lose your way. Look for the simple forms.

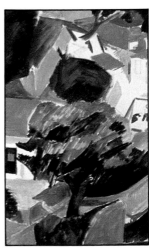

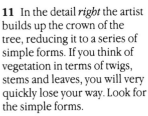

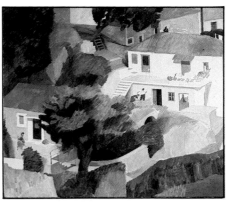

12 The artist captures the atmosphere of heat and light by using yellow ocher, white, Naples yellow and burnt sienna for the warm tones *far left*. He warms up the areas of shadow by adding alizarin crimson to the cool blue-gray.

13 This painting evolved slowly at first but in the final stages all the elements suddenly come together *left* and the images emerge.

What the artist used

The artist used a fine-weave canvas which he bought off-the-roll and ready-primed, and stretched himself. Stretchers and corner keys are available in a limited range of lengths at most art supply stores. If you require particularly large sizes you may have to order them. His brushes were hog hair rounds ranging in size from Nos 6 to 10. He used a No. 4 sable to make the underdrawing and a 3B pencil for the sketch. He used turpentine, a little linseed oil and a large wooden palette.

TITANIUM WHITE

LEMON YELLOW

ULTRAMARINE

RAW UMBER

BURNT SIENNA

ALIZARIN CRIMSON

NAPLES YELLOW

SAP GREEN

YELLOW OCHER

COBALT BLUE

VIRIDIAN

CADMIUM RED

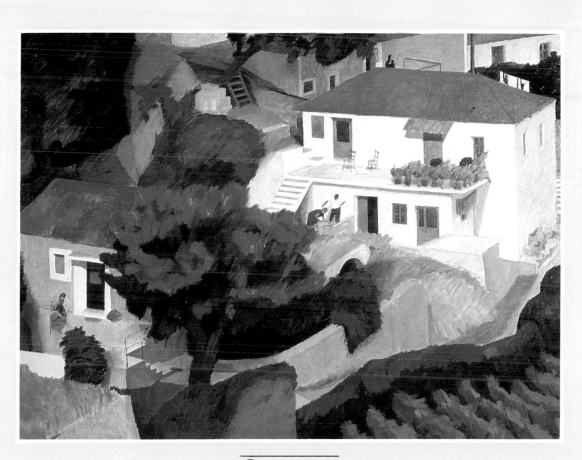

Greek Village

Reflections in a Stream

This painting is one of a series in which the artist investigated reflections – how they should be depicted and what they can contribute to a composition. Artists often take a subject and study it exhaustively over a period of months or years. It is an excellent way of learning because it forces you to really study and analyze your chosen subject and you gradually build up a sequence of works which chart your progress – this can be both revealing and rewarding.

The artist's support is hardboard which he has prepared with an acrylic primer. The primer creates a seal between the paint and the support and prevents the oil from being absorbed. It also provides a pleasant texture and a good key for the paint. In this case the smooth side of the hardboard is being used – the artist abraded it with sandpaper before applying the primer. The rough, textured side of hardboard may also be used, but you will need to apply several coats of primer to ensure that the surface is properly sealed.

The artist worked from his sketchbook in which he had made several studies of the subject. He started by making a simple drawing in willow charcoal on the board. He then flicked off excess dust and redrew the image in paint. The water has been treated as a simple inverted image of the subject. Mirror perspective is easy to master because the reflecting surface, the water, is always horizontal. All the points of the reflections lie vertically under the objects reflected, and the vanishing lines of the objects and the reflections run to the same vanishing points. When faced with a subject like this do not allow yourself to be confused by the details. Approach

the subject with confidence and paint what you see – there is no substitute for close observation. In this painting the reflections are treated positively, using strong, precise strokes and pure colours. Notice the way in which the artist has varied his brushstrokes, long horizontal strokes being used to establish the surface of the water and vertical strokes to suggest the reflections. If there is any movement in the water the reflected image will not be an exact mirror of the object – here the reflections are rendered as a combination of hard-edged shapes, linear marks and fuzzy color to convey the rippling movement of the water.

In this picture the simple forms are important – the semicircle of the bridge becomes a complete circle with its reflections, the square of the building becomes an elongated rectangle. These geometric shapes are softened by the softly rendered and dashed background. This illustrates the many elements which contribute towards the making of successful pictures.

1 This charming spot is one which the artist has known since childhood. This drawing *right* was made with a worn felt-tip pen.

2 The artist worked on this painting in the studio, using his sketchbook. Working in this way has its advantages – you can interpret the subject freely. The artist starts with a charcoal drawing which he reinforces with thin paint *left*.

3 The artist keeps the underdrawing as simple as possible *above left*, indicating only the basic outlines of the subject. He draws the reflections in the same way as the rest of the subject – drawing the main shapes as mirror images.

4 The underdrawing is now established and the artist begins to block in the color *above*, applying the paint freely, working on all parts of the painting at the same time. He uses sap green to indicate areas of foliage and grass, and yellow ocher for stonework.

LETTING THE GROUND SHOW THROUGH

It is not necessary to cover the surface of the support entirely, even in oils. The white of the ground can make an important contribution to the final image. Here the artist has deliberately let the whiteness of the ground show through the dabs of paint in order to enhance the intensity and drama of the color. The white ground gives an added luminosity to the colors and at the same time suggests the haste and directness with which the paint was applied. In the river the movement and light-scattering qualities of the water surface are suggested by the way in which the ground sparkles through between the separate dabs of color.

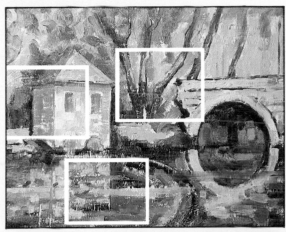

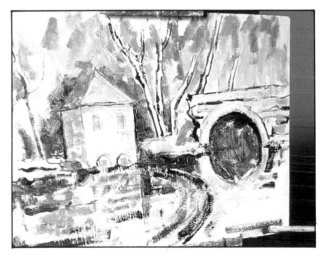

5 Using a No.6 flat bristle brush, the artist continues to lay in the paint *above*. He uses short, blocky strokes for the masonry and longer strokes for the vegetation.

6 In this detail *above* we see the artist working into the reflections under the bridge, treating the reflections as positive images.

7 The artist continues to block in the main areas of the painting, using a limited range of colors and working quickly with a fairly large No.6 brush *above*. At this stage he uses thinned paint so that it can be worked over as the painting progresses. Notice the way he uses vertical strokes for the reflections and horizontal strokes for the water.

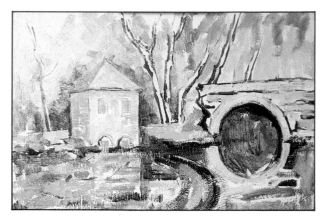

8 By developing the tonal ranges of a limited number of colors *above*, the artist ensures that the final painting will have an underlying harmony. He works into all areas of the painting rather than concentrating on one part.

9 In this detail *above right* we can see the quality of the paint and the importance of the mark of the brush. The original color was blocked in with thinly diluted paint, but the artist uses progressively thicker paint which holds brushmarks, creating texture.

10 Using a soft-fiber, synthetic No.6 brush, the artist redraws the trunks of the trees, *below left*. This brings the trees forward and knocks the undergrowth back, so that each object can be seen to occupy a particular position in space.

11 *Below right* the artist develops the trees by darkening the spaces between the trunks, just above ground level. This increased depth of tone gives the impression of distance, increases the range of tonal contrast in the painting and adds bulk to the forms.

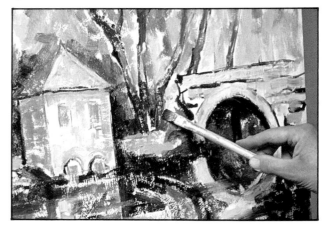

12 The color of the water is determined by the colors in the surrounding landscape. In the picture *left* the artist takes those colors into the water, using darker tones to suggest depth.

13 Using a light touch and undiluted paint *right*, the artist brushes the picture surface, creating flickering highlights on the water surface. These combine with the white of the support to convey the impression of light on water.

What the artist used

For this painting the artist used a piece of hardboard measuring 24 × 30 inches. This he prepared by roughening it with sandpaper and applying an acrylic primer. He used charcoal and a selection of brushes – Nos. 3 to 12 flats and a No. 6 synthetic for reinforcing the lines of the drawing. He used student's quality paint, turpentine, linseed oil and a large wooden palette.

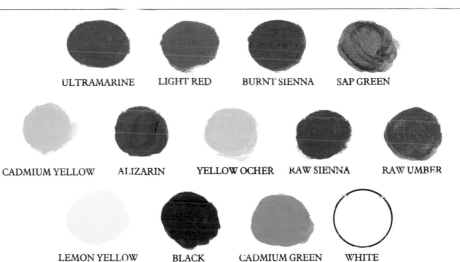

ULTRAMARINE LIGHT RED BURNT SIENNA SAP GREEN

CADMIUM YELLOW ALIZARIN YELLOW OCHER RAW SIENNA RAW UMBER

LEMON YELLOW BLACK CADMIUM GREEN WHITE

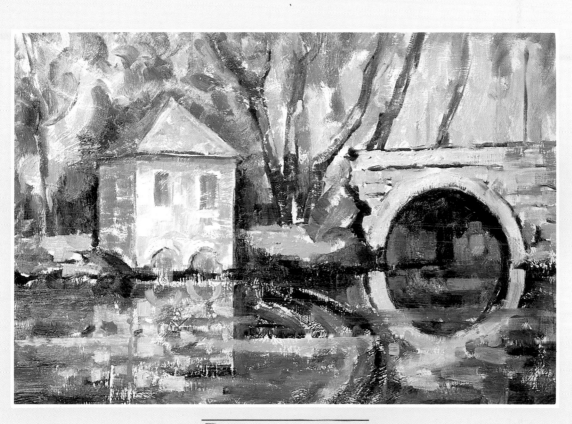

Reflections in a Stream

Shadows on Snow

This chilly winter scene was painted on the spot, but fortunately the artist did not have to work out of doors – he was able to paint before a large window which overlooked this attractive bit of country. He was interested in the subject because it offered him the opportunity to work with a very limited palette. He was fascinated by the simple forms: the strong silhouette of the tree against the winter sky and the play of the long shadows on the snow. His method was slow and methodical and the painting was completed over several days to allow each stage of the painting to dry.

He worked on a fairly cheap cotton canvas which he stretched and prepared with an emulsion glaze mixed with emulsion paint. This mixture produces a quick-drying, pleasantly textured ground. He started by making a careful drawing in pencil. While he was drawing he planned his approach, deciding which areas he would deal with first. He worked with fairly thin paint, diluted with turpentine. In most areas only one layer of paint has been used and the paint layer is therefore relatively thin so that the texture of the canvas plays an important part in the finished paint surface.

Much of this procedure is based on painting the negative of the shape, letting the image emerge from its surroundings. This is particularly well-illustrated in his approach to the tree. Its shape is well-established quite early in the painting, but as a white shape only – he added the color at quite a late stage. His approach to the shadows on the snow is similar. These have been painted as positive shapes with a mixture of cerulean and white. But later, when he uses white to paint the snow, he draws back into the shapes of the shadows, adusting their outlines and correcting the drawing. This approach to painting and drawing is an excellent way of ensuring that the images are accurate.

This painting was very thoughtfully conceived and executed. Each stage was carefully considered, the layers of paint handled as discrete elements and the painting built up from separate areas of color in a way that resembles a stained-glass window. Despite this rigorously systematic approach, however, the painting has a sparkle and immediacy which reflects the artist's pleasure in the subject. The understated quality of the paintwork draws attention to the simple but effective composition, and to the decorative extravagance of the tracery of the tree against the sky.

1 You should work from nature whenever possible. This need not mean standing outdoors in all weathers. This subject *right* was painted from a window, so the artist was protected from the weather.

2 The artist started by making a fairly detailed drawing of the subject. He worked directly on to the canvas using a 2B pencil. In the detail *above* we can see the texture of the canvas, a cheap standard weight cotton duck. This has been primed with an acrylic glaze mixed with emulsion paint to give a non-absorbent surface.

3 *Below* we see the way the artist handles the drawing. Using a simple, unfussy line to indicate the broad areas he pays equal attention to the tree, the fence posts and to the shadows they throw on the snow. When drawing from life, try and concentrate on what you see rather than on what you know should be there.

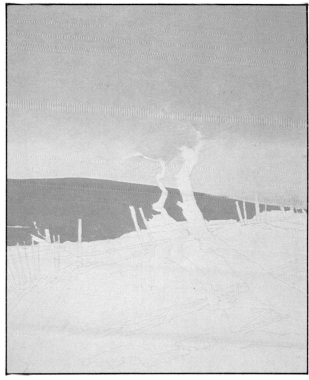

4 The artist starts by blocking in the background *above*. Using cerulean blue mixed with a little white he lays in the sky. The paint is thinned to create a flat paint surface which reveals the texture of the canvas. He adds more white to create a paler blue for the lighter part of the sky.

5 He uses a bluer mixture with a little cadmium yellow to paint the hills in the distance. Notice the way the artist paints around the trees *right* so that they stand out as negative shapes. By looking at silhouettes and background spaces you can improve your powers of observation.

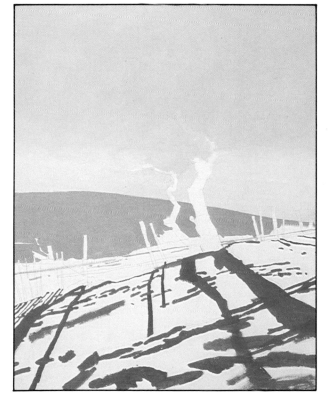

6 By contrast the artist treats the shadows as positive shapes *left*, painting them in carefully with cerulean blue mixed with a very small amount of white and black. The picture is already beginning to emerge and so far only four colors have been used. A very colorful painting can be created using a limited palette.

7 The artist allows the shadow areas to dry. This takes several hours because the paint has been diluted with a little turpentine. He did not thin it too much because its covering power when thinned is not good. When the paint is sufficiently dry he uses a very pale blue mixture to paint in the mid-tones in the shadow areas *below*.

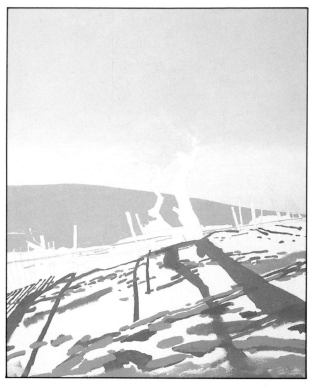

8 The winter sun sparkling on snow has been very convincingly created *left*. Cerulean is a suitable pigment for this subject – with its slightly greenish tinge it captures the chill feel of the subject. Cerulean blue would appear quite warm if placed alongside Prussian blue.

9 *Above* the artist begins to paint the bushes along the field boundary. He uses a mixture of black, raw umber, cerulean and white and a small No. 4 sable brush. He works close to the support, painting the details carefully. The thin paint allows the weave of the canvas to show.

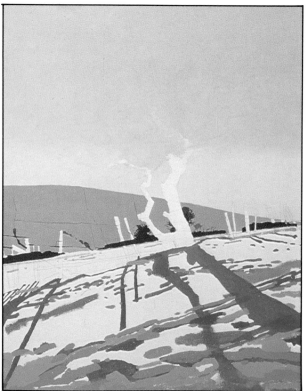

10 The artist develops the foreground area *left*, using the same limited range of colors. He develops the tonal range from the very darkest shadows to the gleaming white of the snow. Using a fine sable brush loaded with paint he flicks in calligraphic marks to represent the fence and the very tip of the brush indicates the field boundaries on the hills.

11 Using pure white paint the artist works back into the shadows on the snow *above*. He uses the white paint to sharpen the lines of the shadows and to correct the drawing. As with the trees, he is again looking at the spaces between the shapes. The crisp edges convey the impression of light on snow.

12 The full circle of the winter sun seen through the branches of the trees is an important feature of this painting *right*. The artist establishes the basic image at this stage, before he starts to paint the trees. He uses chromium orange mixed with white for the aureole and pure white for the center. This methodical approach demands forethought. The artist must plan the sequence of stages very carefully.

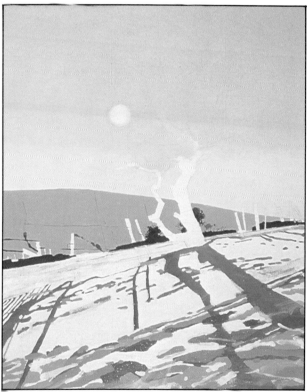

USING A MAHLSTICK

A mahlstick is a cane tipped with a padded knob, usually of chamois. It is used to steady the painting arm when the artist is working details into the painting. You can make your own from a garden cane, tipped with cotton wool wrapped in cloth and firmly secured with string. The artist uses the mahlstick by resting the padded end on the canvas or on the edge of the stretcher. The brush hand is then steadied on the stick.

13 The sun introduces an important focal point into the painting and the use of chromium introduces a new, warm color note which emphasizes the coldness of the rest of the image *above*. The artist completes this stage by splattering white paint over the foreground, softening the rather tight rendering of the hummocky snow and at the same time suggesting snowflakes.

14 The artist now returns to the hedgerow in the middle distance and using a No.4 sable brush starts to paint the basic outlines of the tree and fence posts *right*. He uses black paint softened with cerulean. Again he works slowly and carefully as he tries to achieve a sharp accurate line which will recreate the effect of dark trunks and branches strongly backlit by the low sun.

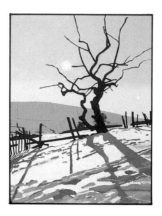

15 As soon as the artist establishes the skeleton of the tree, the painting comes to life *left*. The tree, with the sun hanging in its branches, is the focal point which pulls the painting together.

16 In the detail *right* we see the calligraphic quality of the marks used to describe the smaller branches of the tree. The artist uses pure cadmium red and orange to describe the twigs against the sun.

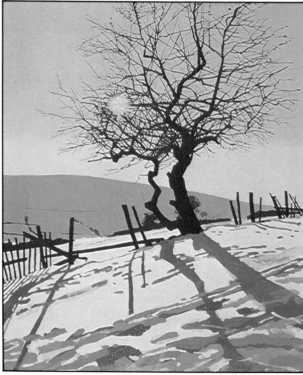

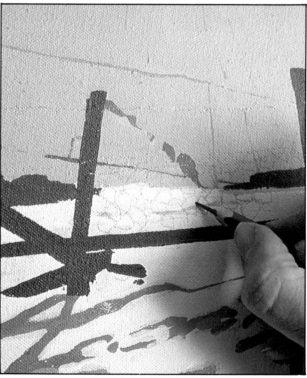

17 At this stage the artist stands back from the work and studies it carefully, comparing it with the subject and assessing the effectiveness of his approach *above*. One of the most difficult decisions for any painter is when to say a painting is finished. Many a painting has been 'lost' because the artist has been tempted to overwork it and has lost the original spontaneity and excitement.

18 *Above right* the artist is using a pencil to draw in the mesh of the wire netting. A pencil with its fine drawing point and the soft grayness of its lead, is ideal for this purpose and the result is convincing. This technique is rather unconventional but illustrates just how free you can be. If a technique creates the effect you seek then it is right for you and for the picture.

19 Having studied the subject carefully, the artist creates some darker areas in the crown of the tree, to suggest more densely clustered twigs. He works into the tracery of the tree canopy *right*, using the cerulean-white mixture which he used for the sky. This is the same process as he used with the shadows on the snow, increasing the accuracy of the image by looking at the spaces around the object.

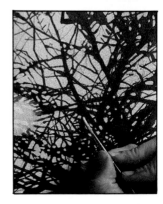

What the artist used

The artist used a cheap cotton duck canvas which he bought off the roll at an art supply store. He stretched the canvas himself to make a support 28 × 24 inches. He primed it with an acrylic glaze mixed with emul-sion paint and applied it thinly and evenly with a small house-painter's brush, working it well into the canvas. He used only two brushes, a No.7 flat bristle and a No.4 sable for the detailed work. He used a mahlstick to support his arm for painting details during later stages, when the painting was wet. He used a 2B pencil for the underdrawing and the chain link fence. His paints were artist's quality be cause cerulean is an expensive pigment not often available in student's quality paint. He used a large, wooden palette.

CERULEAN BLUE

CADMIUM ORANGE

CADMIUM YELLOW

CADMIUM RED

RAW UMBER

BLACK

WHITE

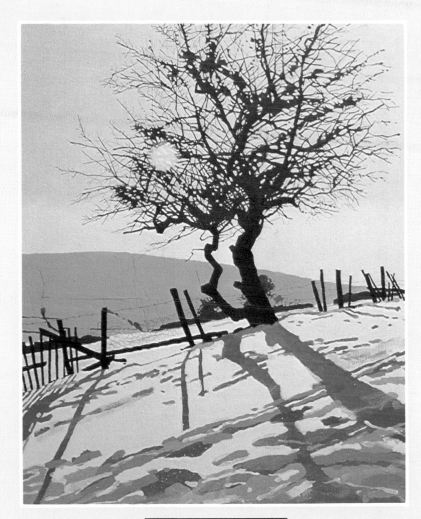

Shadows on Snow

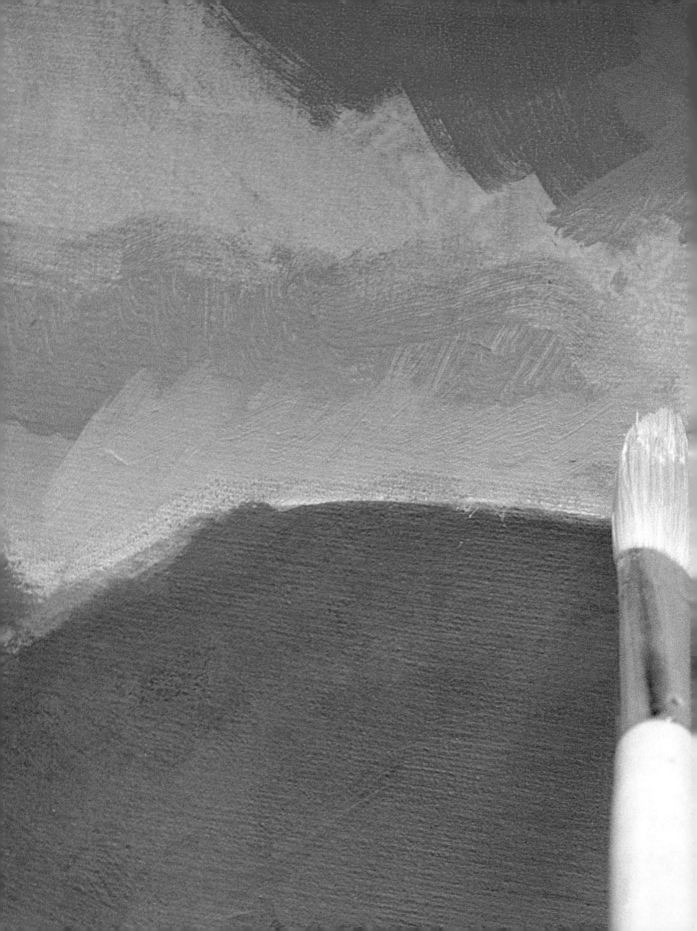

CHAPTER SEVEN

*A*crylic

When acrylic paint was invented in the early part of this century it represented the first major advance in the materials available to artists for more than five hundred years. The term 'acrylic' describes the polymer resins which are used to bind the pigments – the pigments themselves are exactly the same as those used in any other painting medium. Acrylic paints are water soluble and mix with water in all proportions, but will not mix with linseed oil or turpentine. They are tough, permanent, and stable and do not yellow with age as oils do. One outstanding feature is the speed with which they dry. This is both an advantage and a disadvantage. It means that the artist can work quickly, adding more paint to the surface, whether glazing or overpainting, without any risk of the underlying layer contaminating the top layer. On the other hand, acrylic cannot be moved or modified, or scraped off. Acrylic paint is adaptable and can be used to create thin washes or rich thick impastos. Its range can be further extended by the addition of various media. Acrylic paint has been widely used by artists since the 1950s when it was taken up by, among others, Jackson Pollock (1912-56), Mark Rothko (1903-70) and Robert Motherwell (b 1915). The medium has sometimes suffered from being used to imitate other media, but it has qualities of its own and should not be regarded as a poor substitute for the 'real thing.'

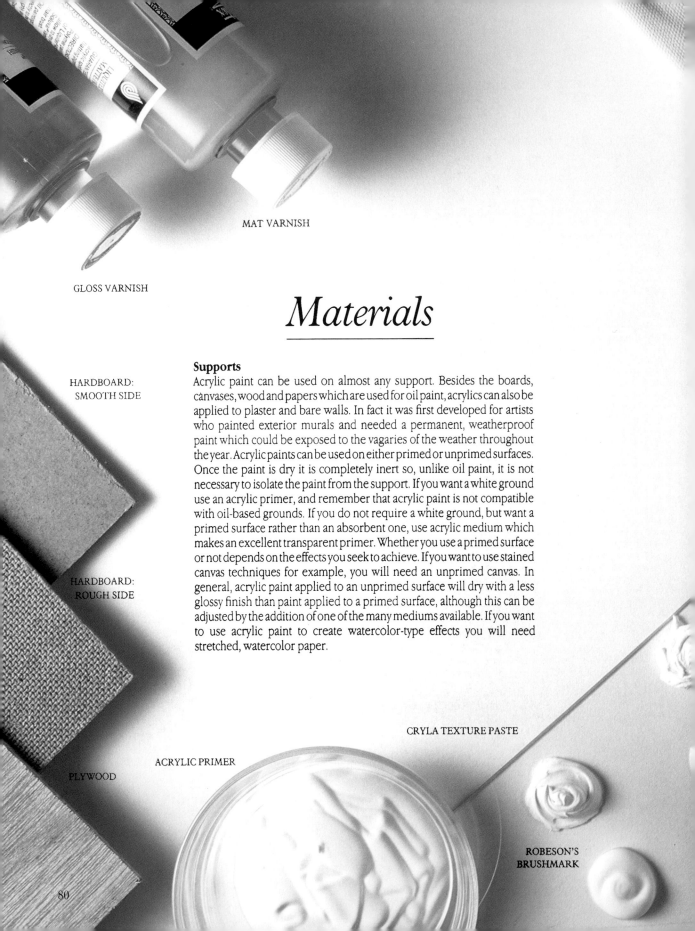

MAT VARNISH

GLOSS VARNISH

HARDBOARD:
SMOOTH SIDE

HARDBOARD:
ROUGH SIDE

PLYWOOD

ACRYLIC PRIMER

CRYLA TEXTURE PASTE

ROBESON'S
BRUSHMARK

Materials

Supports

Acrylic paint can be used on almost any support. Besides the boards, canvases, wood and papers which are used for oil paint, acrylics can also be applied to plaster and bare walls. In fact it was first developed for artists who painted exterior murals and needed a permanent, weatherproof paint which could be exposed to the vagaries of the weather throughout the year. Acrylic paints can be used on either primed or unprimed surfaces. Once the paint is dry it is completely inert so, unlike oil paint, it is not necessary to isolate the paint from the support. If you want a white ground use an acrylic primer, and remember that acrylic paint is not compatible with oil-based grounds. If you do not require a white ground, but want a primed surface rather than an absorbent one, use acrylic medium which makes an excellent transparent primer. Whether you use a primed surface or not depends on the effects you seek to achieve. If you want to use stained canvas techniques for example, you will need an unprimed canvas. In general, acrylic paint applied to an unprimed surface will dry with a less glossy finish than paint applied to a primed surface, although this can be adjusted by the addition of one of the many mediums available. If you want to use acrylic paint to create watercolor-type effects you will need stretched, watercolor paper.

STRETCHED CANVAS STRETCHERS

Paints

There are a great many ranges of acrylic paints on the market and there are
subtle differences between brands. The product you prefer will be a
matter of taste. Most manufacturers produce two types of paint – one more
fluid than the other. The fluid or 'flow' formula is generally used for
covering large areas, while the standard formula has a 'buttery' consistency
more appropriate to creating stiff, textured impastos. The colors avail-
able are much the same as those available in oil paint so the names may be
familiar, though some colors such as naphthol crimson, and phthalo-
cyanine green are new colors available in the acrylic ranges only.

Acrylic paints are available in ordinary tubes, small jars and in large
half-gallon containers. Be very careful with acrylic paint – keep the
nozzle of the tube and the mouths of jars clean and always replace tops –
acrylic paint dries very quickly and will become solid and unusable if left
exposed to the air for even a short time.

Acrylic media

An extensive range of media are available for use with acrylic paint – these
extend the possibilities of the paint considerably. The products vary from
manufacturer to manufacturer, but most produce gloss, mat and glaze
media which change the character of the paint accordingly. If a gloss

LIQUITEX MODELING PASTE

medium is added to the acrylic paint it will impart an additional sheen to
the colours when they dry. It can also be used as a transparent size for
canvas and other surfaces and will strengthen and waterproof paper. When
it is first applied it is milky in appearance but dries to a transparent film.

MAT MEDIUM

CANVAS BOARDS

LASCAUX THICKENER

LIQUITEX PAINT

PALETTE KNIVES

Care should be taken when applying the medium. Air bubbles, which dry to form small white pin marks, can be produced if it is brushed too vigorously. Mat medium can be used in the same way but it does not create a gloss effect. Glaze medium is used to produce transparent glazes. Water tension breaker is mixed with paint to facilitate the staining of raw canvas and is also mixed with acrylic paint when flat washes are required. Color will penetrate into unprimed canvas to create a mat and totally uniform area of color. Other products can be added to the paint to enable it to build up heavy impastos, or to increase its adhesive properties so that other materials can be incorporated for mixed media and collage work. Retarders slow the drying process, but you should realize that these will also change the nature of the paint. None of these media are necessary, and acrylic paint can be used direct from the tube or jar.

Brushes

All the traditional ranges of brushes used for oil painting and watercolor painting can also be used for acrylic painting. Hog hair and synthetic brushes can be used for applying undiluted paint and thick impasto work. Ox and sable brushes and the softer synthetic brushes should be used for handling the paint in a more dilute form, and when you wish to create thin washes and glazes. Painting knives and palette knives can be used to apply the paint, to move it around and to work into it, once it is on the support. Using a knife you can build up heavy impastos, create texture and scratch back into the paint. Acrylic paint responds well to the knife, because the color retains its crisp edges and the paint can be applied very thickly

SYNTHETIC FAN-SHAPED
BLENDER NO.4

HOG HAIR FLAT NO.8

without any risk of cracking. Painting knives are available in a variety of shapes and sizes and each can be used to create a different set of marks, from large areas of smeared paint to narrow linear shapes.

HOG HAIR ROUND NO.3

Cleaning brushes

As with oil paint it is essential that brushes be well cared for, and that means cleaning them thoroughly after every use. In fact, it is even more important with acrylic paint for if dirty brushes are left exposed the paint very quickly dries to a tough impermeability and is impossible to remove with anything less drastic than paint-stripper. A hard brush can sometimes be saved by soaking overnight in methylated spirits and then working the paint out by manipulating the bristles between your fingers. The brush should then be washed with warm water and soap.

Other equipment

You will need a palette on which to mix your paint; one with a high-gloss, non-absorbent surface is most suitable as it is easier to clean – glass and plastic are the most usual, but pads of disposable paper palettes are also very useful. A white dinner-plate will do if you have nothing else to hand. As with brushes, you should be sure to clean your palette carefully after use – before the paint dries to an immovable crust. As you work keep the paint on your palette moist by sprinkling water on to it every now and then, or use a water sprayer.

SYNTHETIC BRIGHT NO.6

SYNTHETIC ROUND NO.11

FLOW FORMULA ACRYLIC PAINT

SABLE ROUND NO.8

Churchyard with Yew Trees

The structures which have been placed in the landscape are a great source of inspiration for the artist. Churches in particular have attracted the attention of many painters. In the past, in the days before ferro-concrete structures, the church was not only the largest, but also the grandest and most richly ornamented building in the neighborhood. It was also the focal point of local activity and therefore assumed an importance both visually and socially. Churches were built as a monument to a powerful God and they were intended to impress and inspire the congregation. Their fascination for the artist lies in the details of their architecture, the way in which a solid, heavy material like stone appears to defy the laws of gravity to soar into the sky, and in what they signify.

In this composition the artist has set the church and the churchyard within a tight framework. The dark-green columns of the yew trees provide the atmosphere and setting, and act as a frame, drawing the viewer's attention into and through the painting. A building seen within a landscape in this way provides interesting changes of tone and form. The hard edges of the structures contrast with, and enhance, the soft sinuous forms of nature, and the verticals of the church tower and tombstones reflect the verticals of the dark-green trees and the geometric shapes of the stones.

Here the artist is exploring the possibilities of acrylic paint used thinly in a manner which resembles pure watercolor or gouache. Many people find acrylic paint difficult to use and as with any unfamiliar medium there are characteristics with which you should become familiar if you are to avoid mistakes and are to be able to exploit the possibilities of the paint. Acrylic paint resembles gouache in that it changes color and goes 'dead' as it dries. This makes it difficult to control the balance of your colors, but with experience you will be able to predict what will happen. The mat, rather dull finish can be a disappointment if you are not prepared for it, but it can be attractive and the paint can be made more glossy by adding one of the acrylic media. Acrylic colors can be rather fierce but, again, this is a matter of taste and can be either exploited or controlled. It also dries very quickly, so one way of working with acrylic is to get the basic idea down outdoors, then complete the painting in oil when you return to the studio. Oil paint works very well over acrylic.

Acrylic often suffers from being used to imitate other media rather than being used as a medium with its own special qualities and possibilities. Here the artist has used acrylic as a new and interesting medium, handling the paint with great skill, working into it, blotting, splattering, working over it, but using the paint fairly thinly. The result is an interesting composition in which sharp edges, and flat, mat areas of color are set off against areas of splattered and blotted texture, a painting which is true to the medium rather than treating it as a poor relative of the 'real thing'.

1 The artist selected this view because he liked the way the trees framed the distant church *right*. He used acrylics because they dry quickly.

2 The artist starts by making a careful drawing of the subject with a 2B pencil on to the previously prepared canvas *left*. Drawing forces you to concentrate and helps you to sort out the material in your mind as well as on the support.

3 The finished underdrawing *right* shows the broad distribution of elements within the picture area, as well as showing certain areas in more detail – for example, the buildings and trees on the horizon. Drawings made for particular purposes contain different kinds of information.

4 Using a mixture of chrome green and black *above*, the artist lays in the darkest tones – the foliage of the two dominant trees and the long shadows on the grass. He then creates texture in the foliage of the distant tree.

5 Acrylic paint used direct from the tube or diluted with water dries to a dull mat finish. The artist introduces texture *left* into the shadows on the grass by rubbing it with coarse sandpaper.

6 The detail *below* shows how mat and opaque acrylic paint can be used and the texture created using sandpaper.

CREATING TEXTURE IN ACRYLIC

In these details we can see how the artist has created texture in the crown of the yew tree in the background. In the first picture he flicks water on to the paint surface to create a splatter effect then, using a wet cloth, he dabs off some of the color. This creates a variegated effect and the final picture shows the kind of texture that can be achieved. This will modify subsequent paint layers.

7 Using chromium oxide mixed with a little cadmium yellow the artist lays in the sunlit areas on the grass *left*. The paint is diluted with water and the artist works quickly, applying the paint very freely. As he works, paint falls on to the high cross in the foreground, adding interesting bits of color which will be incorporated.

8 Using a mixture of chromium oxide, black and white *right* the artist scumbles color over one side of the tree on the right and splatters color on to the crown.

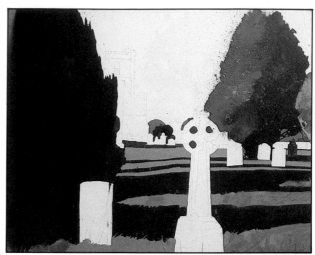

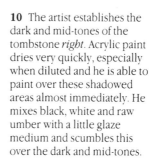

9 The artist uses a mixture of white, black and raw umber for the tower of the church *left*. The shadows are black warmed with a little raw umber. With a small brush he adds the architectural details.

10 The artist establishes the dark and mid-tones of the tombstone *right*. Acrylic paint dries very quickly, especially when diluted and he is able to paint over these shadowed areas almost immediately. He mixes black, white and raw umber with a little glaze medium and scumbles this over the dark and mid-tones.

11 Working in the same way the artist continues to work into the tombstone, creating as much texture as possible *left*. He uses sandpaper to scratch into the surface and then paints over that. In this way he creates a streaky, textured effect.

12 Finally he mixes cobalt blue with a little white and lays in the sky *right*, working carefully around the edges of the church tower and the crowns of the trees. Notice how the acrylic paint covers the bits of color which have strayed into the sky.

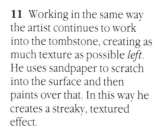

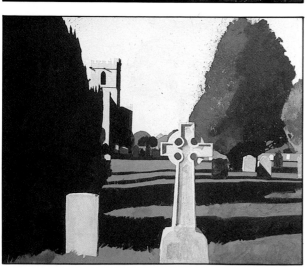

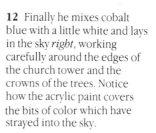

What the artist used

The artist used Liquitex paints on a piece of hardboard, 16 x 20 inches which was prepared with emulsion paint mixed 50:50 with an emulsion glaze. His brushes were Nos. 3, 5 and 7 flats and a No. 4 sable and a decorator's small brush. He used water as a diluent and sandpaper to create texture in some areas of the painting. He mixed his colors on a piece of formica. He used acrylic glaze medium to create thin translucent colors and a water spray to keep the paint moist as he worked.

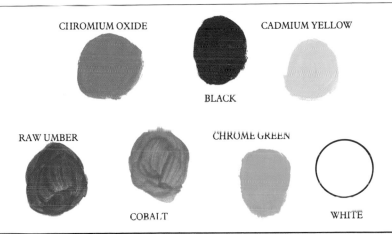

CHROMIUM OXIDE

BLACK

CADMIUM YELLOW

RAW UMBER

COBALT

CHROME GREEN

WHITE

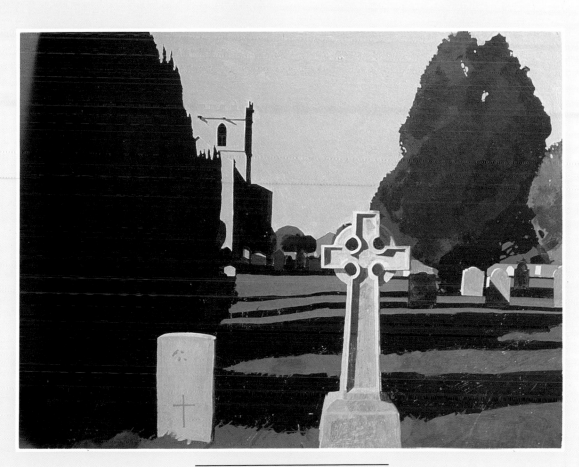

Churchyard with Yew Trees

A Cornfield in Summer

Acrylic paint is one of the most flexible painting media in existence today. In order to exploit it fully you should become familiar with all of its many uses. A good way of doing this is to make a series of paintings in which you try to duplicate the techniques of other media. Here the artist has combined a number of different painting techniques. He started by laying in a traditional oil-type underpainting. He then continued to develop the painting using an assortment of techniques borrowed from other media. Diluted paint was used to lay in a wash, a traditional watercolor technique, to establish the broad areas of the underpainting. Drier paint was used with a fine brush to draw in details. Thick, textured areas were created using dryish paint in much the same way as you would with oil paint.

The artist has chosen to work in the studio from a very simple sketch prepared in the field. On this he had made notes about the colors and the details of the subject – noting, for example, that the flowers in the foreground are daisies. Used in this way a sketchbook is a very useful tool and it also helps to hone your powers of observation – if you know that you will be wanting information when you return to the studio, you are forced to concentrate very carefully on what you see. Make notes of local color, the way the light affects the subject, and the way the forms relate to one another. It is also a good idea to record your first impressions, and the reasons why you thought this particular view worthy of study. You may not return to the subject for a long time, and these notes will refresh your memory and be an invaluable source of information and inspiration.

The artist opted for acrylics for this composition for several reasons. He was short of time and the speed with which acrylic dries allowed him to build up several layers of paint very rapidly. He was also attracted by their covering power – as you can see from the sequence of pictures, his approach involved laying down discrete layers of paint. The opacity of acrylic meant that he could put in highlights and lighter colors at any stage. Much of the color in the foreground, for example, was laid in at quite a late stage, but the last color applied sits clearly on top of the preceding colors. Thus as the painting evolves it looks completely unlike the previous stage – the painting is radically altered, giving the artist great freedom to experiment and change his mind.

The paintwork is varied and exciting. In the foreground there are areas of detailed, busy color where vertical strokes of green are warmed and enhanced by the underlying red glimpsed through the stems of the grass and flowers. Dabs of impasto white describe the daisy heads simply but effectively. The area of broken color in the foreground contrasts with the flat area of creamy yellow in the middle distance, and the smooth, rather flatly applied paint is used to suggest the hills on the horizon.

1 The artist prepared this sketch *right* in the field before working it up into a painting in his studio. It was not intended to be a finished drawing.

2 The artist starts by preparing a detailed tonal underpainting *above*. He uses a well loaded No.8 bristle brush and a mixture of gold ocher and raw umber, and blocks in the basic forms of the landscape.

3 The artist lays in a thin glaze of warm orange in the foreground, and olive green over the hills on the horizon *above*. He then applies a thick layer of lemon yellow across the center.

4 The artist blocks in the hills using a fairly thick mixture of chromium green and yellow ocher *above*. Vermilion is mixed with yellow to make a bright orange for the foreground.

LAYERED EFFECTS

These details show how the artist has exploited the opacity and covering power of acrylic paint in order to build up complex layers of paint. In the foreground he has used a strong, singing orange. This has been overlaid with other colors which cover it incompletely so that the merest suggestion of orange shines through the subsequent layers, creating an impression of warmth and sparkle. Acrylic paint can also be used to create thin glazes which modify each succeeding layer. These can be built up rapidly, because acrylic dries so quickly.

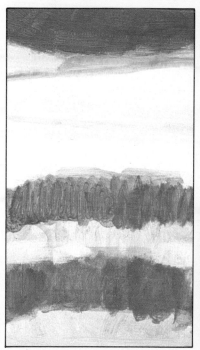
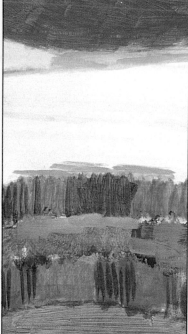
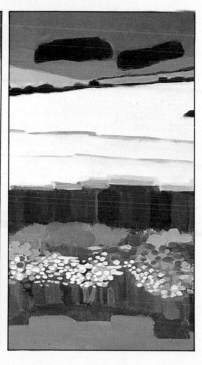

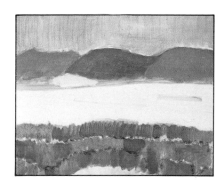

5 The artist works thinly diluted cobalt blue over the ochry colors of the underpainting *above*. With a vivid green made of chrome green and lemon yellow he paints around the bright orange.

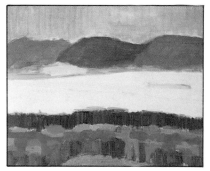

6 The artist continues to develop the foreground with thick dabs of impasto and thin glazes *above*. He uses a variety of greens and grays which he mixes on his palette from the same basic colors.

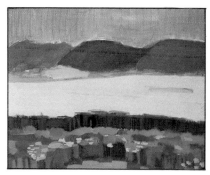

7 The foreground is brought forward by adding small patches of light green and white *above*. The paint is applied with horizontal dabs of color which establish the top surface of the vegetation.

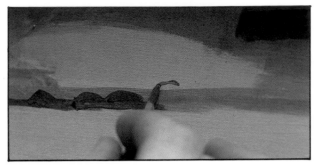

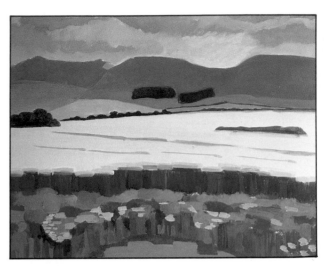

8 The artist develops an area of dark vegetation *above* by building up thin layers of chrome green mixed with black. This method is practical because acrylic dries quickly.

9 The artist turns his attention to the area at the foot of the hills *right*. Using a fine brush and thick opaque paint he develops field boundaries and areas of woodland.

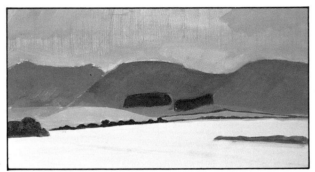

10 *Above* using a mixture of cobalt blue and white the artist scrumbles loose color over the blue glaze. He works the color carefully around the margins of the hills.

11 This detail *right* shows just how exciting paint handled in this way can be. The artist has exploited both the opacity and the translucency of acrylic to create this passage.

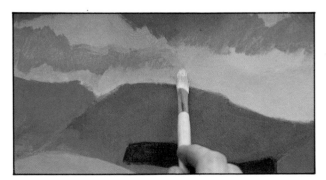

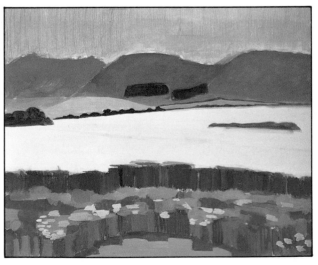

12 *Above* the artist uses bluey grays and pinky grays to develop the hazy, cloudy sky. He scrumbles in each layer of paint so that it subtly modifies the succeeding layers.

13 The artist adds some details to the cornfield *right*. In the final picture *opposite* he has modified the tonal scale of the sky by giving it a unifying glaze.

What the artist used

The artist used a prepared canvas board 20 × 24 inches. When buying proprietary boards you must make sure that they are primed for acrylic and not oil. He used Nos. 3, 6, and 8 flat bristle brushes and a No. 4 sable for detailed work. He used a china plate as a palette.

CHROME GREEN

BURNT UMBER

RAW UMBER

GOLD OCHER

LEMON YELLOW

OLIVE GREEN

VERMILION

BLACK

CADMIUM YELLOW

COBALT BLUE

ULTRAMARINE BLUE

VIRIDIAN GREEN

WHITE

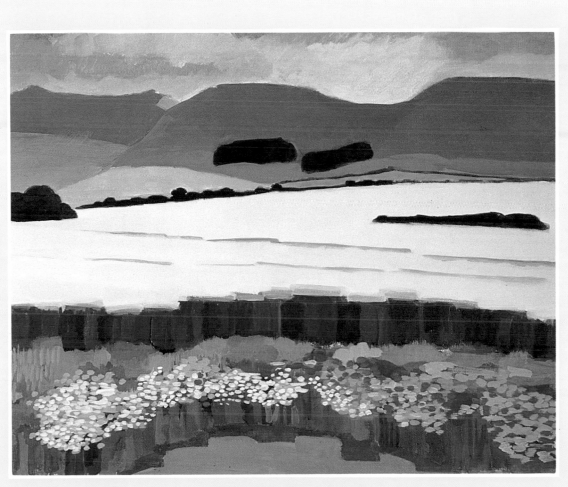

A Cornfield in Summer

A View through a Gateway

Scenes glimpsed through openings always make interesting compositions, and it was this aspect of the subject that caught the artist's eye. The gateway and the hedge are close to the picture plane and the hills which they frame are, by contrast, felt to be at a considerable distance. The straight geometric forms of the gate contrast with the unformed, exuberant growth of the hedge and vegetation. The poles and bars are set at different angles, creating shapes within shapes and criss-cross patterns which lead the eye across and through the picture. One of the struts of the gate, for example, leads the eye inevitably to the tower on the hill which is the focal point of the painting – wherever the eye wanders it always returns to that point.

The artist chose acrylic, because it is a medium which he often uses for quick studies in the field. He likes the feel of the medium and finds it very useful for working outdoors. It dries quickly and it is easy to work several layers of paint and complete a painting at one sitting. From a purely practical point of view, the fact that the painting is dry or almost dry at the end of the day means that it is easier to carry home than a wet oil painting.

In this instance he chose to work with a palette knife, a tool which he often uses with oil paint, but had not used with acrylic because he had thought it would be too malleable and would not hold the knife marks adequately. Every now and then you should explore a new medium, a new method of application, a new support, or even a new size of support. Every artist runs the risk of getting into a rut, working to a formula and becoming cliché-bound. With a new tool or medium you have no experience to fall back on, and this spirit of investigation makes your work fresh and immediate. In this case the artist found the combination of palette knife and acrylic exciting and stimulating, and this is reflected in the freshness and sparkle of the paint surface.

The artist wielded his knife with great freedom. Using the flat of the blade, he worked up areas of texture in the foreground – these generous dabs of color attract the eye and help establish the feeling of recession, and the marks diminish in size as the implied distance increases. He used the length of the blade to lay on large areas of paint and the tip of the knife to make short vertical strokes to describe the sky. Thick, rich paint is the essence of knife painting – whether in oil or acrylic. Don't worry about completely covering the support – here the small areas of white which show through give the painting an additional sparkle which suggests the flickering of natural light and the movement of leaves in the breeze.

It is worth trying a knife painting even if you have never handled a knife. You will be surprised at the range of marks which are possible and it will force you to be bold and direct.

1 The artist chose to paint this view *right* because he was fascinated by the way the hedge enclosed and revealed the landscape beyond.

2 The artist works outdoors on this subject. Even if you prefer to work in the studio you should occasionally paint from nature because it is a unique experience. The artist makes the initial drawing directly on to the canvas *left* with charcoal.

3 Charcoal is a flexible medium, capable of creating a sinuous line. It is easily erased and therefore easily corrected, a great advantage when an artist is evolving a composition on the canvas. Having decided on the outlines of the composition the artist knocks it back with a cloth *right*.

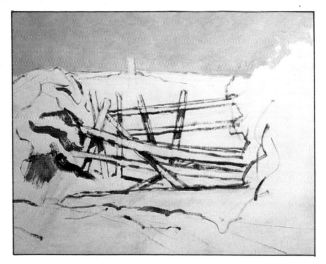

4 Having removed the surface particles from the charcoal drawing, the artist traces over the faint, remaining lines with thinned black paint. He starts to block in color *above*. laying in the sky with a mixture of cobalt blue and white.

5 The artist uses a knife because he is anxious to complete the painting at one sitting. With a palette knife a painting can be built up very quickly indeed. *Above right* the artist develops the foliage in the foreground, laying in pure areas of color side by side. The raised edges of each area will catch the light, adding a light-scattering quality.

6 When working with a painting knife it is best to work *alla prima*, that is, laying on all the pigment in one session and in one layer. *Below* we see how rapidly the painting is developing, given the freedom of a painting knife.

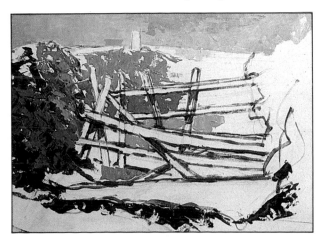

KNIFE MARKS

Here we can see the variety of marks it is possible to make using just one knife. In the first example the artist has used the flat of the blade to lay in areas of flat, clearly formed color in the foreground. In the second example, the side of the blade is used to flick in fronds of foliage. In the third example, he uses the flat of the blade to slur in the color of the sky in order to achieve a smooth, relatively unmodulated paint surface. Finally, we see him using the tip of the blade to work on quite a small scale, laying in the highlights along the uprights of the gate.

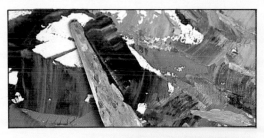

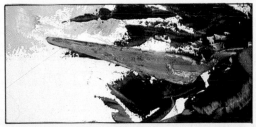

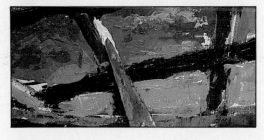

7 In the detail *left* we see thick, glossy paint laid on *alla prima*. In some places the canvas shines through the viridian, a particularly translucent color: in others, different greens have been smeared together.

8 It is possible to work in quite a detailed way with a painting knife – it is not necessarily a crude instrument. The artist works color between the bars of the gate *right*, using small dabs of color laid on with the very tip of the blade. Even the fairly small bars of the gate are rendered with the knife.

9 The details illustrated in Steps 7 and 8 are shown *above* in the context of the whole painting. The artist has moved from one part of the painting to the other, picking up colors and moving them across the canvas. These stray bits of color link the various elements of the painting. The painting illustrates how different the surfaces created by a knife can be. There are small, subtly modulated areas of tone in the sky contrasted with exciting, dragged color in the foliage.

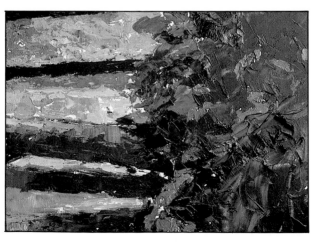

10 The artist establishes a small area of local color on the distant hills using a mixture of yellow ocher, white and cadmium yellow *above*. The artist uses small strokes of the knife to lay in color in this area. By contrasting these with the large, generous marks in the foreground he helps create a feeling of recession.

11 The artist adds more paint in the area of the foliage *left*, slurring some colors but trying to keep the paint fresh.

What the artist used

The paint used was Liquitex acrylic paint – the quality is excellent and there is a good range of colors. The support was a piece of hardboard which he had previously prepared with an acrylic primer. The board measured 24 × 30 inches. He used a selection of painting knives.

BURNT SIENNA

CADMIUM YELLOW

COBALT BLUE

YELLOW OCHER

CADMIUM GREEN

CHROMIUM OXIDE

ULTRAMARINE

SAP GREEN

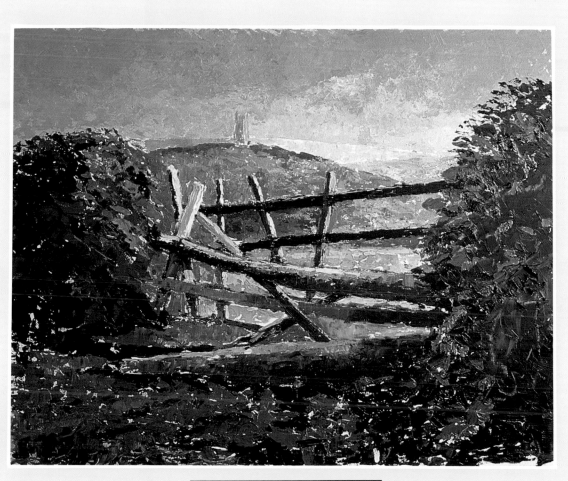

A View through a Gateway

A Village by the Sea

COLLAGE WITH ACRYLIC

Here collage has been combined with acrylic to produce an exciting and colorful mixed media painting. Collage is a good way to study color and composition because it forces you to simplify your shapes and colors. It is also very easy to make changes – the elements of the collage are easily lifted or moved and areas can be covered by gluing further layers of paper over them.

Collage also offers you a variety of edges – if you cut the paper with scissors or a knife you will produce sharp, clean edges. If you tear the paper, however, you will produce irregular edges which will counteract and soften the hard, cut-out look. Exploit the qualities of the papers – their thickness, their texture and the way they crease and crumple. With collage you can approach the design directly – all the elements are simplified and you will not be confused by brushstrokes and paint quality.

To create this painting the artist has worked from a picture found in a travel brochure – proof that subjects can be gleaned from many sources. There is a prejudice against using photographic material as a reference for a painting. This is because the camera has already made many of the design decisions for you: the frame of the picture is dictated by the viewfinder, and the color range is decided by the type of film and chemical reactions in the course of processing. But as long as you are aware of these pitfalls, and are prepared to deviate from the picture, to incorporate images from several sources, to highlight and adjust them, you will produce a painting that is truly original and creative. Collage, by its nature, prevents you producing a slavish copy of the picture.

Acrylic works very well with collage. It is a powerful adhesive, as are the various media with which you can adjust the nature of the paint, and its opacity means that it can cover printed surfaces completely when any other paint would soak into the absorbent paper and result in show-through. Acrylic can be used thick or thin, it can be washed on or used with a dry brush technique to lay in details. The paint can also be made to hold textured materials such as sand and sawdust, though you should be careful not to overload it. You can, in fact, create a painting that works in three dimensions.

This collage was created as an experiment and as a means of freeing the imagination. The artist explored ways of conveying a feeling of space and structure and also developed an exciting decorative surface. With its rich and jewel-like areas of color, its scintillating facets of tone and texture, this collage is an original and delightful object.

1 The artist chose a picture from a magazine *right*. He liked the contrast between the houses and the sea.

2 Having assembled some suitable materials, the artist starts by cutting out some large pieces of blue tissue for the sea and applying glue to the reverse side *above*.

3 The artist uses both paint and glue as adhesives throughout the collage. *Above* he glues on a large area of blue tissue-paper to represent the sea. He presses it firmly so that

it is flat and unwrinkled. Collage forces you to simplify and to be direct. To some extent the materials available dictate the direction of the work.

4 Newsprint is an excellent material which can be used to create a range of tones and effects *above*. Cut paper and torn paper will create very different effects.

THE COVERING POWER OF ACRYLIC PAINT

This detail from the collage illustrates very clearly the range of textures possible with acrylic paint and its excellent covering power. The paint has been overlaid over a range of materials and shows well against the harsh flat colors of the printed images. Although the papers used are absorbent, the acrylic paint is not absorbed, but forms a firm covering film on the surface. The paint can be brushed on or laid on thickly with a palette knife. This, and the speed with which it dries, make it an excellent medium for collage and mixed media work, where you want to build up layers of different materials and colors.

5 *Left* the artist scrunches up some tissue-paper and uses it to apply paint to the surface of the collage. The tissue is both an integral part of the painting and a tool for applying paint.

6 Collage allows the artist to work fast and freely with both large and small elements *right*. So far the artist has used colored tissue-paper, newsprint, brown wrapping paper and various printed photographic materials.

7 In this collage the artist is looking at space and structure and seeks to convey both by using the cut-out shapes as planes of light and dark. He is also interested in the decorative element and uses color, pattern, print and texture to develop the overall design. The artist adds paint to the image *left*.

8 We can see how all these elements combine and harmonize *right* capturing a good likeness of the original image but with a new and original interpretation.

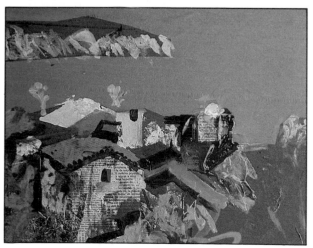

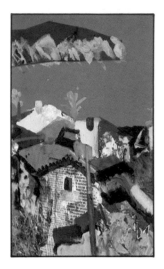

9 The artist works into the image with acrylic paint *left* sometimes working very broadly and at other times working on a much smaller scale to create areas of closely observed detail. The paint responds differently to different surfaces, presenting the artist with yet another challenge.

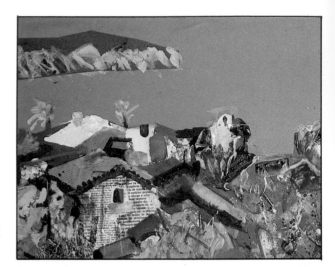

10 The artist creates further interest by varying the way he applies the paint *right*. He introduces passages of dripped, splattered and dotted paintwork, creating a very decorative picture surface.

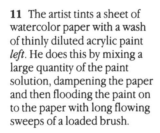

11 The artist tints a sheet of watercolor paper with a wash of thinly diluted acrylic paint *left*. He does this by mixing a large quantity of the paint solution, dampening the paper and then flooding the paint on to the paper with long flowing sweeps of a loaded brush.

12 The artist cuts a piece of canvas for incorporation in the image *right*. Fabric adds texture and color and accepts paint in a very different way from paper. It also provides the artist with a variety of edges.

13 The tinted paper is now dry and the artist cuts it up into strips and pastes it on to the image to create areas of bright jewel-like color *left*. At this stage he also develops the tonal contrasts of the painting with black and white paint.

14 The surface of the picture is now quite textured and heavily worked, so the artist uses a painting knife to lay on the final areas of paint. The final picture *opposite* illustrates just how creative a medium collage is and also how the artist has responded to the medium.

What the artist used

The artist used a sheet of very strong construction paper 24 × 30 inches as a support. His materials were varied: newsprint, tissue-paper, pictures from magazines, fabric, canvas and watercolor paper which he tinted with thinned acrylic paint. His adhesives were glue and the acrylic paint itself. He used a selection of Liquitex acrylic paints and applied the paint with a No. 6 synthetic brush. He also used a painting knife.

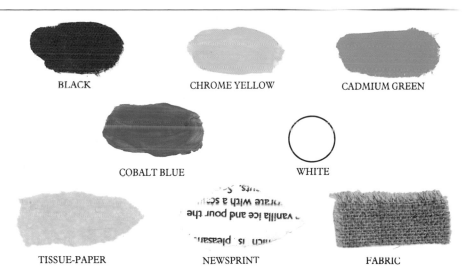

BLACK CHROME YELLOW CADMIUM GREEN

COBALT BLUE WHITE

TISSUE-PAPER NEWSPRINT FABRIC

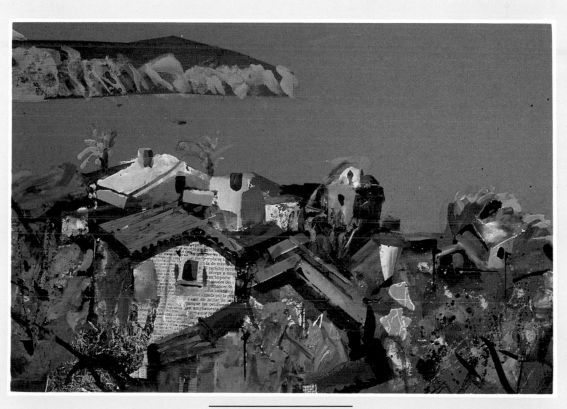

A Village by the Sea

*W*atercolor and Gouache

W atercolor is beautiful, unpredictable and exciting. There are two kinds, both water soluble and both bound with gum arabic. Pure watercolor is transparent – paintings are built up from translucent washes through which the white of the paper shimmers with a pearly opalescence. Gouache, also called body color, is thicker and more opaque than pure watercolor and can be used to create flat, opaque patches of color as well as thin washes. The translucency prized by the purists is sacrificed, but a greater freedom is gained. Watercolors are ideal for landscape painting as they are light and portable and the equipment required is minimal. Because they use water they are cleaner and easier to use than, for example, oil. The two types of watercolor are handled in different ways which reflect their nature. With pure watercolor the artist uses white paper and works from light to dark. It is clearly important to make an early decision about the areas to be left absolutely white. Gouache, on the other hand, works better on a colored ground because the paint contains white pigment, and the artist can correct, overpaint and create fine details. Pure watercolor and gouache can be combined very effectively in paintings which exploit the best features of both.

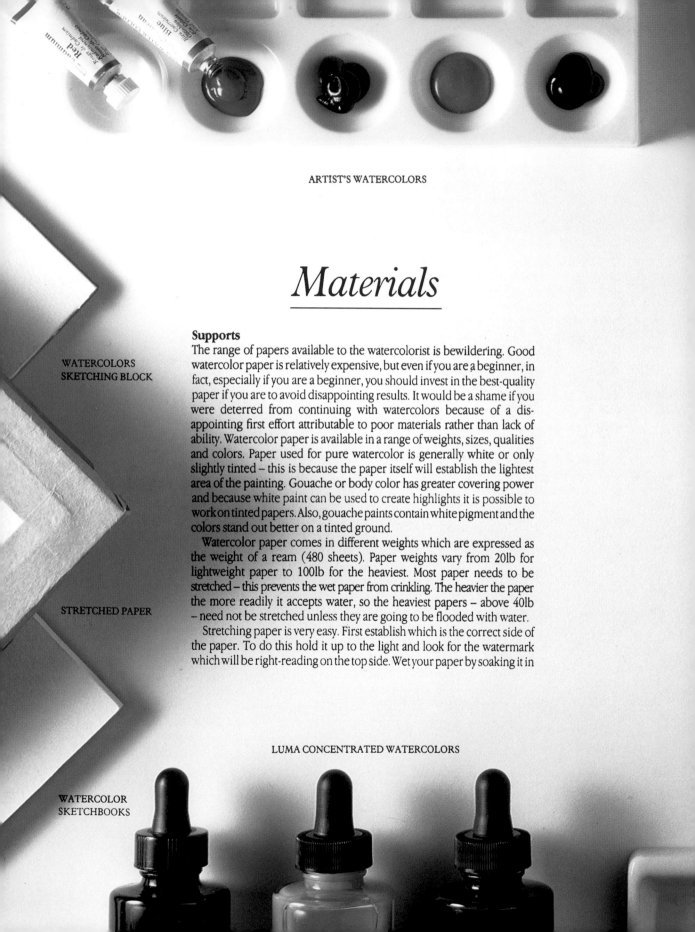

WATERCOLORS
SKETCHING BLOCK

STRETCHED PAPER

WATERCOLOR
SKETCHBOOKS

LUMA CONCENTRATED WATERCOLORS

Materials

Supports

The range of papers available to the watercolorist is bewildering. Good watercolor paper is relatively expensive, but even if you are a beginner, in fact, especially if you are a beginner, you should invest in the best-quality paper if you are to avoid disappointing results. It would be a shame if you were deterred from continuing with watercolors because of a disappointing first effort attributable to poor materials rather than lack of ability. Watercolor paper is available in a range of weights, sizes, qualities and colors. Paper used for pure watercolor is generally white or only slightly tinted – this is because the paper itself will establish the lightest area of the painting. Gouache or body color has greater covering power and because white paint can be used to create highlights it is possible to work on tinted papers. Also, gouache paints contain white pigment and the colors stand out better on a tinted ground.

Watercolor paper comes in different weights which are expressed as the weight of a ream (480 sheets). Paper weights vary from 20lb for lightweight paper to 100lb for the heaviest. Most paper needs to be stretched – this prevents the wet paper from crinkling. The heavier the paper the more readily it accepts water, so the heaviest papers – above 40lb – need not be stretched unless they are going to be flooded with water.

Stretching paper is very easy. First establish which is the correct side of the paper. To do this hold it up to the light and look for the watermark which will be right-reading on the top side. Wet your paper by soaking it in

a bath or tray, moving it around to ensure that it is thoroughly wet, and then lay it on a drawing-board, right side up. Cut strips of gummed paper to the correct length and, ensuring that your paper is completely flat and smooth, use the gummed paper to fix it to the board. Lay the board flat until the paper is completely dry.

Texture is a very important consideration when choosing paper for watercolour. There are three basic finishes: Hot-Pressed (H.P.); Cold-Pressed also called 'Not'; and Rough. Hot-Pressed has the smoothest surface because during the course of its manufacture it undergoes a process equivalent to ironing. It is probably most useful for drawing, but some artists like to paint on a smooth surface. Cold-Pressed paper has a fine texture and is probably the most popular surface. Rough paper has a very distinctly textured finish. Many artists like the way watercolour paint responds on Rough paper. When, for example, a wash is laid on a paper with a pronounced texture, the paper will receive the pigment unevenly – colour will sit on the high areas while the low areas will remain white – giving the paint surface sparkle and texture.

The materials from which papers are made vary. The most expensive papers are handmade from 100 per cent rag. But for most purposes machine-made papers, manufactured from mixtures of rag and wood pulp, are perfectly adequate, certainly for experimenting and for the beginner.

Paints
The watercolourist has a great many decisions to make when buying paints. The first choice is between pure watercolour and gouache, and then between student's and artist's colours. For pure watercolour it is well worth investing in the best quality pigments right from the beginning.

WATERCOLOUR
PAPERS

HOT-PRESSED

NOT

ROUGH

CONCENTRATED WATERCOLOUR

SYNTHETIC ROUND NO.5 SABLE ROUND NO.6

SYNTHETIC ROUND NO.18

 FINE PURE SABLE PURE SABLE BRIGHT

GLASS OF WATER

WATERCOLOUR BOX

They are expensive but nothing can rival the brilliance, permanence and saturated colour of the best artist's colours. In watercolour, more than any other medium, you get what you pay for.

Watercolours can be purchased in several forms: in dry cakes; in small tubes of moist colour; in semi-moist 'pans' or 'half-pans'; or in concentrated form in bottles. The choice depends on personal taste and convenience. The moist paint in tubes and the liquid paint in bottles are best for creating washes on large areas. A box of pans or half-pans is useful for sketching and working outdoors: the lid of the box can be used as a palette and the paint is accessible and does not have to be squeezed out. Paint in this form is compact and, unlike liquid paint in bottles, is not liable to spillage. Dry cakes are watercolour in its purest form; paint in semi-moist pans and in tubes has glycerine or honey added to keep it moist. Watercolours can be purchased in boxed sets or you can buy boxes and fill them with your own selection of colours.

Brushes

You will need a selection of good quality brushes: large flat brushes for laying flat, even washes; round brushes for laying on heavily loaded strokes of colour, and small brushes for rendering very small areas of detail. The size and type of brushes you use will depend on the kind of work you do and the scale at which you work. The very best watercolour brushes are red sable, made from the tail of the Siberian mink. They are very expensive, but properly cared for will last for a long time and repay the investment. Brushes are also made from squirrel (also known as camel hair), ox hair and synthetic materials – though these synthetic fibres have improved in quality, they are still inferior to the natural product. Chinese

TUBES OF WATERCOLOUR

SKETCHING BOX WITH WATER RESERVOIR

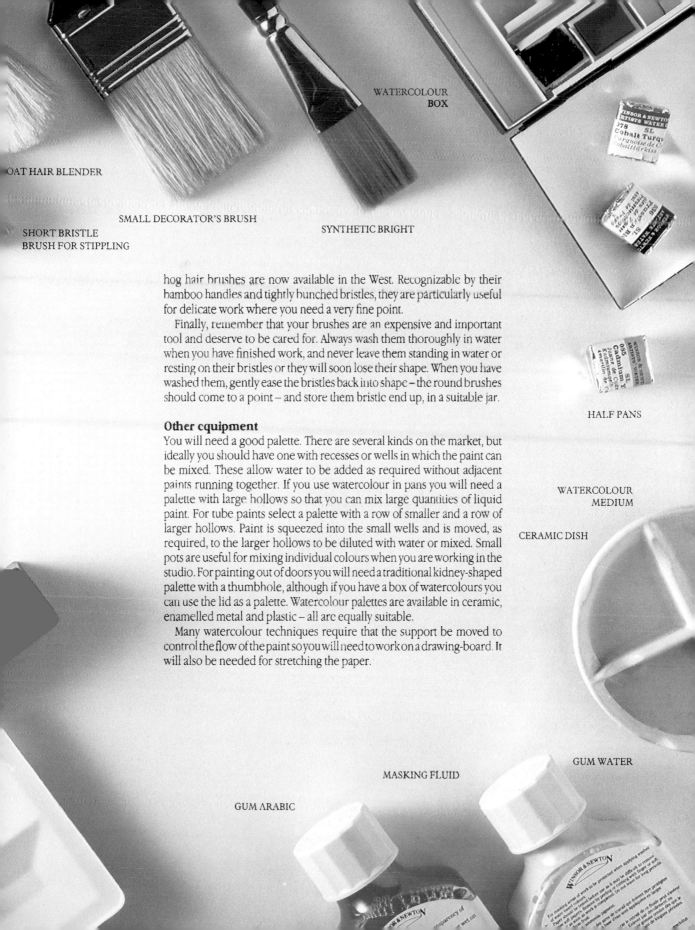

GOAT HAIR BLENDER

WATERCOLOUR
BOX

SMALL DECORATOR'S BRUSH

SHORT BRISTLE
BRUSH FOR STIPPLING

SYNTHETIC BRIGHT

HALF PANS

WATERCOLOUR
MEDIUM

CERAMIC DISH

GUM WATER

MASKING FLUID

GUM ARABIC

hog hair brushes are now available in the West. Recognizable by their bamboo handles and tightly bunched bristles, they are particularly useful for delicate work where you need a very fine point.

Finally, remember that your brushes are an expensive and important tool and deserve to be cared for. Always wash them thoroughly in water when you have finished work, and never leave them standing in water or resting on their bristles or they will soon lose their shape. When you have washed them, gently ease the bristles back into shape – the round brushes should come to a point – and store them bristle end up, in a suitable jar.

Other equipment

You will need a good palette. There are several kinds on the market, but ideally you should have one with recesses or wells in which the paint can be mixed. These allow water to be added as required without adjacent paints running together. If you use watercolour in pans you will need a palette with large hollows so that you can mix large quantities of liquid paint. For tube paints select a palette with a row of smaller and a row of larger hollows. Paint is squeezed into the small wells and is moved, as required, to the larger hollows to be diluted with water or mixed. Small pots are useful for mixing individual colours when you are working in the studio. For painting out of doors you will need a traditional kidney-shaped palette with a thumbhole, although if you have a box of watercolours you can use the lid as a palette. Watercolour palettes are available in ceramic, enamelled metal and plastic – all are equally suitable.

Many watercolour techniques require that the support be moved to control the flow of the paint so you will need to work on a drawing-board. It will also be needed for stretching the paper.

A Vineyard in Italy

This simple, but evocative, watercolour was executed on the spot, but the artist first did a quick sketch in order to investigate the subject. As you can see, he made slight adjustments to the composition between sketch and painting. He simplified and enlarged the hill in the foreground, emphasizing the repeated lines of the vineyards, and moved the village further up the picture area so that there is little or no sky. The swooping lines of the rows of vines lead the eye inevitably through the painting to the group of houses beyond the hill. The artist must be prepared to use and see the unexpected within a subject and to manipulate, consciously or intuitively, for that is the creative process. Any work of art is composed of small elements which are nothing of themselves, but which together create a whole which is unique. Nor does the artist need to 'explain' everything that appears in the painting – it is this which distinguishes the work of the fine artist from that of a technical illustrator who must justify everything in his or her drawing. The unique conjunction of ideas, images and colour makes a particular painting beautiful, satisfying and compelling.

When you are composing a painting you should think in terms such as balance, harmony and dynamics. Here the artist has fixed upon a feature of the scene before him and has played with it, exaggerated it and made of it something new. He has used the parallel lines of vines as a prop; they create a pattern of alternating green and pale yellow across the bottom half of the picture. They converge along the perspective lines and thus help to explain the space in the foreground and lead the eye from foreground into background, creating a rhythm which runs as an undercurrent through the painting. Artists create rhythms within their work by stressing the direction of structural lines, by the quality of the line used and, of course, by the composition – by the way the elements of the painting are disposed about the picture surface and the way the images are contained within the picture frame. The simple,

regular, repeated pattern of the foreground is contrasted with the bright, busy, staccato area of the village in the background, with its jumble of shapes and colours. It is these sorts of contrasts, stresses and tensions which make one painting compelling and lively and another, which may be equally ably executed, dull and boring.

The artist opted for watercolour because it is a medium which he likes and finds convenient to use out of doors. The translucent washes and brilliant colours suited the subject and recreated very effectively the quality of the light. He worked quickly on paper which he had stretched. The 'Not' texture of the paper gave the work a sparkle which conveyed the warmth of a sunny day. The large details illustrate very well the way in which the texture of the paper contributes to the feel of the work, catching the paint in an almost fortuitous way and channelling the colour as it runs over the paper surface, so that in some areas the paint 'sits' on the raised areas, but penetrates more completely in others.

If you study the painting carefully you will find that the individual elements are actually very simply described, but the whole works well, and is a coherent and convincing representation of the subject.

1 The artist painted this simple but evocative watercolour in front of the subject. He started by making the charcoal sketch *right*.

2 Working on stretched paper, the artist lays a warm neutral coloured wash mixed from raw umber, Prussian blue and permanent yellow *above*.

3 The artist lets the first wash dry completely so that he can judge the colour exactly He lays another wash of the same mixture over the first *right*.

4 The artist lays a wash of Prussian blue to establish the sky area. He then paints the buildings using washes of light reds and grays *above*.

5 The artist lets the paint dry and then starts to fill in areas between the washes with passages of pure, bright color *below*. He works wet over dry to avoid color bleed.

6 The artist has used a variety of techniques *above*. In some places he has created pure, transparent washes, in others these are overlaid by a wash of a different color to create a third color. The colors have sometimes been allowed to bleed into each other creating a soft edge. In other areas colors are juxtaposed with a sharp edge.

CREATING A COMPLICATED EDGE

It is possible to create quite complicated areas of color using watercolor paint. The method shown here is very simple. First, the artist wet the paper in the area he wanted to color, working carefully up to the edge of that area. He then worked paint into the damp area, letting it spread right to the edges. He then dried the area by dabbing it gently with blotting paper, to give it a pale, even texture.

7 The detail *above* shows how important the texture of the paper is, influencing the way the paint is accepted. The artist bleeds Paynes grey into Prussian blue.

8 In the detail *right* we see the variety of edges and marks that can be created and the way in which one color can show through another.

9 With a brush loaded with terre verte *above*, the artist lays in a large area to represent the tree on the left of the picture.

10 *Above right* the artist lays in the strong converging lines of the vines with terre verte. He uses a single decisive stroke of the brush for each row.

11 The sweeping lines of the vines make an important contribution to the picture, leading the eye into the picture space and linking foreground and background *below left*.

12 The artist reinforces the rows of vines with a mixture of terre verte and Paynes gray *below*. By using strong intense color in the foreground he brings that area forward.

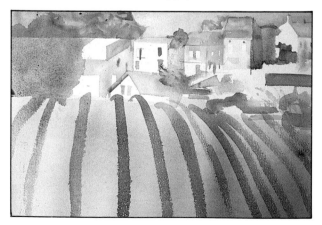

What the artist used

The artist used a set of artist's quality watercolors in half-pans. The box was specially designed for working outdoors – it has its own in-built water reservoir and a lid which turns into a water pot. He used a good quality 'Not' watercolor paper, 12 × 16 inches which he had stretched the previous night on a drawing board. He used Nos. 4 and 11 sable brushes. He used the lid of the paint box as a palette.

RAW UMBER

YELLOW OCHER

CADMIUM RED

PAYNES GRAY

TERRE VERTE

PRUSSIAN BLUE

BURNT UMBER

HOOKERS GREEN

PERMANENT YELLOW

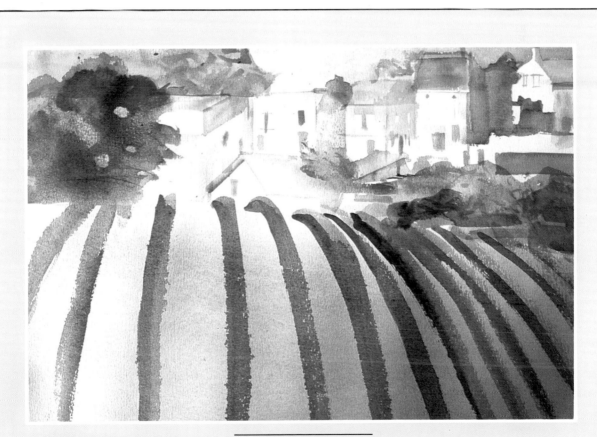

A Vineyard in Italy

The Motel

Often what the artist leaves out is as important as what he or she includes in a painting. Here the artist has improved on the subject by simplifying it, by highlighting certain features and by leaving out others such as the clutter of cars on the right. This editing of information is an important part of the creative process and it is something which the painter can do far more easily than the photographer. The composition is based on a series of simple shapes: the broad horizontal band of the roof which is balanced on the right by a block of verticals – the trunks of the trees. The way in which the shapes 'bust' the edges of the composition is deliberate. The continuation of objects beyond the edges of the picture frame is a fairly new concept in painting, adopted by the Impressionists from Japanese art. The device creates a sense of immediacy and intimacy, the viewer is made to feel that he or she is glimpsing only part of a scene and that the objects have an existence beyond the confines of the painting. When, on the other hand, all the objects sit comfortably within the picture frame the impression created is one of separateness and independence, of a painting that is complete in itself.

The cropping of images can be used in many ways to create different effects. By cropping a moving figure the artist can suggest movement into, or out of, the picture. By allowing an object such as a column, a tree, a building or a figure to break through the edges of the picture at both the top and bottom the artist creates the illusion that the subject is right at the front of the picture, on, or in front of, the picture plane.

The sense of depth and recession in this painting is conveyed by a series of converging lines – the shadow on the left, the white line in the road, and the line of trees on the right. These all conspire to lead the eye into the painting. These features were there, but the artist composed and cropped his picture so as to highlight them – he used what was there to his own ends. Similarly, he has taken aspects of the subject which first attracted him and has emphasized and highlighted them. He liked the pure, strong, simple colors and in his painting these are purer, stronger and simpler. He liked the geometric feel and the strong linear feel of the repeated motifs of windows, doors and shrubs along the front of the motel. Thus while the painting is faithful to the subject it is, nevertheless, almost abstract in feeling.

The artist used pure, transparent watercolor which was well suited to the bright, sun-drenched scene and the clear slabs of local color. The paint is handled with authority and imagination. By using masks he was able to work freely into the foliage of the trees, splattering paint to create modulations of color. A plastic ruler was used to create a sharp dividing line between the tree and the roof top.

1 The artist was fascinated by the way the strong vertical and horizontal stresses in this urban landscape balanced each other *right*.

2 Using a 2B pencil the artist makes a fairly detailed drawing directly on to the previously stretched watercolor paper *left*. He uses simple lines to create an accurate drawing.

3 The artist mixes cobalt blue in a small ceramic pot. With a large No. 10 brush he lays in a wash for the sky *above left*. With Paynes gray he lays in the foreground.

4 The composition does not change much after the initial drawing Watercolor but in the paint fresh it is sometimes necessary to plan the order of working *above*.

5 Using green mixed with gum arabic, the artist starts to paint the trees *left*. Gum arabic gives the watercolor more substance without losing its translucency. It also dries to a glossy finish and allows the artist to build up very intense colors.

6 The artist paints the foliage of the palm tree with pure watercolor *right*. He uses sap green but this time does not add gum arabic, because he wants to develop that area using a series of washes. With gum arabic the painting would become too dark too quickly.

7 The spiky leaves of the palm tree are created by laying down overlapping washes, *above*. The wet paint is blotted with tissue to create texture.

8 *Above right* we see the effects achieved by working into gum arabic as explained on page 112. The watermarks resemble the texture of a leafy tree.

9 The painting is progressing in a series of clearly defined stages *below left*. Each stage advances the work rapidly, but between each stage the painting must be left to dry.

10 With a mixture of burnt sienna and alizarin crimson the artist lays in the roof of the motel *below*. The shadow in the foreground is created with Paynes gray.

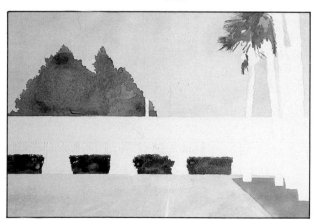

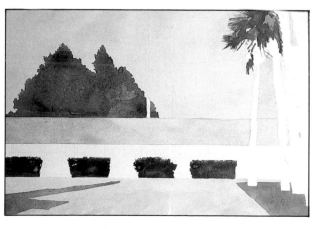

USING A MASK

The artist wanted to create a lot of texture to suggest the foliage of the tree. Using detail paper, which is not quite as transparent as tracing-paper, he traced out the shape he wanted to mask off. Then, using a craft knife, he cut out the shape of the crown of the tree. He then laid the mask over the painting so that the area on which he wanted to work was exposed and other parts were protected. He could then work with considerable freedom. The foliage of the tree had been painted with sap green mixed with gum arabic. Using a small, house-painting brush, he splattered more gum arabic and sap green on to the crown of the tree in order to create an evenly stippled effect. When he peeled off the mask the tree was heavily textured but the surrounding areas were clean.

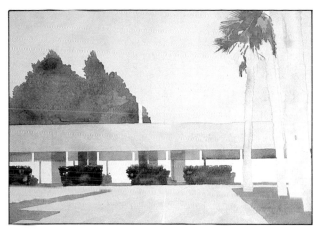

11 A mixture of alizarin crimson and raw umber is used for the red doors, Paynes gray for the windows and shadows and dilute raw umber for the trunks *above*.

12 *Right* the artist uses a fine brush, Paynes gray and a ruler to create shadows along the door frames, the tiles along the apex of the roof and the shadows under the eaves.

13 In the detail *left* we see how the artist's approach has simplified the subject, giving the painting an abstract quality. It remains, however, a realistic representation.

14 Working up to the ruler again, the artist draws in the telegraph poles *bottom left*. The white line in the road and the line of the tree trunks lead into the painting.

15 *Below* the artist uses a mixture of sap green and Paynes gray to work more detail into the foliage of the palm trees. The secret is to get the necessary amount of detail to be descriptive and decorative without overworking the painting. Notice the quality of the paint where the wash of the tree trunks overlaps the sky.

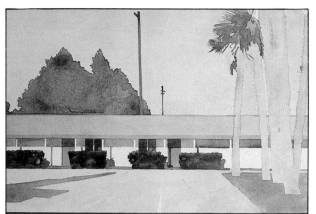

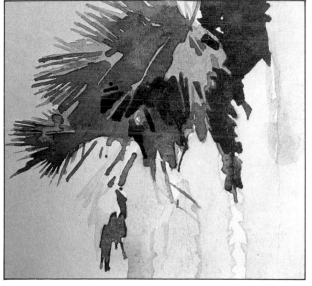

16 The artist uses raw umber to draw the lines which encircle the trunks of the palm trees and to indicate where leaves have broken off *right*. At the very base of the tree he uses a soft pencil to create a local area of texture.

17 More raw umber is used to develop texture in the upper parts of the tree trunks *below*. This area illustrates how the same color can be worked layer upon layer, building up different densities of color. This degree of detail attracts the eye and the scale of the marks indicates that the area is nearer the picture plane.

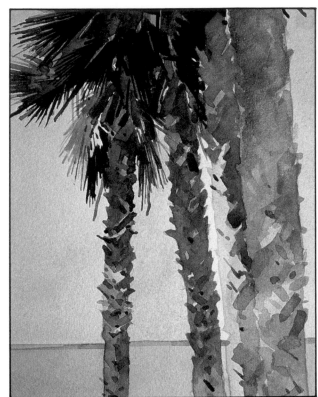

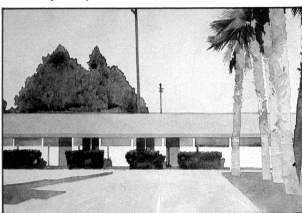

18 The artist works yet more color and texture into the foliage of the tree – again using sap green *above*. With a mixture of raw umber and Paynes gray he returns to the upper part of the tree trunks. These trees break the picture frame, fixing them firmly at the picture plane and setting the other areas of the scene further back in perspective.

19 The artist uses a ruler and pencil to draw in the overhead wires *far left*.

20 Such a practice would be frowned upon by purist watercolorists, but the result is extremely effective *left*. The painting is not a traditional watercolor, but the artist has explored and exploited the full potential of the medium. The final painting *opposite* is an eloquent testimony to the flexibility of the medium and the inventiveness of the artist. Passages of pure, transparent wash are set against areas of descriptive and highly textured paint.

What the artist used

The artist used Bockingford H.P. water-color paper which he stretched on a drawing board with gummed paper tape. He used a set of artist's quality watercolors in half-pans, a small bottle of gum arabic which can be purchased from most art supply stores, and a 2B pencil for the initial drawing and for working fine details in the later stages. He used a mixed fiber No. 10 brush for laying washes, a No. 4 sable and a No. 1 sable for very fine work. He used a ruler for creating straight lines. He used detail paper and a craft knife to make the mask and a decorator's brush for the splattered effects.

ALIZARIN CRIMSON

BURNT SIENNA

SAP GREEN

PAYNES GRAY

COBALT BLUE

RAW UMBER

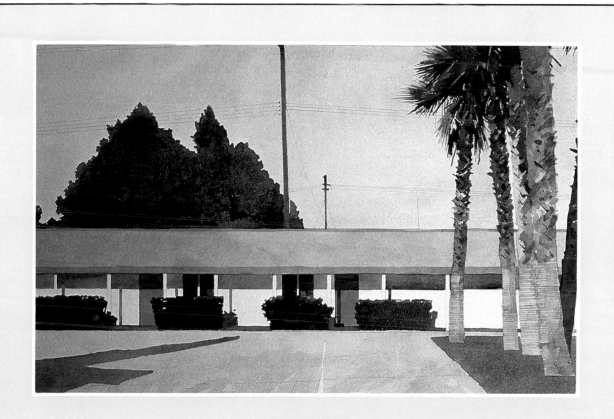

The Motel

Distant Hills

The artist has many ways in which he or she can create the illusion of space and depth in a painting. Linear perspective and the overlapping of objects are particularly important when you are portraying urban views or busy scenes with crowds of people. Aerial or atmospheric perspective is yet another trick which the artist can employ. Aerial perspective deals with the way in which tones and colors are reduced in value as the distance between the object and the viewer increases. Objects which are viewed from close up are painted in their full tonal and color values: surfaces facing the light source will be bright and light; those turned away from the light source will be dark. Objects farther away will show less of a contrast between their dark sides and their light sides. In aerial perspective, objects are seen to be modified by the atmosphere, so that as objects recede into space they take on a bluish tone, and those at the greatest distance appear to be pure blue. You will have noticed the way in which mountains on the horizon often appear blue and the way in which the shade of blue is affected by the light and by the amount of water in the atmosphere, so that just before it starts to rain they look bright blue.

In this exercise the painter has used many of these methods to help create an impression of space in his painting. The tree in the foreground is painted sharply and clearly with strong contrasts of light and dark. The trees at the greater distance have less clearly defined areas of light and dark and in the distance the hills are a cool blue.

Another thing to remember is the way in which warm and cool colors work. Cool colors tend to recede while warm colors tend to advance towards the surface of the picture plane. If there is a bright red object in the foreground of your painting it should be painted with a strongly saturated red such as cadmium red. If the red object is at a distance, the red should be toned down, otherwise it will advance and upset the balance of the painting, contradicting the feeling of space which you are trying to create.

Another way in which the artist has conveyed the feeling of depth is by making one of the trees break the frame of the picture, thus creating the illusion that it is at the very front of the picture, on the picture plane. By bringing the foreground images forward the artist makes the background objects recede by comparison.

The picture is constructed from a series of very simple color areas laid in as washes, yet the qualities of the pure, understated watercolor, the texture of the paper and the artist's knowledge of his materials combine to create a wonderfully atmospheric landscape painting.

1 The artist wanted to paint a watercolor which would illustrate aerial perspective. He chose this subject *right* because it had some strong shapes and a distant horizon.

2 The artist mixes a large quantity of cobalt blue watercolor paint in a small ceramic pot. Using a well-charged No. 10 squirrel brush, he lays a pale blue wash across the top of the previously stretched watercolor paper *above*. He works quickly so that the paint does not dry and form edges before he has completed this stage.

3 The artist uses the hollows in the lid of his paint box as a palette *above*. This picture also illustrates how much color you need to mix if you are going to lay a wash over a large area. Another point to notice is that all the paints in this box are shades of blue or green. The artist has another box in which he keeps reds, yellows and browns.

LAYING A FLAT WASH

The secret of laying an area of flat unmodulated colour is starting with damp paper. Mix a large quantity of the colour you want to use, otherwise you will have to stop and the paint will dry with a hard edge. Load a good quality brush with paint and lay a single strip of colour across the top of the paper. The board should be tilted slightly so that the colour from one stroke will run down and mingle with the colour from the next stroke. Continue to work backwards and forwards down the paper until the sheet is completely covered. Let the wash dry before you do more work on the painting.

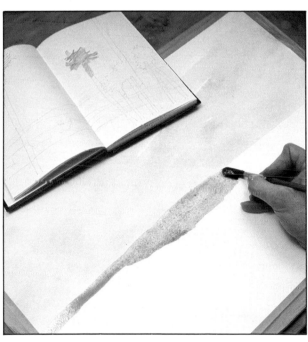

4 Using a darker blue mixed from cobalt and Paynes grey the artist lays in the most distant hills which lie against the horizon *above*. The artist lets the first wash dry.

5 The artist refers to his sketch. These hills *right* should be darker in tone than the sky, but not too dark as he wants to increase the tonal strength towards the foreground.

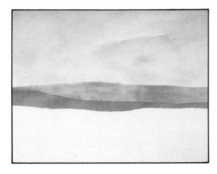

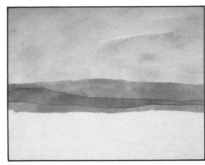

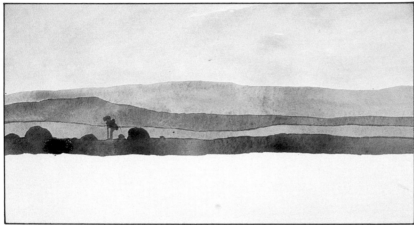

6 The artist leaves the painting to dry before applying another wash *far left*. You can assist the drying process by using artificial heat – an electric hair drier is excellent for this purpose. He then applies another wash of cobalt blue mixed with more Paynes grey.

7 The artist repeats the process *left* and lays in another dark blue wash.

8 Using a darker paint, the artist now blocks in the details of the middle distance *left*. If the illusion of space is to be created, this area should not be too clearly defined and the tonal contrasts within the area should be minimized.

What the artist used

The artist used a good-quality water-colour paper 36cm x 54cm/14in x 21.5in, with an H.P. surface. He used artist's quality paints, a B pencil for the drawing, a No. 10 squirrel brush and a No. 4 sable. He also used gum water and mixed his paint in a large ceramic palette, some small, round ceramic palettes and in the lid of his paintbox.

COBALT BLUE

PAYNES GREY

RAW UMBER

SAP GREEN

9 The artist now starts to work into the foreground area *above*. The details in this area should be rendered more definitely, with sharper outlines and using more saturated paint.

10 The artist works carefully with a No. 4 sable brush *above*. He moves the paint around the paper surface, rather than scrubbing it, pushing and pulling it to the shape he requires. Then he leaves it to dry.

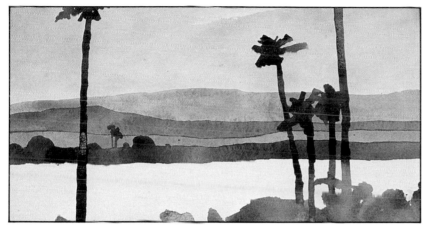

11 The picture is complete *left* except for a thin wash which the artist lays in to establish the middle distance. In the final picture *below* you can see how successfully a very convincing feeling of recession can be created, even in a relatively formless scene such as this where there are no obvious perpective lines and no overlapping objects. The way in which the trees break or almost break the picture frame at top and bottom is a useful device which brings those elements forward on to the picture plane, pushing the other features back into the distance by contrast

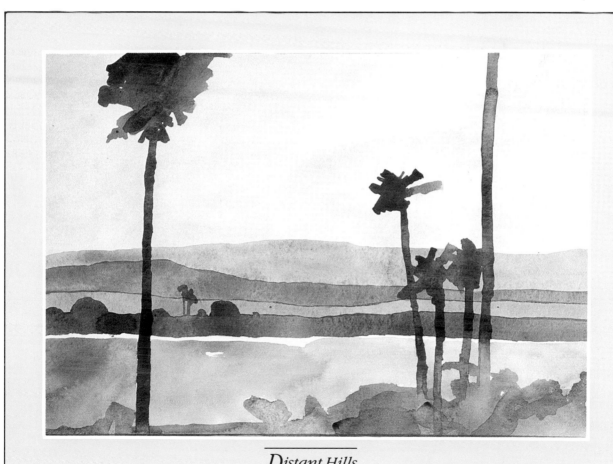

Distant Hills

View across Fields

This deceptively simple picture shows just how flexible watercolor can be when used in a controlled way by someone who really knows and likes the medium. Watercolor is very exciting to use, and excellent results can be achieved provided that you realize its limitations and use good materials. You must, for example, start with good-quality, absorbent paper which has been stretched. Poor or unstretched paper will crinkle and the result will be disappointing. In all the watercolors illustrated in this book the artists have used artist's quality paint. In watercolor it is worth spending money on the best pigments.

The artist started with a simple, but accurate, drawing. He then laid in a broad wash for the sky. Before he started he mixed up a large quantity of dilute paint so that he could apply the paint without interrupting the flow and thus ensure even coverage, without harsh lines or watermarks. If you want the edges of your color areas to be clearly defined you must allow the first wash to dry before you start laying in a second. If wet paint is laid over, or alongside, a painted area that is not yet dry, the colors will run into one another forming a softly merged junction between the two – an effect which you may sometimes desire. When the sky was dry he laid in an area of green for the foliage of the trees and hedge, using a small sable brush to draw the fine details of the silhouette of the foliage against the sky.

Look carefully at this area of the painting. The artist has managed to create a great variety of textures to suggest foliage. He has splattered water on to dry paint and lifted off the color to create areas of lighter color. He has mixed gum arabic with paint to create areas of denser, but still translucent, color which has a slight sheen. He has worked one layer of paint over another in order to build up denser areas of color. He has sprinkled water on to areas where gum arabic has been mixed with the paint, and as the paint dries, areas of lighter color emerge. The paintwork is both descriptive and decorative.

Watercolor requires great skill and confidence in order to create convincing and pleasing images and this skill and confidence cannot be gained from books. You must use the medium in order to get a 'feel' for it, so that you are able to anticipate what will happen in a certain set of circumstances. When you are happy with the medium you will also feel freer to incorporate the unplanned happenings which characterize the medium.

Watercolor is difficult to adjust for you cannot paint over and obliterate as you can with oil paint. Nevertheless, it is possible to make some changes even when the painting is dry. You can wet an area and use a brush, or blotting-paper to lift off color. You can even use a knife to scrape away an offending part of the painting but this should only be resorted to in extreme cases for it destroys the texture of the paper.

1 The artist developed this watercolor from a drawing *right*. It combines simple areas of color with a band of greater complexity.

2 The artist mixes a large quantity of cobalt blue paint with a little Paynes grey for a wash *above*. With a No.10 squirrel brush he lays in the sky, working quickly.

3 The artist prepares a solution of sap green and uses this to lay in the hedgerow in the distance, tickling the paint around the intricate details of the bushes and trees *right*.

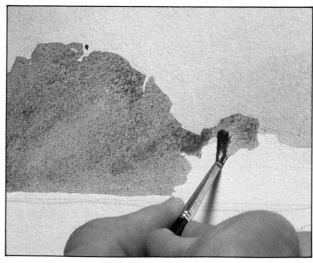

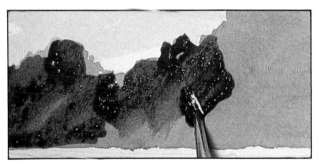

4 The artist leaves the painting to dry between each stage *above*. If you want colors to bleed, lay them side by side without letting them dry.

5 *Below* the artist has mixed some sap green paint with gum arabic and is working it over the hedgerow. This allows him to develop a range of tones in that area.

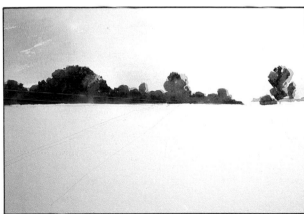

6 The effect of the gum arabic is to make the paint darker and slightly less translucent. The artist lets the color dry and will return to this part of the painting later *above*. If you

have not used gum arabic before you should consider doing so – it adds a new dimension to the paint and an opportunity to develop texture and tone.

USING GUM ARABIC

Gum arabic is the medium that binds the pigments in watercolor. A dilute form is also very useful. It adds richness and texture to watercolor and, because it acts as a kind of varnish, keeps the colors very bright. The artist started by painting the hedge with pure watercolor. He then mixed dilute gum arabic with the paint and you can see how much denser the color is. He added more texture to the foliage of the tree by sprinkling it with water, creating splattered areas of lighter color which suggest the pattern of light on leaves. He then blotted the wet area and more of the color lifted off.

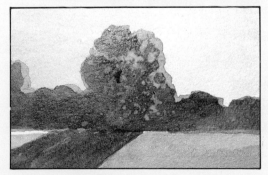

7 The artist mixes sap green with raw umber and with a dilute solution of this starts to lay in the foreground area *above*. Uneven color will suggest the texture of grass.

8 At this point the artist works back into the hedge with water *right*. He wets a brush and drops water on to the areas which he wants to lighten.

9 He then lifts the color by dabbing it with a piece of tissue *left*. The color lifts unevenly creating an area of varied tones which suggest the light and shadow on foliage.

10 *Above* the artist lays in sap green to represent the grassy field in the foreground. He leaves this to dry. Remember to keep the board flat until the paint is dry.

11 The lane which runs diagonally across the painting is laid in with raw umber *left*. The paint is used in a fairly concentrated solution and is laid on loosely.

12 *Above* the artist uses a small decorator's brush to stroke a mixture of gum arabic and water into the foreground area. This creates a very subtle streaky effect.

What the artist used

The artist used a large sheet of mold-made paper 12 × 16 inches. The paper had a fairly smooth surface described as 'Not'. The paper was stretched on a drawing board and fixed with strips of gummed paper tape. He used a set of artist's quality watercolors and several white ceramic palettes. He used four brushes, squirrel and sable Nos. 6, 7 and 10 and a small decorator's brush for creating splattered textures. He used a small bottle of diluted gum arabic and some tissue for creating texture.

LEMON YELLOW PAYNES GRAY

COBALT BLUE SAP GREEN RAW UMBER

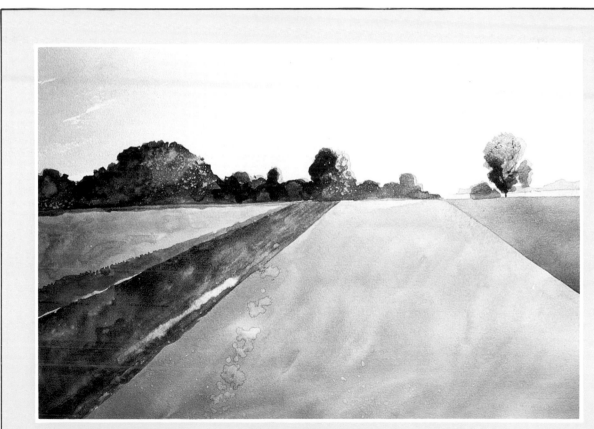

View across Fields

Old Harry and His Wife

WATERCOLOR WITH GOUACHE

This picture relies on two elements for its impact: the composition, with its strong simple shapes; and the quality of the paint surface. The artist has resisted the temptation to 'fill in' the spaces, and the large, relatively uncluttered areas of the sky and sea are left to stand for themselves, allowing the eye to rest or wander slowly over the picture enjoying the paint surface. In fact, no part of a canvas is ever really empty for the 'empty spaces' are covered in paint, and even if the support is exposed it should be regarded as an area of color, rather than as a gap or a space. Here the relatively empty areas are counterpointed and enhanced by the rocky cliffs and outcrops. In these areas the artist has used a variety of techniques to achieve a subtly variegated surface.

The way you approach a painting may depend on your intentions towards the subject, whether, for example, you want to make the scene look attractive or desolate. Your approach may also depend on your mood at the time of painting, or the light and other environmental conditions affecting the subject when you first observe it. You can generate a feeling of excitement in a painting in many different ways. Certain colors make us feel happy, others are exciting, others create a feeling of serenity. These aspects of color are exploited by advertisers, interior designers and marketing people who want to control our moods. Here the artist has used a light color scale and clear, coolish colors to create a feeling of calm and distance. He has used a very limited palette – cobalt blue, Paynes gray, lemon yellow, sap green, ivory black and raw umber.

The artist has established the main areas of the painting by laying washes of color, modulated to reflect the subtle, opalescent variations of sky and sea. But he has used a variety of techniques to create the rocks known as 'Old Harry and His Wife'. Masking fluid was used to cover the brightly lit area so that he could create the shadow areas using layers of gray washes. He used a fine brush to work in the details, and sprayed on paint with a decorator's small brush. He worked into areas using a mixture of gum water and paint, and when this was dry, he worked back into it with water creating areas of lighter color. Finally, he used white gouache to create the opaque white areas of broken water.

2 The artist starts by making a simple line drawing *above* – he does not require much detail because he will develop the subject as the painting progresses. He just needs a few guidelines.

3 With a small paint brush and masking fluid the artist blocks out the sunlit tops of the rocks *left*. In this area he will use his lightest tones.

4 With a dilute solution of cobalt blue the artist lays in a loose wash for the sky *below*, leaving some white showing.

1 This scene *right* presented the artist with an opportunity to explore the textural possibilities of watercolor.

5 The painting is allowed to dry at this stage *above*. This is important particularly after laying in a fluid wash. The board should be laid flat to avoid the color running.

6 With a dilute solution of Paynes gray the artist washes in the sea area, again moving the fluid paint loosely in order to create varying tones *right*.

7 The artist now works lemon yellow into the area where the chalk stack is reflected in the water. The flared effect is achieved by running water into the Paynes gray *above*.

8 With a mixture of ultramarine and Paynes gray the sea is darkened *right*. Watercolor is very direct and the artist should be prepared to incorporate 'accidents'.

9 With a very fine brush and the same mixture of colors the artist paints details into the reflection *left*. Always plan your work as watercolor is difficult to correct.

10 The basic areas of the painting have been established *above*. The artist has worked from light to dark and has used the areas of color as negative spaces to draw the rocks.

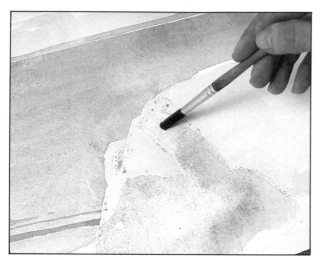

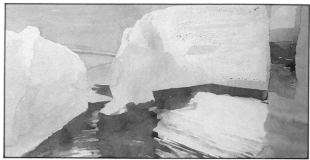

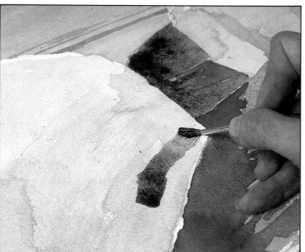

11 Using a mixture of black and yellow ochre the artist washes in the shadow areas on the rock. The areas of lighter tone are protected by the masking fluid *left*.

12 Now that the darker tones are beginning to be added the rocks start to emerge from the background *above*. They are no longer flat shapes but bulky objects occupying space.

13 With thinly diluted black paint the artist indicates the very darkest areas of the painting – the deep shadows between the rocks, *left*.

14 *Below* we see just how important tonal changes are in establishing form and bulk within a painting. The tonal changes must be accurately and subtly handled.

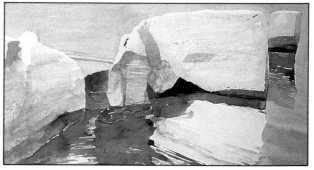

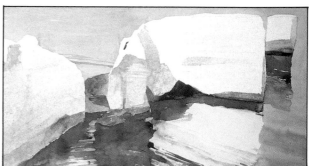

15 Having established most of the darker tones the artist now removes the masking fluid *left*. He does this by rubbing it gently with his finger. A soft putty rubber can also be used.

16 With the masking fluid removed *above* the highlight areas are revealed and the rock stacks begin to emerge as convincing forms. The artist now establishes the halftones.

17 The artist wants to evoke the texture of the chalky rock. The artist mixes a solution of Paynes gray and splatters it on to the paper *above*.

18 With sap green and a fine brush the artist paints the grass which caps the rock *below*. This establishes the top surface of the rock and adds a new important area of local color.

DRY BRUSH WORK

The artist used dry brush techniques to create a range of dry, scratched marks. It is important to use only a minimum of paint so he squeezed excess paint from the brush. In some places he used a broad brush, spreading the bristles below the ferrule so that they separated into a series of fine points in order to lay the paint down in a series of fine lines. A smaller brush was used to draw in fine details.

19 The artist continues to work into the stacks *below*. Watercolor changes as it dries. As you become familiar with the medium you will be able to anticipate what will happen, but there is always an element of surprise with watercolor.

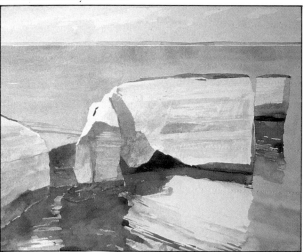

20 In the detail *far left* we see the artist using yet another technique to create texture. He gently brushes water on to an area of the painting which he had painted with dilute gum arabic. An area of paler color will emerge when it has been left for a while.

21 The artist wants to work more texture into the shaded area of the rocks. To protect the rest of the painting and to allow him to work freely the artist masks off the rest of the painting with four sheets of paper *left*.

22 The artist mixes a solution of Paynes gray with a little raw umber and uses a small decorator's brush to splatter color on to the picture *far left*. He does this by flicking the bristles briskly.

23 The artist removes the masking papers to reveal the worked area *left*. You can be free in your method of working while being very specific about the area you want to treat. You can work into quite small areas in this way. Wait until the paint is dry before you remove the mask.

24 In the detail *far left* the variety of tones, the overlapping washes, the watermarks, the marbled effects and the way colors meet and mingle are effects that can be created with watercolor. The artist has picked out the strata within the chalk rock by drawing on the dry paint with a pencil.

25 So far the artist has used pure transparent watercolor. On the *left* he adds a final detail with white gouache, scumbling on the opaque white paint to create the broken foaming water around the base of the rock.

What the artist used

The artist used a large sheet of watercolor paper 21 x 30 inches. This was stretched on a drawing-board and fixed with gummed paper tape. He used a set of artist's quality watercolors and a tube of designer's white gouache. For the drawing he used a B pencil. For the painting he used three brushes – a squirrel No. 10 and a sable No. 4, and a decorator's small brush for spraying on paint. He also used gum arabic, a ruler, and masking fluid. He had a set of small ceramic pots for mixing his colors and washes.

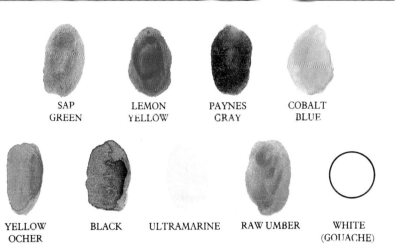

SAP GREEN LEMON YELLOW PAYNES GRAY COBALT BLUE

YELLOW OCHER BLACK ULTRAMARINE RAW UMBER WHITE (GOUACHE)

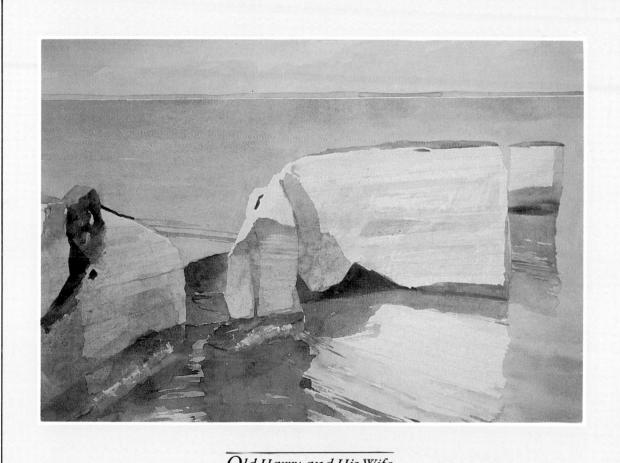

Old Harry and His Wife

Sky at Sunset

GOUACHE

The sky at sunset is an obvious subject for the landscape painter, but is fraught with problems. The brilliant light effects do not last long so you must be in the right place at the right time.

In this case the artist made a quick sketch on the spot and used this and a photograph as a basis for his painting. He started working on the painting as soon as he returned home while the vivid colors and the excitement of the experience were still with him. He laid in the broad outlines that evening, worked on the painting the next day and completed the details the following day.

He worked very quickly, using only four colors. He chose gouache because he felt that the density of the color was more appropriate to the flamboyance of the subject than the more restrained transparency of pure watercolor. The painting consists of three bands of color: a wash of ultramarine establishes the sky; cadmium red and cadmium yellow describe the sea, and the land in the foreground is laid in with black. The two outstanding elements of the composition are the rather strange cloud formations and the winter trees seen in silhouette against the sky. Notice how carefully the artist has planned and executed the painting, even though it was painted at great speed. He studied the cloud formation carefully, and decided that in order to convey the impression of rosy red light shining from behind the cloud he would have to lay that in first. He painted a light yellow halo, and allowed this to dry before using a mixture of ultramarine mixed with a little orange to paint the cloud. He let the color dry so that the colors would not run together in an uncontrolled way. Where he did want the colors to bleed he laid some water on to the paint surface. He also introduced water into the dark clouds – this caused the paint to dry unevenly creating irregularities in the density of the color. When the area was partially dry he dabbed at it with a tissue to lighten certain areas and thus vary the tones.

The final effect suggests the splendor of the setting sun with great realism. It relies on the artist's knowledge of the medium, the way it will react in certain instances, when to work wet into wet, when to let the paint dry, and what will happen when water is added to already dry paint. At the same time he has let the paint work for him, incorporating any chance effects.

1 The artist used this photograph *right* and a sketch made at the time as the basis for the gouache painting. It was an exciting and challenging subject.

2 The artist makes a simple pencil drawing *above*, in which he indicates the broad outlines of the subject. With masking fluid he picks out the fine details of the trees.

3 With a mixture of cadmium yellow and cadmium red the artist lays in a fluid wash to describe the sea which has been turned orange by the setting sun.

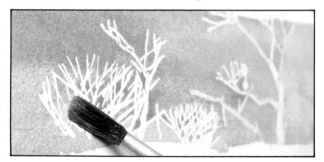

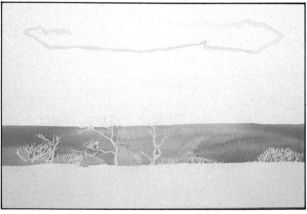

4 The artist adds a little ultramarine to the wash to tone it down slightly, keeping the wash wet to avoid lines and watermarks. He uses the same mixture to trace the aureole of light which surrounds the dark cloud *above*. This will be developed when he paints the cloud and sky.

5 The artist has squeezed small amounts of cadmium red, cadmium yellow and ultramarine around the edge of a white plate he is using as a palette *above*.

6 The artist paints the dark cloud using a No. 4 brush well charged with paint *below*. He does not scrub the paint but moves it over the picture surface.

7 He introduces more yellow around the perimeter of the cloud and allows the blue and yellow to mingle creating a flared effect *above*. When the paint is partially dry the artist dabs it with tissue. This area combines the controlled use of paint and fortuitous happenings.

USING MASKING FLUID

Here the artist has used masking fluid to paint out the complicated tracery of the trees. Masking fluid, which can be purchased from any artist's supply stores, is applied with a brush. It dries very quickly and you can then work freely into the surrounding areas. Remove the masking fluid by rubbing with your finger or a soft putty eraser.

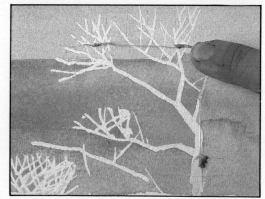

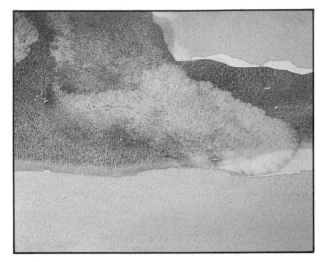

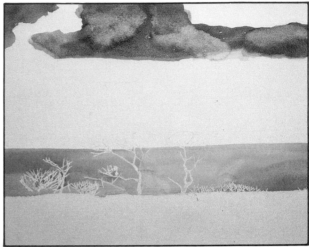

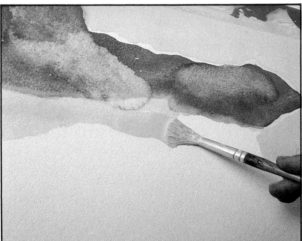

8 The paper contributes to the painting *above left*, affecting the way the paint is received and adding texture. In one place blue had bled into yellow creating one type of surface, in another where the paint has been blotted there is a grainy texture.

9 The artist has developed two distinct areas of the painting *above*. In this way he has been able to let one area dry completely while continuing to work on another area.

10 The artist now turns his attention to the rest of the sky *center left*. He lays it in with a mixture of white and ultramarine, an opaque covering mixture which highlights the difference between pure watercolor and gouache. In a pure watercolor white would never be used.

11 The painting is left to dry at this stage *left* and as it dries the sky develops an uneven streaky appearance. When it is dry the artist removes the masking fluid by rubbing it with his finger. The trees emerge as white areas despite having been painted with orange and blue.

What the artist used

The artist used a sheet of stretched H.P. watercolor paper 21 x 30 inches, designer's gouache, squirrel and sable Nos. 10 and 4 brushes, a No. 1 sable for the detail. He used a small bottle of masking fluid.

CADMIUM RED

ULTRAMARINE

CADMIUM YELLOW

IVORY BLACK

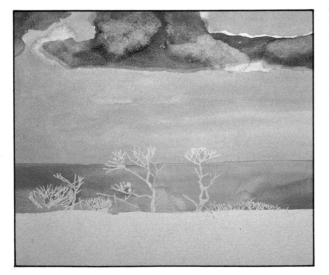

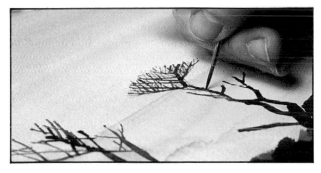

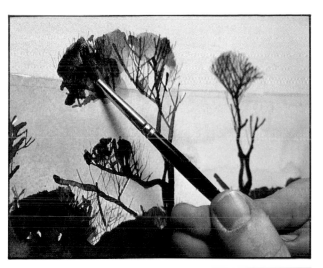

12 Using black paint the artist paints in the skeleton of the trees *above*. The previously painted area and the white paper accept the paint in different ways.

13 Thinned black paint is used to scumble in the tops of the trees where the smallest twigs blur the silhouette *right*. The foreground area is washed in with the same solution.

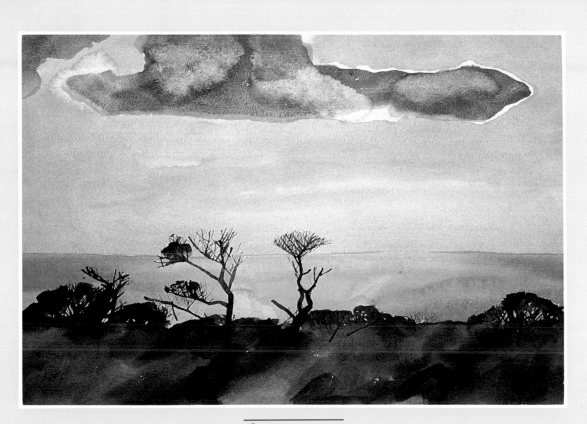

Sky at Sunset

CHAPTER NINE

*P*astel

Pastel is a medium which hovers between painting and drawing. The pigment is bound with gum arabic or, occasionally, with tragacanth and then molded into sticks, but so lightly that it crumbles on to the surface with a minimum of pressure. Pastels have an immediacy which makes people feel that they are somehow dashed off in a very short time. This is, as you will soon discover, far from true. A letter from the artist, Maurice Quentin de la Tour (1704-88) to the Marquis de Marigny, the brother of Madame de Pompadour, is reassuring, for it lists the same difficulties as anyone working with the medium today will experience. 'Pastels, my Lord Marquis, involve a number of further obstacles, such as dust, the weakness of some pigments, the fact that the tone is never correct, that one must blend one's colors on the paper and apply a number of strokes with different crayons instead of one, that there is a risk of spoiling the work done and that tone has no expedient if the spirit is lost' Nevertheless, pastel offers the most direct method of getting pure pigment on to the surface. Pastels as we know them came into use little more than two hundred years ago but the real pioneer of the medium was a Venetian, Rosalba Carriera (1675-1758), one of the few female artists to achieve fame in the seventeenth century. Pastel painting became a craze and by 1780 there were 2,500 pastelists working in Paris. The freshness and spontaneity of pastels appealed to the Impressionists and Degas, who was their principal exponent, developed the technique far beyond the traditional formulae of the eighteenth-century masters. The charm and freshness of pastels, their purity of color and their immediate response when applied to the support, make this subtle and often neglected medium a delight to use.

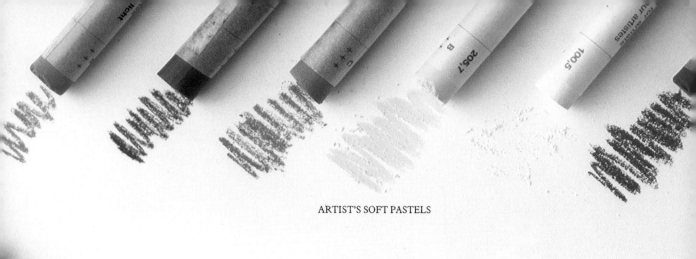

INGRES PAPER

PUTTY ERASER

Materials

Supports

The effectiveness of pastel depends to a considerable extent on the color and texture of its support. Paper must have sufficient 'tooth' to rasp off the pastel as it is drawn across the surface and to hold the pastel powder. Color is important because some of the background may be left showing through as highlights or, in the case of darker papers, to provide dramatic contrasts or shadows. Papers suitable for pastel work include white or tinted fibrous paper with a properly pigment-receptive grain, such as good-quality watercolor or drawing paper. A type of soft, fine sandpaper-surfaced paper is specially made for pastel, and a very soft, velvety flock paper is also available. Prepared canvas or thin cheesecloth glued to card or wallboard can also be used. Ingres paper is the most reliable colored paper for pastel work. To avoid the risk of a tinted paper fading, some artists prefer to tint their own supports. One method is to rub the paper with a damp rag that has been dipped in the powdered ends of pastel sticks. Pastel paper is available in a wider range of colors. The paper should be of good quality, sized and fairly thick.

ARTIST'S SOFT PASTELS

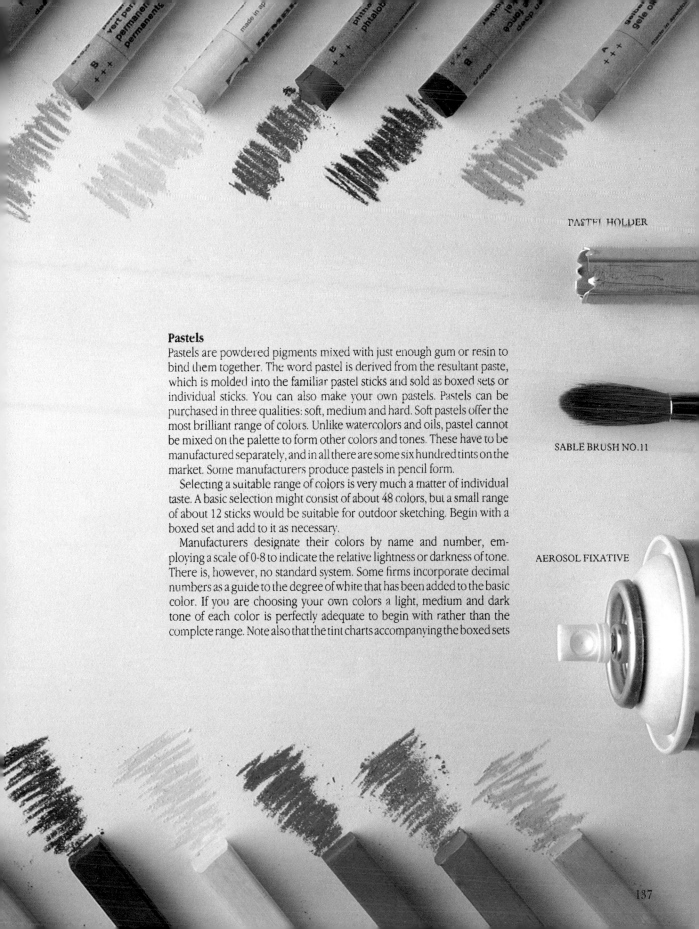

Pastels

Pastels are powdered pigments mixed with just enough gum or resin to bind them together. The word pastel is derived from the resultant paste, which is molded into the familiar pastel sticks and sold as boxed sets or individual sticks. You can also make your own pastels. Pastels can be purchased in three qualities: soft, medium and hard. Soft pastels offer the most brilliant range of colors. Unlike watercolors and oils, pastel cannot be mixed on the palette to form other colors and tones. These have to be manufactured separately, and in all there are some six hundred tints on the market. Some manufacturers produce pastels in pencil form.

Selecting a suitable range of colors is very much a matter of individual taste. A basic selection might consist of about 48 colors, but a small range of about 12 sticks would be suitable for outdoor sketching. Begin with a boxed set and add to it as necessary.

Manufacturers designate their colors by name and number, employing a scale of 0-8 to indicate the relative lightness or darkness of tone. There is, however, no standard system. Some firms incorporate decimal numbers as a guide to the degree of white that has been added to the basic color. If you are choosing your own colors a light, medium and dark tone of each color is perfectly adequate to begin with rather than the complete range. Note also that the tint charts accompanying the boxed sets

PASTEL HOLDER

SABLE BRUSH NO.11

AEROSOL FIXATIVE

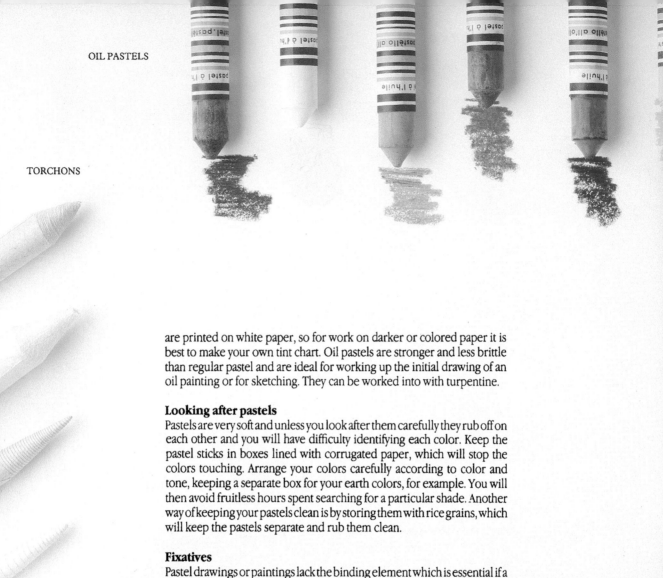

TORCHONS

are printed on white paper, so for work on darker or colored paper it is best to make your own tint chart. Oil pastels are stronger and less brittle than regular pastel and are ideal for working up the initial drawing of an oil painting or for sketching. They can be worked into with turpentine.

Looking after pastels

Pastels are very soft and unless you look after them carefully they rub off on each other and you will have difficulty identifying each color. Keep the pastel sticks in boxes lined with corrugated paper, which will stop the colors touching. Arrange your colors carefully according to color and tone, keeping a separate box for your earth colors, for example. You will then avoid fruitless hours spent searching for a particular shade. Another way of keeping your pastels clean is by storing them with rice grains, which will keep the pastels separate and rub them clean.

Fixatives

Pastel drawings or paintings lack the binding element which is essential if a picture is to be durable. Fixatives act as a binder, fulfilling the function of oils, gums and glues in other media. The binder is sprayed on to the paper after the drawing is finished and fixes the particles of color to the ground. Almost any adhesive material can be used as a fixative, the choice depends

OIL PASTELS

TURPENTINE

on the nature of the ground and medium being used. Fixatives can be purchased readymade in aerosol cans or, more cheaply, in bottles, in which case they are applied using an atomizer or mouth spray. Some artists use hair spray as a cheap alternative. Pastels can be fixed from the back or from the front, depending on the nature of the work and the amount of pigment on the surface. The picture can also be fixed after each layer – Degas did this in order to build up a thick impasto.

Other equipment

You will need a drawing-board. A glass slab on which to mix pastel powders would also be useful. A palette-knife may be necessary if you are going to mix pastel colors or use turpentine to work into oil pastel. A torchon, a pencil-shaped stump made of tightly rolled paper is useful for blending colors together. Chamois stumps are wooden sticks tipped with chamois and these too can be used for blending colors. Pastel is a messy medium – a holder will keep the pastel, your fingers and the work clean. It can be bought from an art store or you can make your own from a piece of card secured with tape. Sandpaper or glass-paper can be used to sharpen pastels for detailed work. A soft, kneadable putty eraser will be useful for erasing lightly worked areas and for lifting color to create areas of highlight.

Stonehenge

SOFT PASTEL

The subject of the painting on these pages is a megalith – a huge stone monument built in prehistoric times. The original function of these structures is lost in the mists of time, but they have acquired accretions of symbolic, religious and magical significance.

The artist was attracted by the sculptural quality of the subject, the starkness of the stones against the clear blue sky and the brilliant, unnatural yellow of the field of rape seed, a startling new color in a very traditional English landscape. He used a colored ground. Pastel contains a certain amount of white chalk and thus works better on a colored ground.

The monument is set within a landscape. The artist has conceived the composition as a series of horizontal bands interrupted only by the granite stones which link the two zones – the sky and the earth. The horizon line is set almost midway in the picture area, drawing attention to the dominant features of the painting. The picture relies on its bold layered structure for its impact.

The composition and the colors combine to convey a sense of stability and calm. Horizontal lines tend to suggest tranquillity, just as broken staccato lines suggest animation, and cool colors reinforce this feeling. Even in a very naturalistic landscape such as this, you should look for the abstract elements that underlie the composition. Think about the way the elements are disposed over the picture surface, about balance and imbalance, about color and texture, and the way line is used.

The artist started by making a careful drawing, he established the sky, laying in the color thickly and flatly, to create an opaque area of blue. The way he has worked into the blue of the sky with white to depict the small, fluffy clouds shows just how good the covering power of pastel is. The clarity of the image is heightened by the way in which the artist has emphasized the silhouette of the stones, by working around them with the blue pastel.

The areas of light and shadow on the stones are treated as discrete patches of color, emphasizing the hewn, faceted quality of the rock. In the foreground the green pastel has been laid on with loosely directional strokes which simply, but effectively, describe the grassy area, while the gray of the paper provides the mid-tone.

2 Using a very soft 4B pencil, the artist draws the main features on the soft gray Ingres paper *above*. He draws quickly to finish the painting before the light changes.

3 The artist lays in the sky with pale blue pastel *left*. He uses the color thickly. He breaks off a small piece of the pastel stick and uses the side of it to lay on the color.

4 The sky is now established *below*. It was laid in quite rapidly but it was hard work covering such a large area. The standing stones are revealed as negative images against the blue of the sky.

1 The artist made this pastel painting on the spot *right*. Pastel is easily transported and the equipment necessary is limited to the pastel sticks, a support and fixative.

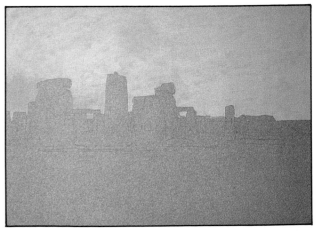

BLENDING PASTEL

Pastel can be used as a drawing medium, as a painting medium or as a combination of both. In some areas, the artist has blended the colors – in others he has retained their linear quality. In the detail below we see how the artist has laid an area of white pastel in the sky, and blended the colors with his finger to suggest the soft fluffiness of clouds. In the other detail, he has added white as a highlight on the stone. In this case, however, he does not want to blend the colors, but neither does he want the white to stand out too much, so he has knocked it back slightly, by flicking it with a cloth.

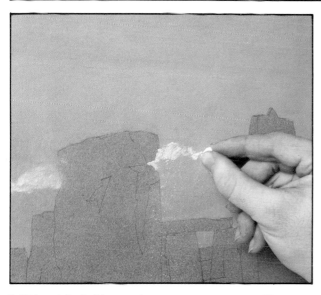

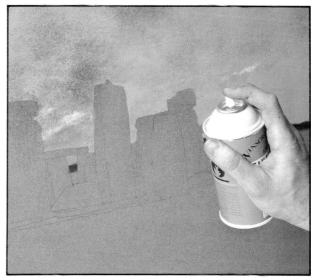

5 With a stick of white pastel the artist scribbles in the small clouds just above the horizon *above*. Pastel consists of almost pure pigment and has excellent covering power, and the artist is able to cover the blue of the sky with the white pastel. When sufficient color has been laid on, he blends the powdery pigments with his finger. He blends some areas more thoroughly than others to soften the outline and create a convincing cloud effect.

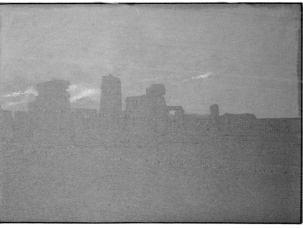

6 The artist fixes the pastel pigment to the support with an aerosol spray *above*. He holds the can about 18 inches from the support and applies a fine spray, moving the can from left to right with a broad sweeping motion. Pastels can also be fixed by spraying from the back. The blue pastel has become darker but will dry to its original color.

7 The fixative has now dried *left* and the artist begins work on other areas without fear of shifting the color.

8 Pastel is both a drawing and a painting medium. It is possible to apply color in thin films or to build up thick impastos. At the same time it is also possible to create a range of linear marks and to build up colors and shapes in much the same way as with drawing media. The artist hatches in bright green to represent the grass *left*. The gray of the paper represents the mid-tones.

9 The artist streaks gray pastel into the grass to create the darker tones and to give form to the blades of grass *right*. The grass is made up of three colors – green pastel, gray pastel and the gray of the support.

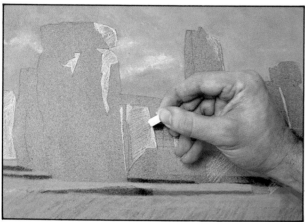

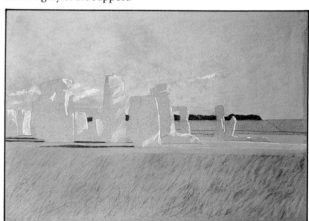

10 With black Conté crayon the artist lays in the shadows by the standing stones and the bank of bushes in the distance *above*. The Conté crayon is harder to apply than the pastel so he has to exert a little pressure. With white pastel he establishes the lighter tones of the standing stones. Again the gray paper represents the mid-tones and is also effectively the local color, for it is the color of the stones themselves. He lays in the color with fine hatched strokes which he will blend later. He varies the amount of white he lays on, studying the subject to assess just how the light is falling.

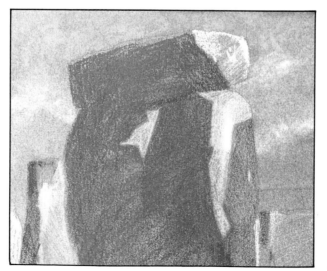

11 The painting builds up *above*. The artist has added cadmium yellow in the area of grass to the right of the group of stones. He applies the color with a combination of hatching and rubbing.

12 The deep shadows on the standing stones are created with a petrol blue pastel, which is hatched and rubbed *left*. Further tones and textures are developed on the light sides of the stones using the black Conté, gray pastel and a 4B pencil. The artist completes the painting by applying cadmium yellow to the field in the distance.

What the artist used

The artist used a sheet of soft pearly gray Ingres paper 16 × 20 inches. The painting is large and this gave him problems when it came to laying down the flat blue tones for the sky – it was a slow and tedious task. He used a selection of soft artist's quality pastel sticks and a 4B pencil which was used for the initial drawing and for putting detail into the standing stones. He sprayed the painting with an aerosol fixative.

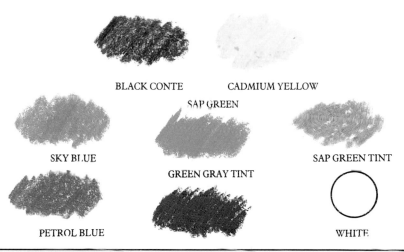

BLACK CONTE CADMIUM YELLOW

SAP GREEN

SKY BLUE

GREEN GRAY TINT

SAP GREEN TINT

PETROL BLUE

WHITE

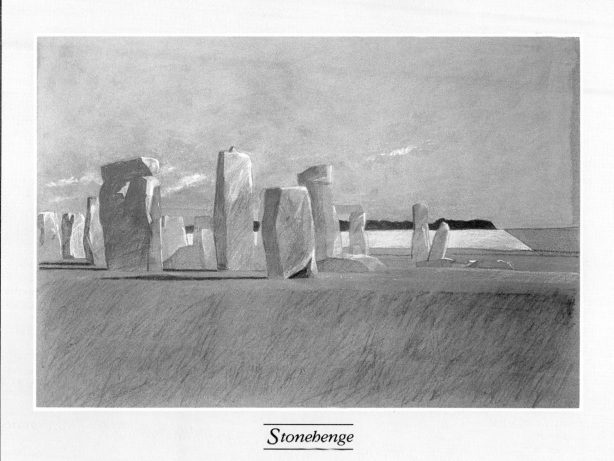

Stonehenge

Poppies in Haute-Provence

SOFT PASTEL

In this charming pastel painting, the artist's obvious delight in the special qualities of pastel is evident. With the confidence born of an extensive knowledge of and familiarity with the medium, she has built up the painting using minute dabs and dashes of pure color. The artist dispensed with an initial drawing, preferring to concentrate on the color components of the scene, working with great concentration and putting down exactly what she saw, so that the image emerges from the finished work, shimmering with light and warmth. The landscape has been described accurately, but the artist has relied on her intuitive feeling for the placing of one color next to another, rather than on any formal geometric or linear scheme. The approach is deceptively simple, but it requires great concentration, a feel for the medium and the subject, a sound knowledge of drawing and the theory of color and perspective.

Despite the almost abstract quality of the composition the artist has managed to establish quite clear areas within the painting and has conveyed a feeling of light, space and recession. Color can be very important in conveying a feeling of recession and space in a painting and can be used to create optical illusions. When warm and cool colors are situated in the same plane, and at the same distance from the eye, the warm colors will advance and the cool colors will recede. Thus, if warm and cool colors are used in a painting, as here, the eye is persuaded that it is moving backward and forward in space as it moves across and through the painting. So the red poppies in the foreground advance and dominate that area of the painting. In the background, pale, hazy pinks and blues dominate, and in that area of the painting the distinctions between one element and another are blurred. The artist has blended the colors and has used smaller strokes of color. This is aerial perspective rather than linear perspective.

The sky has been blocked using the side of the pastel, the texture of the paper creating the grainy, broken effect, which reflects the sparkle of natural light. Small energetic strokes of color are used to create the structure of the foliage in the foreground area. All these marks are later modified by blending them using fingers and a torchon. The painting demonstrates the more painterly, less linear aspects of pastel.

PASTEL MARKS

Pastel is a very flexible medium and the sticks of color can be handled in many ways. In the details below we show a range of marks made with pastel sticks. In the first the artist used varied pressure to achieve a variegated line. In the second he flicked on the color, with light pressure, creating a crisper line. By working across this in the other direction he created a hatched effect. To achieve light but even coverage he used the blunt end of the pastel and firm, even pressure. By laying on color with the side of the pastel he created areas of broad grainy color.

1 The artist started by making a simple exploratory drawing of the subject, analyzing the different areas of the composition and making notes about the color she would use *right*. The painting was executed on the spot.

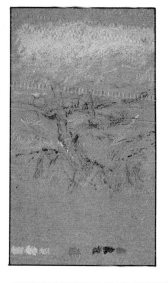

2 The artist has chosen a tinted paper so that traces of the paper will show through the finished painting as a middle tone. She blocks in the sky with grainy masses of cobalt and cerulean blue and a warm mauve *left*

3 Strokes of yellow, light green and dark green are used to create the structure of the foliage and touches of blue and mauve link this area with the sky *right* The artist completes the picture by adding rose and salmon pink to stand for the poppies in the field *below right*.

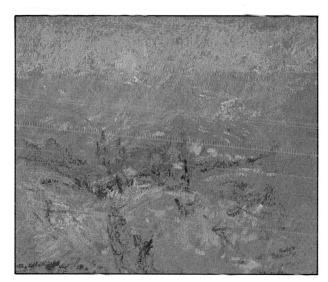

What the artist used

The artist used a good-quality, gray tinted pastel paper, 6 x 4 inches, a selection of soft pastels, and a fixative.

COBALT BLUE

CERULEAN

LIGHT PINK

LIGHT MAUVE

LIGHT OLIVE GREEN

BLUE-GRAY

DARK OLIVE GREEN

RAW SIENNA

RED

YELLOW

BROWN

DEEP ROSE PINK

SALMON PINK

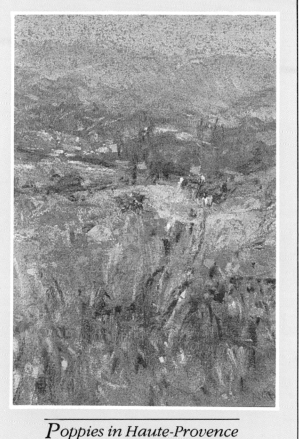

Poppies in Haute-Provence

Olive Grove in Crete

SOFT PASTEL

This quick sketch of an olive grove in Crete was executed on the spot. The artist made a sketch with a view to working it up into a painting at a later date. Pastel is ideal for this purpose for it can be used as both a drawing and a painting medium, is easily transported and the materials are simple and easy to carry. Here the artist has used a sheet from a pad of Ingres paper. These pads are sold with a range of colored paper, allowing the artist to select an appropriate color while in the field in front of the subject. Here he has chosen a dark-blue paper which corresponded to the dark shadows among the trees.

There are many hundreds of colors available, often only barely distinguishable from one another, and the problem of making a selection can sometimes be daunting, especially for someone unfamiliar with the medium. You will find that there are ten different whites to choose from, for example. You can buy boxes of pastels which have been selected for certain purposes, figure work or landscape sketching.

Pastels can be used in many ways. Here the artist was interested in getting down an impression of the scene, the play of light and a brief description of the colors as quickly as possible. He worked with great speed and energy, using scribbled, energetic marks which describe and follow form. The dark blue of the support shows through the scribbled color, acting as a middle tone, representing areas of shadow and giving an underlying coherence to the drawing. In places the pastel has been used on its side to allow speedy coverage of the surface. In other areas, where the artist has required a sharper line, he has broken the pastel in two so that he has a sharp corner to work with. He has modified the colors of the pastel by working one loosely over another, but he has not overworked the colors or blended them, because he wanted to retain the directness of the application.

1 This is one of a series of photographs which the artist took on a visit to the island of Crete *right*.

TEXTURE IN PASTEL

In the details below we show how the artist can exploit the linear quality of pastel to create areas of exciting color using a divisionist technique. He started by laying on the pigment thinly, allowing the color of the support to show through. Over this he laid short open strokes of blue. The colors in this example are all modified by the colors which surround them and by the warm, pink tones of the support which shows through as a uniting element.

2 The artist chose a dark blue paper against which he works the lighter tones of the subject *left*. He starts by laying in tones in white, Naples yellow and raw umber.

3 The artist works light blue and black Conté into the tree stump in those areas which are turned away from the light *below*. With Naples yellow and white he lays in the earth.

4 The pastel is loosely applied *above*. The artist uses hatched lines to build up the colors, tones and forms. He is recording his impressions rather than producing a 'finished' pastel.

5 The artist uses yellows, greens and a variety of marks, dashes, dots and hatching to describe the foliage of the trees in the distance *above*. With a Naples yellow he warms up the foreground.

6 Brown pastel and black Conté are used to indicate the trunks and branches of the trees in the distance *above*. The artist warms up the tree stump with ochers and then returns to the foliage, adding

more color and blending the colors here and there, and smudging the pastel to a hazy film in others. In the final sketch *below* we can see how simply yet evocatively the scene has been captured.

What the artist used

The artist used a sheet of blue Ingres paper 12 x 16 inches. His pastels were taken from a set sold especially for landscape, though he added to this collection. He used an aerosol spray to fix the pigment to the support.

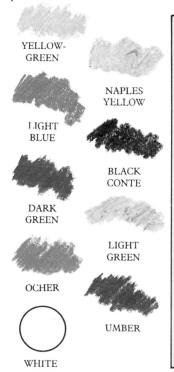

YELLOW-GREEN

NAPLES YELLOW

LIGHT BLUE

BLACK CONTE

DARK GREEN

LIGHT GREEN

OCHER

UMBER

WHITE

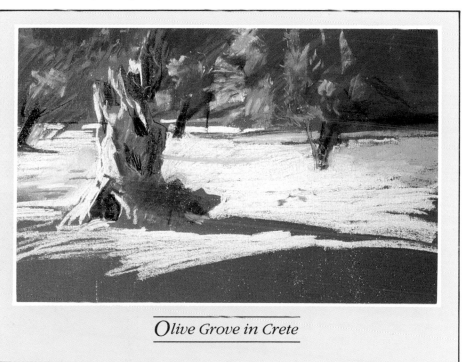

Olive Grove in Crete

Scenes by a Canal

SOFT PASTEL

Pastels are a very convenient medium for sketching outdoors. They are light and because it is a dry medium you do not need to carry water or any other liquid diluent with you. Pastel is applied direct – rather like dry paint. It is vigorous and exciting, the powdery surface increasing the refraction of light so that it has an intensity of color which is unmatched by any other medium. Because it has virtually no binder it is the nearest thing to pure pigment you can use. This is particularly useful when you are making sketches in the field with a view to working them up in the studio, the very intensity of the color will act as an excellent jog to the memory, intensifying what you see.

In this series of sketches made by a canal, the artist has used brilliant patches of color laid on with a vigour which reflects both the responsiveness of the medium and his response to the subject.

The artist stores his pastels in a shallow box which he has lined with corrugated paper. In order to avoid confusion he always returns the pastel to its correct position after use. Other people use several boxes, one for greens, one for reds and so on.

The artist worked sitting on a folding stool with his paper attached to a board. You can also work directly on a pad which should provide a firm enough support. Some artists prefer to work at an easel so that they can walk about and step back to view their work from a distance.

A colorless fixative is essential when working in pastel. You will need to fix the painting before you take it home, but you will also need to fix it if you want to build up a thick impasto. This will allow you to work over the initial pastel color without disturbing it, and enable you to build up thick layers of pigment.

Pastel can be manipulated to produce thick and thin lines and textures. For instance, the sharp edge of a broken pastel, drawn lightly across the paper, will produce a fine line. By laying the side of the pastel flat on the paper, a flat even area of color can be laid down. Heavy pressure forces a lot of pastel into the grain of the paper, light pressure reveals more paper through the color. Pastel laid on flock paper gives a velvety patch of color: on fine canvas it produces flat color. On glasspaper and on Ingres paper much of the texture shows through the pastel. Delicate contrasts can be achieved by covering a torchon or stiff brush with powdered pastel and applying it lightly across the picture. Fine hatching, cross-hatching or alternating strokes of different colors and tones produce effective shading. Wide regular strokes can be used for more open work.

In this series of studies made by the canal side the artist has looked at the same subject from a number of different viewpoints. This is an excellent exercise, forcing you to look very carefully at the subject. You will find that after a few hours sketching in this way you have a much better grasp of the subject, some useful reference material and possibly the beginnings of a painting.

FIXING PASTEL

Pastel is a fairly delicate medium because the powdery pigment sits on the surface of the support and can easily be smudged. The easiest way to fix pastels is with an aerosol fixative which can be sprayed over the picture. If you want to build up a thick impasto you should fix each layer before applying the next. Fixative does dull the pigment slightly – you can reduce this effect by applying the fixative from the back of the support. It will permeate the paper and fix the pigment without affecting the color.

1 The artist first made a felt tip sketch on which he recorded notes about color *right* and then made the pastel sketch.

2 The artist starts by drawing the main outlines of the subject in charcoal. He then blocks in color, working quickly, *left*. He lays on the pigment rapidly by using the side of a small piece of pastel.

3 The detail *above* shows how thinly the color is laid on, so that the texture and the color of the paper show through, influencing the way that the pigment will be viewed.

4 Pastel colors cannot be mixed as simply as oil or watercolor paints but they can nevertheless be used to create new colors. One method is illustrated *above*.

Here the artist has laid down flesh pink pigment and black Conté and overlays it with loosely hatched light red. He does not blend the colors, but they mix in the eye.

5 The patches of red and green show just how intense pastel colors can be *above*. The artist holds the pastel upright so that he can use the flat end to draw the tiller.

What the artist used

The artist used light gray pastel paper 12 × 16 inches, charcoal and fixative.

LIGHT GRAY

LIGHT ORANGE

LIGHT GREEN

PINK

WHITE

LIME GREEN

BLUE-GREEN

CRIMSON

BLACK CONTE

GREEN

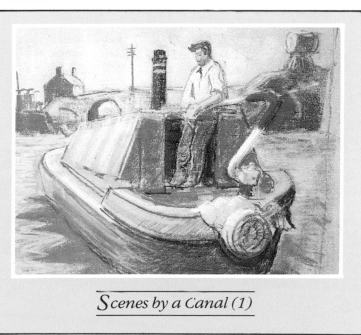

Scenes by a Canal (1)

1 The bright simple colors attracted the artist to this particular scene *right*. He made the felt pen sketch very quickly, noting down colors and details.

2 The artist is interested in the bright local colors rather than forms, structure, tone or composition. He therefore requires only a simple drawing. He makes a quick charcoal drawing *left* in which he sets out the broad arrangement of the study. He then fixes the charcoal.

3 The artist lays in broad areas of flat color *above*. He has a small selection of pastels with him and because he wants to use pure color rather than mixed color he has to make do with approximations. He is interested in the color combinations so his range of colors suits his purpose.

4 The loosely applied colors allow the white of the support to show through, giving the sketch a lively sparkle *above*. Pastels are often executed on tinted grounds which affect the pigment. The colors of the final sketch illustrate how bright pastel pigments can be.

What the artist used

The artist used white drawing paper 7 × 10 inches, charcoal and fixative.

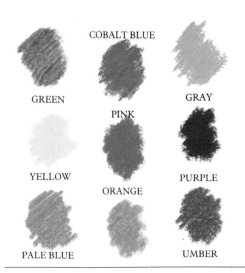

GREEN

COBALT BLUE

GRAY

YELLOW

PINK

PURPLE

PALE BLUE

ORANGE

UMBER

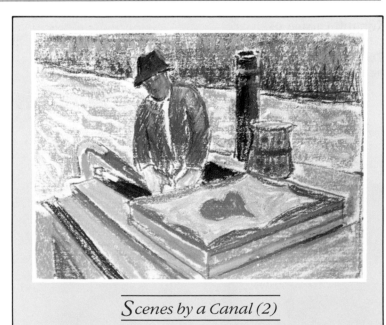

Scenes by a Canal (2)

1 These moored barges with laundry hanging out to dry *right* provided the artist with a complex subject, a combination of overlapping shapes and unusual angles.

2 The artist is working on green Ingres paper. He starts by sketching in the main elements of the composition in white pastel. He then blocks in the areas of lightest tone, again using the white pastel *left*. This pastel is intended as a sketch and is developed very quickly. The artist particularly likes the shapes and forms.

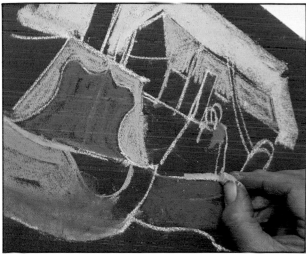

3 The artist blocks in the sky with pale blue pastel, adds an area of bright crimson local color and then works into the hulls of the barges with yellow ocher *left*. The dark ground establishes the darkest tones, so all the other colors must be lighter in tone.

4 The water provides a particularly interesting subject and we can see some of the ways in which the artist tackles it *right*. He lays on fairly thin color which the dark ground shows through. The color is hatched, blended, stippled and dashed.

What the artist used

The artist used green Ingres paper 12 × 16 inches and an aerosol fixative.

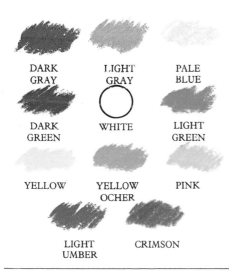

DARK GRAY LIGHT GRAY PALE BLUE

DARK GREEN WHITE LIGHT GREEN

YELLOW YELLOW OCHER PINK

LIGHT UMBER CRIMSON

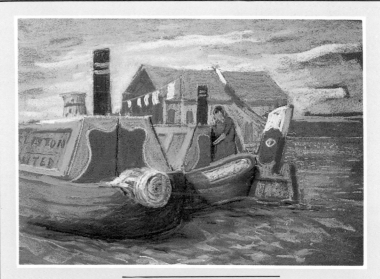

Scenes by a Canal (3)

Sea and Sky

OIL PASTEL

Oil pastel is a relatively recent innovation. It resembles the traditional pastel, but the sticks of pigment are bound with oil rather than gum or resin. Oil pastel behaves in a different way from traditional soft pastels and should be exploited for its own distinctive characteristics. Oil pastels tend to be less responsive and delicate than pure pastels, and the most satisfactory results are achieved by using them for detailed work on a small scale and for work in which you want to create texture and thick impastos. Oil pastels are often used in mixed media painting. The oil binder makes them fluid and they can therefore be blended with each other and with other media. Nor do they rub off in the way that soft pastels do. Whether you use oil pastel will depend on your technique and your intentions, but it is worth experimenting with them, always remembering that they are unlike any pastel you have used previously.

Oil pastel is a very exciting and flexible medium. It is not possible to achieve the soft, subtle tones of pure pastels, but with imagination and dexterity it is possible to get some splendid results, especially using mixed media techniques. You can, for example, use oil pastel to lay in the broad, general outlines of a composition and then overpaint with gouache. The oil pastel may reject the paint, but this problem is solved by mixing a little soft soap into the paint – the gouache will then cover the pastel quite effectively.

Here the artist has used a variety of techniques to exploit the medium's potential, and has painted with the pastels using many of the techniques available in oil painting. He has used strong diagonal strokes to establish the main areas of the sea, sky and land. With a wide palette knife he pressed small pieces of pastel on to the picture surface, using the knife to create strongly directional strokes. Using long sweeping strokes and short stabbing strokes he has conveyed the impression of broken water. He has blended the pastel on the palette by working into it with a cotton bud dipped in turpentine and has then scratched back through the blended surface. The finished painting illustrates very clearly the scope of this medium, the richly textured surface and its painterly qualities.

2 Using cerulean blue and ultramarine, the artist roughs in color in the area of the sea, sky and land *above*. He uses widely spaced diagonal strokes and at this stage does not blend the colors.

3 The artist applies white and gray pastel, changing the direction of the strokes in the foreground and following the direction of the original strokes in the sky *below*. He works opaquely.

1 The artist started by making a very brief underdrawing *right* directly on to the support – strong, stretched paper. He did not need very much detail because the subject is very simple.

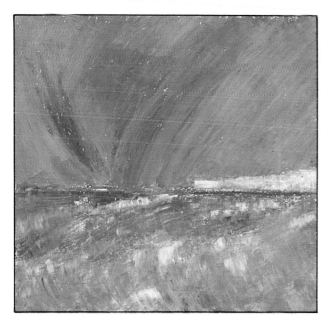

OIL PASTEL WITH TURPENTINE WASH

Oil pastel is a very flexible medium which, in many ways, resembles oil paint. Here the artist has applied an area of even, but grainy oil pastel to a textured canvas support. He then moistened a brush in turpentine and worked into the pastel, spreading the color so as to create a wash, working it well into the grain of the support. Finally he used soft, even strokes to apply texture over this washed area.

4 Using ultramarine the blue of the sky is strengthened especially in the darker areas and near the horizon *above*. White pastel is dashed and dabbed into the foreground to suggest the foam of the breaking waves. It also creates texture in this area.

5 In the detail *below* the artist presses bits of white pastel on to the support using the tip of a broad palette knife. He also uses the knife to scratch into the pastel and to create directional marks. Again this creates texture and draws attention to the foreground.

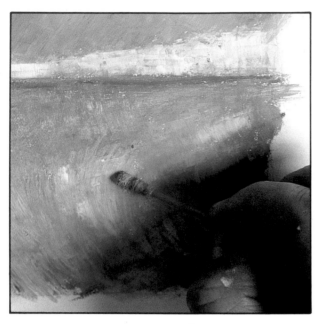

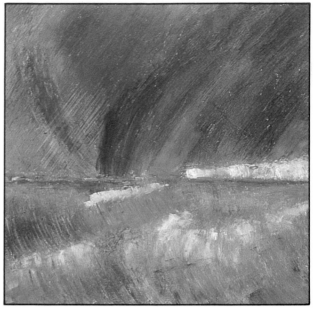

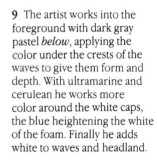

6 In the detail *above* oil pastel is being used in a way similar to oil paint – the artist works over the pastel surface with a cotton bud dipped in turpentine. The turpentine moistens the pastels so that the colors can be blended, removing linear strokes. This technique creates the effect of broken water.

7 The artist has worked turpentine over the entire picture surface *below* so that almost all the pastel strokes have disappeared and the white of the support no longer shows through. This effect cannot be achieved quickly – the artist must work slowly and methodically or the surface of the support will be damaged.

8 The artist continues to work into the painting, darkening the sky with dark gray diagonal strokes which suggest an enclosing dome *above*. He works thick white pastel into the headland and breaking waves. With the palette knife he scratches back through the pigment to reveal flashes of the white support.

9 The artist works into the foreground with dark gray pastel *below*, applying the color under the crests of the waves to give them form and depth. With ultramarine and cerulean he works more color around the white caps, the blue heightening the white of the foam. Finally he adds white to waves and headland.

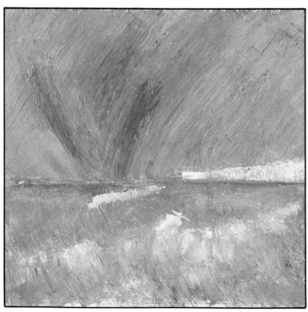

What the artist used

The artist used good quality drawing paper which he stretched on a drawing board. He worked on a small scale 7 × 9 inches. He used a selection of oil pastels, turpentine, a palette knife and cotton buds.

BLACK

ULTRAMARINE BLUE

PAYNE'S GRAY

CERULEAN BLUE

WHITE

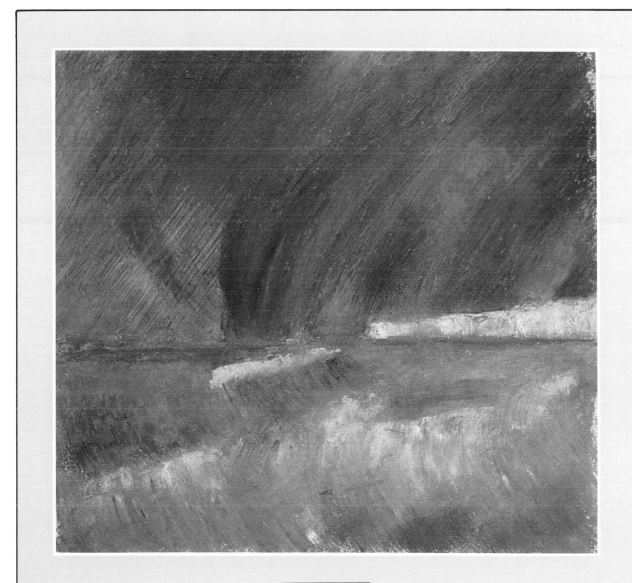

Sea and Sky

Drawing

The immediacy of drawing, the fact that little or no preparation is necessary and the ready availability of materials, has commended the process to artists throughout the ages. Artists make drawings for many reasons; to investigate and solve problems, as preparations for paintings and as works of art in themselves, but these are arbitrary categories which often overlap. Drawing for painting has a long tradition, as the collections of drawings in the world's great galleries and museums testify. However, few drawings pre-date the Renaissance, not because they were not made, but because they were not valued as objects. Drawings were working documents discarded after use. With the dawn of the Renaissance there was a kindling of interest in all aspects of the natural world and artists responded to this by making drawings which explored the human figure, animals, anatomical specimens, in fact virtually all aspects of nature. They also made drawings in which they sought to refine their knowledge and resolve difficulties encountered in compositions. They worked out problems of foreshortening, analyzed the folds on drapery and investigated perspective. Today the artist is confronted by an even greater range of drawing tools than ever before. Some are appropriate for particular purposes – the drafting pen, for example, is particularly suited to detailed work on a small scale, whereas ink demands a more generous, flowing style. Your choice will depend on your style, your personality, and the purpose of the drawing.

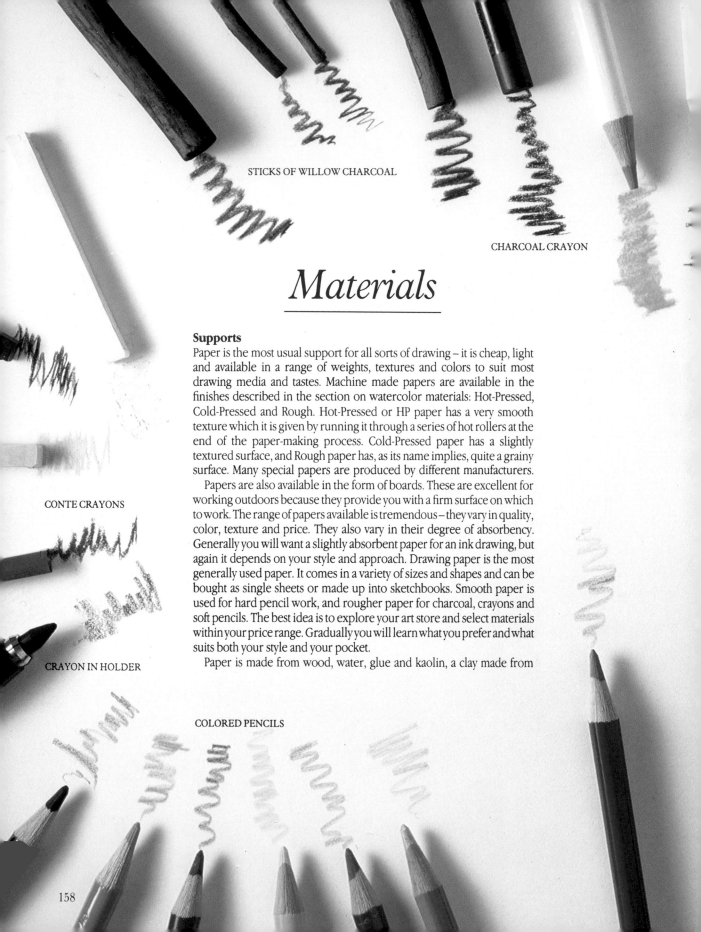

STICKS OF WILLOW CHARCOAL

CHARCOAL CRAYON

CONTE CRAYONS

CRAYON IN HOLDER

COLORED PENCILS

Materials

Supports

Paper is the most usual support for all sorts of drawing – it is cheap, light and available in a range of weights, textures and colors to suit most drawing media and tastes. Machine made papers are available in the finishes described in the section on watercolor materials: Hot-Pressed, Cold-Pressed and Rough. Hot-Pressed or HP paper has a very smooth texture which it is given by running it through a series of hot rollers at the end of the paper-making process. Cold-Pressed paper has a slightly textured surface, and Rough paper has, as its name implies, quite a grainy surface. Many special papers are produced by different manufacturers.

Papers are also available in the form of boards. These are excellent for working outdoors because they provide you with a firm surface on which to work. The range of papers available is tremendous – they vary in quality, color, texture and price. They also vary in their degree of absorbency. Generally you will want a slightly absorbent paper for an ink drawing, but again it depends on your style and approach. Drawing paper is the most generally used paper. It comes in a variety of sizes and shapes and can be bought as single sheets or made up into sketchbooks. Smooth paper is used for hard pencil work, and rougher paper for charcoal, crayons and soft pencils. The best idea is to explore your art store and select materials within your price range. Gradually you will learn what you prefer and what suits both your style and your pocket.

Paper is made from wood, water, glue and kaolin, a clay made from

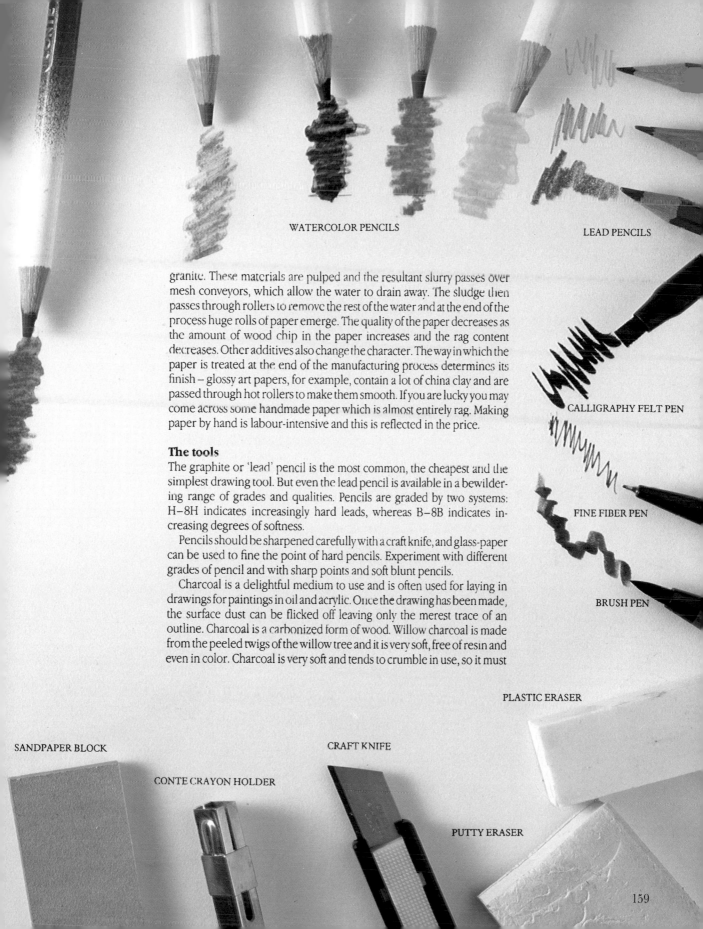

WATERCOLOR PENCILS

LEAD PENCILS

CALLIGRAPHY FELT PEN

FINE FIBER PEN

BRUSH PEN

granite. These materials are pulped and the resultant slurry passes over mesh conveyors, which allow the water to drain away. The sludge then passes through rollers to remove the rest of the water and at the end of the process huge rolls of paper emerge. The quality of the paper decreases as the amount of wood chip in the paper increases and the rag content decreases. Other additives also change the character. The way in which the paper is treated at the end of the manufacturing process determines its finish – glossy art papers, for example, contain a lot of china clay and are passed through hot rollers to make them smooth. If you are lucky you may come across some handmade paper which is almost entirely rag. Making paper by hand is labour-intensive and this is reflected in the price.

The tools

The graphite or 'lead' pencil is the most common, the cheapest and the simplest drawing tool. But even the lead pencil is available in a bewildering range of grades and qualities. Pencils are graded by two systems: H–8H indicates increasingly hard leads, whereas B–8B indicates increasing degrees of softness.

Pencils should be sharpened carefully with a craft knife, and glass-paper can be used to fine the point of hard pencils. Experiment with different grades of pencil and with sharp points and soft blunt pencils.

Charcoal is a delightful medium to use and is often used for laying in drawings for paintings in oil and acrylic. Once the drawing has been made, the surface dust can be flicked off leaving only the merest trace of an outline. Charcoal is a carbonized form of wood. Willow charcoal is made from the peeled twigs of the willow tree and it is very soft, free of resin and even in color. Charcoal is very soft and tends to crumble in use, so it must

PLASTIC ERASER

SANDPAPER BLOCK

CRAFT KNIFE

CONTE CRAYON HOLDER

PUTTY ERASER

159

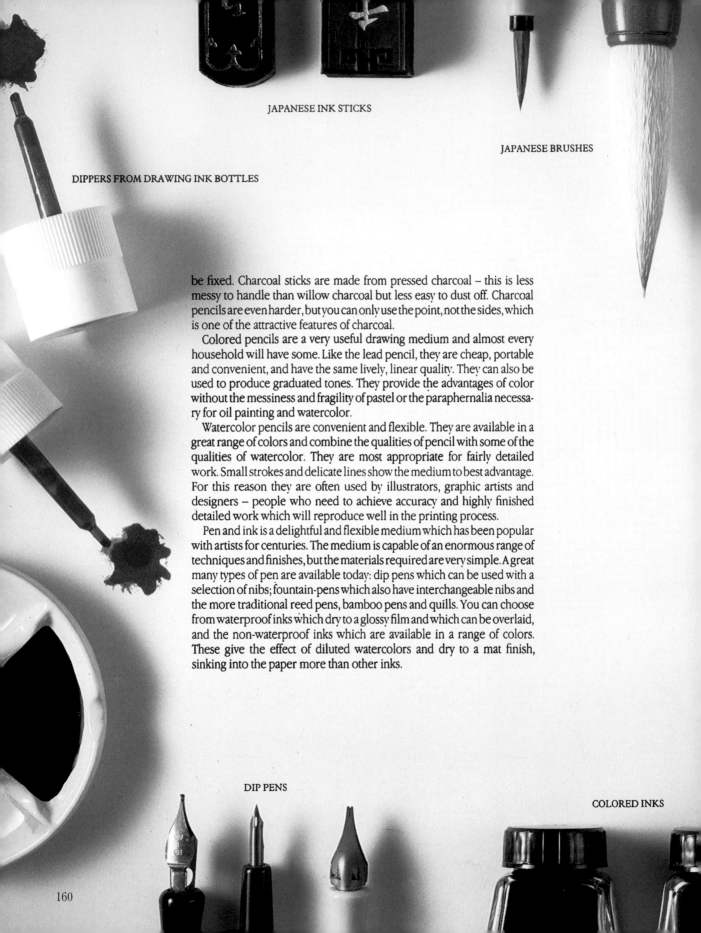

JAPANESE INK STICKS

JAPANESE BRUSHES

DIPPERS FROM DRAWING INK BOTTLES

be fixed. Charcoal sticks are made from pressed charcoal – this is less messy to handle than willow charcoal but less easy to dust off. Charcoal pencils are even harder, but you can only use the point, not the sides, which is one of the attractive features of charcoal.

Colored pencils are a very useful drawing medium and almost every household will have some. Like the lead pencil, they are cheap, portable and convenient, and have the same lively, linear quality. They can also be used to produce graduated tones. They provide the advantages of color without the messiness and fragility of pastel or the paraphernalia necessary for oil painting and watercolor.

Watercolor pencils are convenient and flexible. They are available in a great range of colors and combine the qualities of pencil with some of the qualities of watercolor. They are most appropriate for fairly detailed work. Small strokes and delicate lines show the medium to best advantage. For this reason they are often used by illustrators, graphic artists and designers – people who need to achieve accuracy and highly finished detailed work which will reproduce well in the printing process.

Pen and ink is a delightful and flexible medium which has been popular with artists for centuries. The medium is capable of an enormous range of techniques and finishes, but the materials required are very simple. A great many types of pen are available today: dip pens which can be used with a selection of nibs; fountain-pens which also have interchangeable nibs and the more traditional reed pens, bamboo pens and quills. You can choose from waterproof inks which dry to a glossy film and which can be overlaid, and the non-waterproof inks which are available in a range of colors. These give the effect of diluted watercolors and dry to a mat finish, sinking into the paper more than other inks.

DIP PENS

COLORED INKS

SMALL SYNTHETIC ROUND

COLORED PAPERS

SYNTHETIC FLAT

In technical drawing evenness of line is essential and the stylo-tip pen was evolved to meet this requirement. These pens have tubular nibs which are available in a wide range of widths. The nib units are interchangeable so that you can use several nib sizes with one barrel. The most common type of stylo-tip pen is the drafting pen. The Isograph was a further development of this, and was designed to overcome the problem of ink drying and to give a better ink flow and line quality.

Felt-tip and fiber-tip pens are now produced in a vast range of types, a large selection of colors and an almost daunting range of point thicknesses. They have a dependable, flowing and consistent line, and with their soft tips they are almost as sensitive as the tip of a brush. They are available in both water-soluble and permanent alcohol-based varieties.

Other equipment

You will gradually want to add other items to your collection of drawing equipment. These will include a selection of knives for sharpening pencils, cutting paper or scratching mistakes from paper surfaces. You will also need a pencil sharpener and these are available in a great range of shapes, sizes and prices, from the simple hand-held plastic sharpener to desk-top models and those specially designed for sharpening the leads of clutch pencils. A block of glass paper will be useful for getting fine points on pencils or on sticks of charcoal. You will also need a selection of erasers – a soft putty eraser for erasing pencil marks from soft paper and harder eraser pencils for small-scale work and for erasing ink marks. Torchons made of tightly rolled paper are useful for blending or spreading chalk, pastel, pencil or charcoal. You will find that art stores are delightful places to browse and learn.

WATERCOLOR
PAPERS

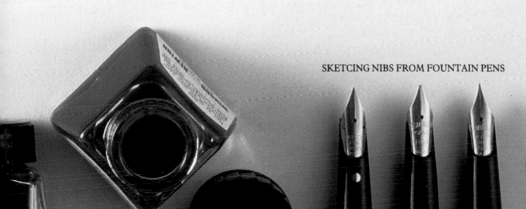

SKETCING NIBS FROM FOUNTAIN PENS

DRAWING PAPER

Palm Trees

PEN AND INK

The artist chose this subject because it was ideal for illustrating the variety of marks of which the dip pen is capable. The graceful shapes of the fronds of the palms are particularly appropriately represented by the fluid line of the pen with its variety of thicks and thins. The strong simple images allow the artist to create a lively decorative surface, exploiting the different marks that can be achieved with the same pen. The areas of solid black add another element, and sparkle against the white of the paper.

Do not begin ink drawing until you have practiced movements with pens. Work on a fairly smooth paper and learn to use the minimum of pressure to get an even flow of ink from the nib on to the paper. Try to use exactly the same amount of ink on your nib each time and learn to judge when the ink will run out – you do not want to be in the middle of a long unbroken line when it happens.

Steel nibs for dip pens are sold in a wide range of thicknesses and degrees of hardness. Special drawing or sketching nibs are also available and these are particularly sensitive, having soft nibs which produce a fluid line which swells and thins as the pressure is altered. Fountain-pens have a reservoir and they too are sold in a range of thicknesses and softnesses. Pens especially designed for sketching are on the market, and can be bought in sets – one barrel with an assortment of nibs. The advantage of a fountain-pen is that you do not need to juggle with an open bottle of ink – a great advantage when you are working outdoors. The pleasure of drawing with a well-used dip pen is hard to beat, though those who have used them say that an old goose quill or a reed pen is really the ultimate drawing instrument.

This drawing is an exuberant demonstration of the capabilites of the medium. By varying the pressure he applies to the pen, the artist can control the amount of ink he deposits on the paper. Without any pressure he creates a thin line, but more pressure causes the nib to open up and ink floods the surface. The direction of the mark is important – with a flicking movement he creates a lively line which is thick at the beginning and narrows rapidly. Brushes can be used to create a completely different range of marks and finally, there is the ink wash, which can be used to create an area of even tones. When pen and ink is fully exploited it can create colorful drawings in black and white.

1 The artist selected this subject *right* because he liked the strong simple shapes. He wanted to experiment with pen and ink and the varied leaf shapes were a good subject.

2 The artist is working on a large scale – 21 × 30 inches – on white drawing paper. He makes a fairly detailed drawing with a 4B pencil *left*. The drawing is more detailed than it might be for a painting of the same subject, because the artist is interested in the drawn shapes, pattern and line.

3 A pen can be handled in a great many ways, each of which will elicit a different kind of mark. *Above* the artist creates a leaf of a palm frond by drawing the pen away from the spine of the frond, applying pressure at the start of the stroke so that the nib opens up, flooding the paper with ink.

4 In the detail *left* the artist applies light pressure at the end of a stroke, flicking the pen as he works so that the end of the stroke trails off into a very thin line. This degree of control can only be achieved by experience. Experiment with marks on scrap paper.

5 The columnar pattern on the trunk is caused by palm fronds breaking off. The artist draws the pattern carefully in ink and then works back into it *left*, creating solid areas of black on the shaded side of the tree. His technique is realistic and highlights the pattern of the naturally occurring forms.

6 So far the artist has tackled one tree and yet he has had to exploit a considerable range of marks, and hand movements. He has used only line and solid black *right*. At a later stage he will introduce half-tones which will play down the pattern and make the images appear round.

7 In the detail *above* the artist draws the foliage of the small mushroom shaped tree in the center of the picture. He does not draw every leaf, nor does he draw the leaf forms exactly – he reduces the leaves to an approximation of the shape and then draws enough to imply the rest. The eye of the viewer will fill in the gaps. Painting and drawing is about illusion, tricking the eye into reading what is not there. He suggests the underside of the crown by using solid black for the shadow.

8 The artist lays in scratchy hatched lines *above right* to describe the fronds of the tree in the background. He drags the pen across the paper surface, using the side of the nib rather than the point.

9 In the detail *right* the artist uses a variety of stubbly marks to indicate the texture of the foliage of the largest tree. He uses short stabbing strokes, applying enough pressure to force the nib open, creating the well-inked marks.

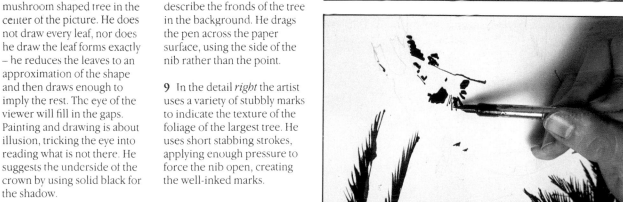

EXPLORING PEN AND INK MARKS

Here the artist shows just some of the marks that can be made with pen and ink. Some, like hatched and cross-hatched lines, are rather obvious. But the possibilities are almost infinite and the marks can be varied further by changing the way you hold the pen and the amount of pressure you apply. Many of the patterns and textures were dictated by the nature of the subject, for example, the dense stippled textures and drawn ovoids used to suggest foliage and the dashed marks used for the palm fronds.

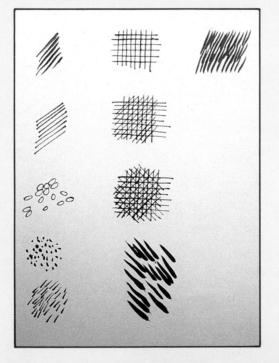

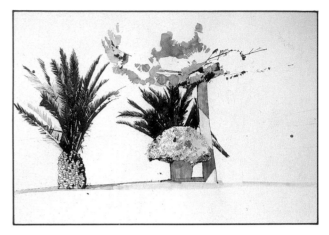

10 The picture evolves *above*. The technique is quite laborious, especially as the artist is working on quite a large scale. If you are trying pen and ink for the first time you should think about working on a smaller scale.

11 The artist mixes a small amount of ink with water and with a No.4 sable brush lays in areas of mid-tone *below*. He assesses the position and extent of these by studying the subject through half-closed eyes. This allows him to see lights, darks and mid-tones.

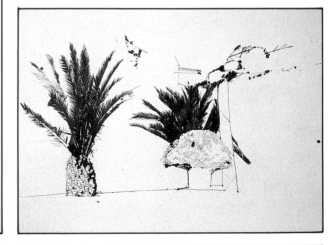

12 With a No.2 sable brush and a solution of ink and water the artist now begins to work into the crown of the tree, laying areas of mid-tones among the foliage *right*. In this detail we can see very clearly the range of marks that are possible with pen, brush and ink. Compare the sharp linear marks of the pen with the soft ovoids from brush and wash.

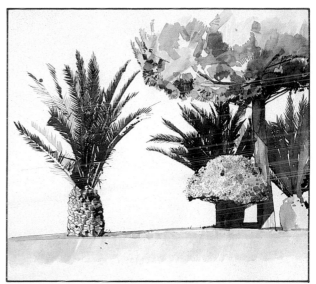

13 The artist now works into the washed areas with pen and ink *above*. This highlights yet another aspect of the medium for the ink takes quite differently on the washed areas than on clean paper. This is because the ink solution partially seals the paper so that subsequent layers of ink are less fully absorbed. They sit on the surface and form sharper edges.

14 The drawing is lively and convincing, the variety of marks and washes combining to create a realistic image which captures the feeling of light and shade and at the same time draws attention to the characteristics of the individual trees and the peculiarities of their foliage. At this stage *above right* the trees have form and seem to occupy a fixed volume and space.

15 The artist now lays in a pale wash for the background *left*. When this is dry he lays another, paler, wash alongside it. In this way he very simply implies recession. However, the main area of interest are the trees in the foreground, so the background is treated very simply. He also works half-tones into the trunk of the tree and the foliage, judging each against the next.

16 Before the washes are dry the artist blots the drawing with a sheet of blotting paper *above*. The paper was becoming rather wet and there was a danger that it might crinkle. The blotting paper also lifts of color in places. creating texture and adding interest to the mid-tones. He uses a fine brush and thinned ink to paint in more fronds on the palm trees.

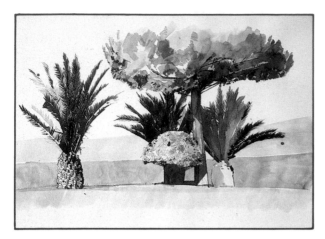

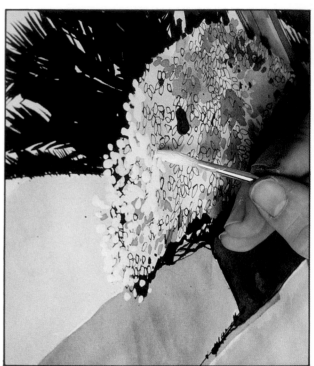

17 The darkest tones have been established with solid areas of black, the mid-tones with a thin ink wash and the lightest tones are represented by the white of the paper *above*. The artist starts to lay in highlights with opaque white gouache.

18 With white gouache and a fine No.2 sable brush the artist picks out the lightest tones on the crown of the small tree *right*. The tonal range of the drawing has now been increased from the deep black of the solid ink to the opaque white of the gouache.

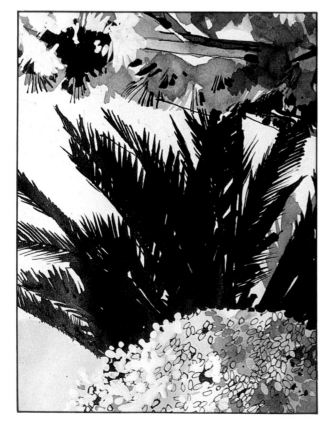

19 The detail *left* illustrates some of the range of marks that can be created with this medium. The white gouache tells particularly well against the solid black and the thin washes. The contrast between the translucency of the washes and the opacity of the gouache and the solid blacks is another interesting feature of the work.

20 Here the artist works more gouache over the foliage *above*, using the paint to draw individual leaves and clusters of leaves. He uses a well-loaded brush and puts down the paint thickly in order to achieve maximum cover. The paint is moved loosely over the paint surface – it is not scrubbed because that would damage the paper surface.

21 The detail *left* illustrates how the white paint is manipulated, pushed and pulled to build the shapes of leaf clusters. Here as at every stage throughout the drawing the artist is constantly checking the image against the subject, correcting when necessary but always developing the image so that the final picture is the product of concentrated observation. It is simple but effective and demonstrates the range of the medium.

What the artist used

The artist used white drawing paper which he had stretched and taped to a drawing board. The support was quite large 21 × 30 inches. He used waterproof ink for the drawing and a non-waterproof ink for the washes. He used a dip pen with a selection of nibs and Nos. 2 and 4 sable brushes.

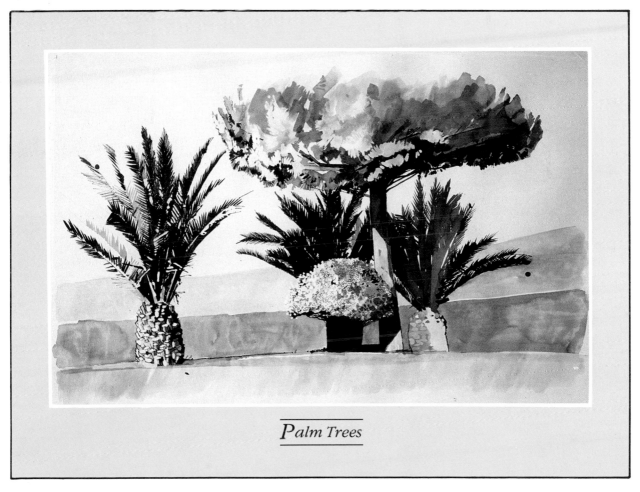

Palm Trees

Garden with Trees

COLORED PENCIL

In this composition, the horizon is fairly low with just over half the depth of the picture devoted to the area of the sky. On to this the strong, dark sculptural columns of the ornamental cedar trees project, linking the earth with the sky. The artist has not been afraid to use empty spaces. He has let them stand, allowing the eye to rest or wander over the picture surface, enjoying the colors and textures. The empty areas increase the importance of the areas of activity within the drawing. The carefully rendered trees, with their hatched and broken color, are enhanced by the flat areas of blue and green which surround them.

The artist has chosen to use colored pencil, a very cheap and convenient medium. It can be used on a great range of supports, even brown wrapping-paper. Here the artist has used a smooth drawing paper. Colored pencils can be used very effectively to investigate color and tone. In this closely observed drawing the artist has used various techniques to create a range of subtle colors. By hatching and cross-hatching and by overlaying different colors he has created quite subtle modulations of color and tone. He has laid down small areas of color, much as you would with paint and, working from the light to the dark, has built up the colors so that each shows through and modifies succeeding colors in a way that imitates natural light. He has exploited the linear quality of the pencil, and has drawn the forms of the trees, observing and following the skeleton of their branches, the way the leaves grow from those branches.

As with other media you must learn to use it and you must use it to learn about it, to find out what it is capable of. Notice the different ways the artist holds the pencil. When he is drawing the tree, he holds it tightly, close to the point, laying in small intricate details. When he wants to cover the sky areas with an even mesh of loosely scribbled lines, he holds it more loosely, grasping it farther up the shaft and moving it in a natural sweeping motion which finds its own rhythm. While you should always be in control of your medium, you should, nevertheless, be aware of what it is naturally inclined to do and work with it rather than against it. This feel for the medium can only be gained by experience.

1 This scene *right* provided the artist with an interesting study in light and shadow. He liked the strong horizontals and verticals, the sculptural feel of the trees and the contrast of empty space and busy areas.

2 The artist starts by making a very rough pencil drawing with a soft 4B pencil on the white drawing paper *left*. He indicates the broad arrangement of the elements. He lays down small blocks of lemon yellow and moss green on the sunlit side of the trees. He works lightly laying the color in different directions. He then starts to lay in the sky with a light blue pencil.

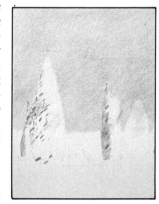

3 The artist lays in the sky by holding the pencil loosely and working rapidly, creating hatched marks *below left*. He works in different directions, building up a mesh of color so that the marks disappear and he achieves a uniform tone.

4 With yellow ocher and raw sienna the artist lays in the background *below*. He applies the color lightly so that he can work over it later.

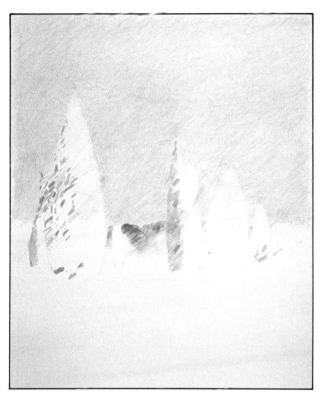

CREATING A SHARP EDGE WITH PENCIL

Here the artist wishes to create a sharp edge to describe the area of shadow falling across the lawn. He was able to achieve this easily and quickly by laying a ruler on the support along the line of the shadow. Holding the ruler firmly with his left hand, he made rapid hatching marks up to it, working steadily from left to right. When finished, this line of color has a special geometric quality which accurately reflects the contour of the shadow and provides a pleasing contrast with the rapidly scribbled texture of the lawn.

5 It is important not to be too definite with colored pencil until you are sure of how you are going to handle the drawing *above*. It is difficult to erase without damaging the paper surface. You also need to keep the points of the pencil sharp if you want to achieve intense color. Blunt pencils tend to be rather woolly.

6 The artist works into the tall columns of the trees with black pencil, laying the color in different directions which follow the form of the tree *below left*. He works into the greens already laid down, connecting and adjusting the drawing.

7 In the detail *below right* we see how the lighter colors are allowed to show through the darker overlaid colors, convincingly suggesting the way light catches the foliage. Here the artist is using black pencil to draw the thin, rather skeletal form of the tree on the extreme left.

8 The artist has built up the forms of the trees *far right* by reducing them to simple facets of light and dark tones. He lays on the color by varying the direction of the pencil strokes, molding and describing form as he goes

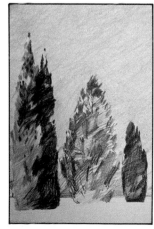

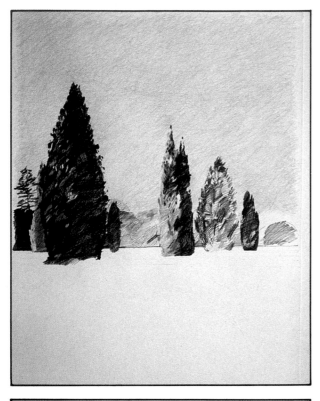

9 The elements of the picture are beginning to build up *left*. The trees tower upwards and are seen in silhouette against the pale even tone of the sky. The artist has used the colored pencils to describe the individual characteristics of each tree. The pencils used here are fairly hard, but the color is intense. Others are softer but may be thinner in color. Watercolor pencils are often very good quality.

10 Using a Prussian blue the artist blocks in the shadows which fall across the lawn *above*. He lays in the color rapidly, working up against a ruler in the manner illustrated on the previous page. Notice the way in which he has used the negative shape to describe the tree on the left, using the darker pencil to draw back into the light green, tightening and correcting the outline by working into the negative shape.

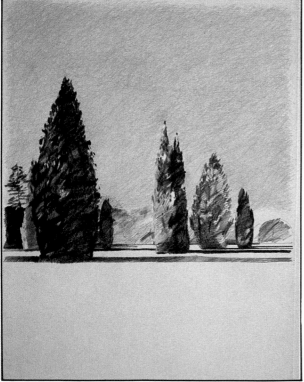

11 The drawing is complete except for the grass in the foreground *left*. Already the artist has managed to explain the space by using overlapping forms, paler color and less resolved shapes in the background and by the strong horizontal line of shadow which falls across the lawn, firmly establishing the middle ground.

12 The artist applies a loosely worked web of moss green and dark green to the grassy area in the foreground *above*. He works in the same way as he did for the sky but here he wants the pencil marks to tell. They represent the blades of grass and the coarser texture also helps the perspectival illusion, by making the eye 'see' this area as closer because the marks are larger.

What the artist used

The artist used good quality white drawing paper 16.5 × 23.5 inches. He worked on a large scale which is difficult with colored pencil – you might find it easier to work on a smaller scale especially if you are trying the medium for the first time. Blocking in large areas of color with such a small point is very time consuming and tiring. He used a set of good quality colored pencils which he chose for the intensity of their color. He also used a ruler and a 4B lead pencil.

PRUSSIAN BLUE

BLACK

DARK GREEN

YELLOW OCHER

BURNT SIENNA

LIGHT BLUE

LEMON YELLOW

MOSS GREEN

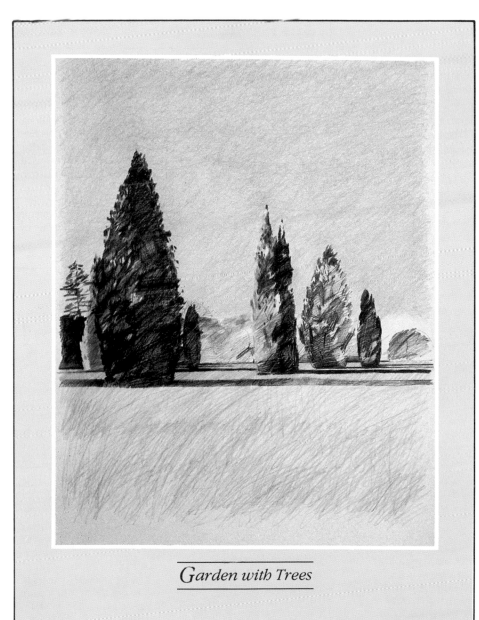

Garden with Trees

171

Country Lane in France

WATERCOLOR PENCIL

This particular view has much to recommend it as a subject for the painter. It is composed of a series of pleasing and varied shapes such as the full, round forms of the trees, with the strong, repeated verticals of their trunks following, and explaining, the line of the road. The generous sweep of the road leads the eye into the painting and off through the narrow gap where it passes between the trees. The dramatic geometry of the road sign, which is right up against the picture plane increases the sense of depth within the painting by a dramatic change of scale. Rhythms within the painting are contrasted by the straight uninterrupted line of the horizon, and counterpointed by the large empty areas of the green fields.

Watercolor pencils are a special kind of pencil which combine the qualities of pencil with some of the qualities of watercolor. They are most appropriate for fairly small-scale work, but are very flexible. They are worked as you would a color pencil, but when water is added to the surface the color becomes liquid and can be blended and moved in a way that resembles watercolor. They are very useful for work outdoors. The artist can make the original drawing, indicating the areas of color and tone and can then work on it further when he returns to the studio. You may even decide to start with watercolor pencil and complete the painting at home in watercolor.

Watercolor pencils can of course be used just like ordinary colored pencils, and for this purpose they are excellent, for they are soft, of good quality and have an excellent range of colors.

Here the artist was exploiting their watercolor qualities. He worked into the detailed areas, such as the trees on the horizon, with a sharp pencil, laying down hatched marks and overlaying green with black to create the deep, velvety quality of the foliage. The sky has been handled in the same way as in the previous colored pencil drawing, but when the mesh of lines was complete he used a brushful of water to blend the blues so that the pencil marks disappear. In the finished painting some areas retain the linear marks of the pencil, others are washes of color in which no trace of the pencil marks can be found.

1 The artist made this watercolor drawing from a photograph *right* taken on a visit to France. He liked the flat country side, the sweep of the road and the geometric form of the road sign.

2 The artist starts by sharpening his pencils *above*. Only with a sharp point can he get the intensity of color which he requires. He uses a blade rather than a pencil sharpener, because it gives him more control over the kind of point he makes.

3 With a lime green pencil the artist lays in the foliage of the trees *above*. He then works into the same areas with different greens and finally with black pencil, changing the direction of his strokes all the time. He studies the photograph carefully.

4 The artist continues to work into the trees so that the original light color is revealed as a faint glow through the overlying dark tones *right*. He works from light to dark. It is almost impossible to adjust the color once it gets too dark.

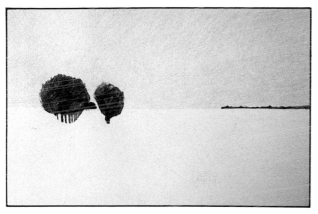

5 The sky is built up with a loosely laid web of pale blue pencil marks *above*. The artist works rapidly, hatching the color and working first in one direction, then in another, so that a pale even film of color is created. With a black pencil the artist blocks in the thin line of bushes on the horizon.

6 With a pale lime green pencil the artist lays in the area of bright green on the brow of the hill *below*. He lays flat color, hatching it with even strokes in one direction, and overlays this with hatched strokes in the other direction. The pencil marks are fine and laid close together.

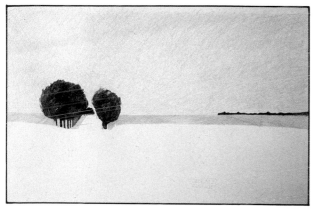

7 With a darker shade of green the artist lays in shadows by the trees in the distance *right*. He uses black pencil to draw the parallel shadows cast by the trees. He uses the lime green pencil to lay in the grass in the foreground, working more freely than previously because this area is nearer to the viewer. Notice the way he draws up to the sign post and the road, using the negative space to describe the forms. At this stage he sees the signpost and the road as spaces.

BLENDING WATERCOLOR PENCIL

Watercolor pencil has the qualities of colored pencil combined with some of the qualities of pure watercolor or gouache. Here we can see how the artist has built up the colors of the crown of the tree by laying down lime green, which he then hatched over with sap green, followed by black. As you can see, the lines of the pencil are clearly visible at this stage. The artist worked into this area with a brush and water and the overlaid colors dissolved and ran into one another creating a subtly modulated area of blended color in which the marks of the pencil are only barely visible.

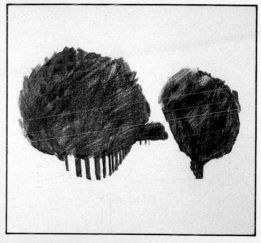

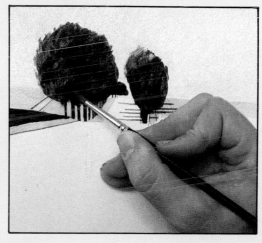

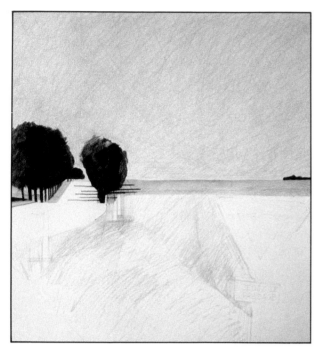

8 The picture begins to develop *left*. The sense of recession and depth is very convincing, as the eye is led along the country road and through the gap in the trees. The color in the foreground is still loose and thin, and the artist continues to work into this area until he has created a dense saturated area of color.

9 With a No.4 sable brush the artist starts to apply water to the foreground area, working the water gently into the color so that the pigment is lifted and blended and the pencil marks disappear *right*. When this area dries the artist works more pencil over the color and then blends this with water, working up the area until he has achieved the desired intensity.

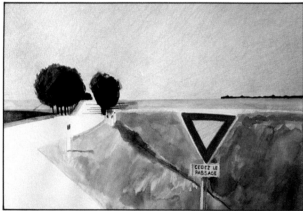

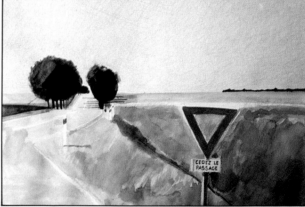

10 With bright red pencil the artist lays in the road sign – an important area of local color *above*. The warm red brings the sign right up to the picture plane, pushing the cooler tones of the greens and blues further back by contrast. This rapid change of scale from a large object in the foreground to the distant landscape is a device often used by artists when they want to create a rapidly receding space.

11 *Above right* the artist washes in the gray of the road and the center of the sign with a thin wash of gray watercolor. He wants to keep these areas pale and untextured, so he abandons the pencil with its linear marks. Watercolor pencil and watercolor make good companions and can very successfully be combined in this way.

12 The very last stage is to wash in the blue sky *left*. The artist again loads a No.4 sable brush with water and gently blends the color, so that the pencil marks fade and the sky becomes uniform in tone. It is not necessary to flood the paper especially as the artist is using drawing paper which has a tendency to crinkle. The artist blends parts of the foliage of the tree creating both blended areas and linear areas.

What the artist used

The artist used a large sheet of drawing paper 12 × 16 inches. He made the initial drawing with a 4B pencil and also used this to work some details into the drawing at the final stages. He used good quality water-color pencils made by Prismalo and a No. 4 sable brush. His other equipment included a blade for sharpening the pencils, a drawing board and a jar of water for blending the colors.

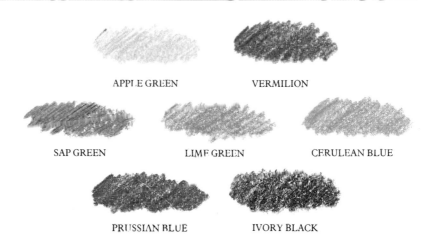

APPLE GREEN

VERMILION

SAP GREEN

LIME GREEN

CERULEAN BLUE

PRUSSIAN BLUE

IVORY BLACK

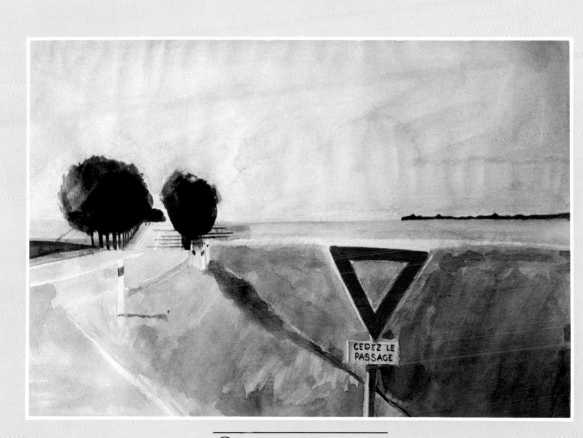

Country Lane in France

Box Hedge with Bench

DRAFTING PEN WITH FIBER PEN

In this picture the artist has used both a drafting pen and an ultra-fine fiber pen. The drafting pen is a stylo-pen, essentially a designer's tool, which is often used by the fine artist. The even, regular lines it produces are very different from those made by ordinary drawing pens. They use a special insoluble, drawing ink so it is not possible to soften your line with water. The pen is designed to produce a line of even width which does not blot, very unlike the fluid line which can be made with a dip pen. They are, however, very portable and because the pen has a reservoir the artist does not need to keep stopping to dip the pen in ink. On the negative side, drafting pens can be finicky and temperamental – the pen must be kept in an upright position as you draw and must be constantly shaken to keep the ink flowing. Used with imagination and sensitivity the pen can create a fine descriptive line. The artist needs a sensitive touch and should develop a system of hatching and cross-hatching to achieve a variety of tones.

The ultra-fine pen which the artist used produces a line very similar to that made by the drafting pen. The line is slightly less mechanical and the thickness of the line can be varied by changing the angle between the tip and the paper. Furthermore, the tip does get slightly softer with use. The ink does not get clogged in the pen and so there is no need to keep shaking it.

The artist was attracted by the almost abstract images presented by this subject: the tracery of the trees silhouetted against the sky; the strong dark horizontal of the hedge, repeated by the lighter tones of the path and the grassed area in the foreground; and the geometric shape of the bench mirrors and summarizes the verticals of the trees and the horizontals of the hedge and path. The artist has emphasized these aspects of the composition in his treatment of the different elements. He has highlighted the delicacy of the trees seen against a sky in which the paper has been left to stand as white. The hedge has been handled as a solid but decorative surface and the bench has been left to stand as a negative image, white against the dark background. The strongly geometric shapes have afforded the artist the opportunity to evolve a vocabulary of marks to describe the different areas. Tones are created by putting down more or fewer lines. Using a system of hatching and cross-hatching, he has created a range of light and dark areas, which suggests both depth and contours. The surface has been handled thoughtfully and methodically, building up a carefully modulated network of fine lines which has many of the qualities of an engraving. The artist has been forced to invent a new vocabulary which exploits the best qualities of the pens. The result is a cool image.

1 This scene *right* offered simple and geometric forms, well suited to the drafting pen with its slightly mechanical feel.

2 The basic structure of the tree is established using fine lines made with a 0.4 drafting pen *above*. The artist uses the pen in a slightly unorthodox way, dragging it across the paper with the tip tilted.

3 In the detail *right* the pen is held in a more upright position and the line created is therefore thicker and more uniform in width.

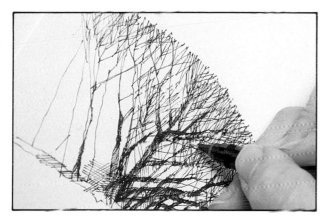

4 The artist builds up a web of lines to create darker tones *above*. This technique demands a very controlled way of working. By putting down more lines the artist creates darker tones, by putting down fewer lines he creates lighter tones.

5 The artist uses the pen to draw the branches and twigs of the tree *below*, using more closely spaced lines for the trunk of the tree. On the right he describes the small dark tree by laying down a much more regular web of lines.

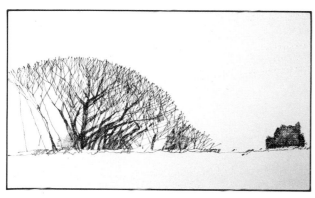

6 The artist uses a fiber pen with a very fine tip *right*. It resembles the quality of line of a drafting pen, but it is not quite so hard or even. As the fiber tip becomes softer with wear it creates a different kind of line, whereas the line created by a drafting pen is unvarying. The quality of the mark made by this fiber tip pen is very similar to that made by the 0.4 drafting pen.

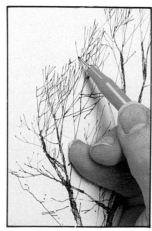

CREATING TEXTURE WITH A DRAFTING PEN

In the details below we illustrate just some of the effects that can be achieved with a drafting pen, an implement which has sometimes been rejected by artists as too mechanical. As you can see, used with imagination, it is possible to create a very impressive range of marks and textures. In the first picture, the effect has been created by drawing a series of freehand lines using pens with nibs of different widths. Compare this with the next picture in which the lines were drawn with a ruler. The rather scratchy, spidery lines were created by holding the pen loosely so that it glanced off the paper surface. The sets of dots and dashes were created with two different nibs, one fine and one thicker.

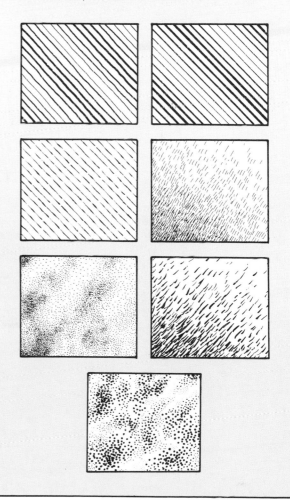

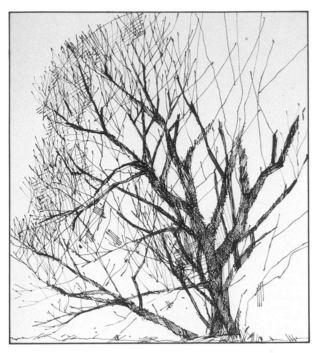

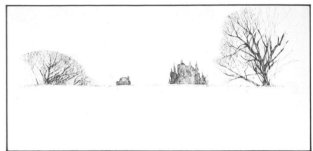

7 The tree *left* is drawn with the fiber tip pen. The artist draws the tree trunk with a series of very closely and regularly laid hatched marks. He draws the twigs on the tree with a single line, but the clusters of tiny twigs at the ends of the branches are suggested by overlaying open hatched lines.

8 This is a very slow method of working, especially as the artist is working on quite a large scale. It took him several hours of painstaking work to reach this stage *above*. The drawing point which he is using is very small compared to the size of the paper.

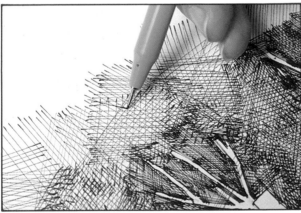

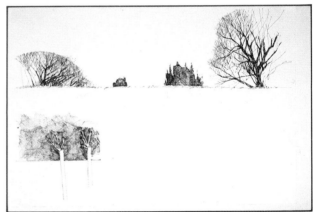

9 The artist uses a system of cross-hatching to lay down the tones of the box hedge *above*. With a new and fairly unfamiliar drawing instrument the artist has to develop a new vocabulary of marks to use in different circumstances. Both instruments require a methodical approach, and both are difficult because the artist cannot rub out any mistakes. If he does want to make any changes he will have to paint them out with white gouache.

10 In the detail *top right* the hatching system builds up to create a realistic impression of the box hedge and also weaves a decorative pattern The artist draws the trees by putting in the background around them, so that they stand out white against the darker tones of the hedge.

11 The artist lays down the tones around the park bench *right* and between the timbers so that the bench emerges from its background.

12 The medium selected for this drawing is not easy to handle but the artist has evolved a set of marks and a method of working which admirably suits both the medium and the subject *right*. The final image *below* has a graphic simplicity, and a pleasing mixture of simple forms and busy, textured surfaces. Every now and then you should force yourself to experiment with a medium which is new or unfamiliar.

What the artist used

The artist used a sheet of drawing paper, 12 x 16 inches, 0.4 drafting pen, ink and a fine fiber tip pen.

Box Hedge with Bench

Urban Landscape

PENCIL AND COLORED PENCIL

The uncompromising lines of modern offices may not have occurred to you as an obvious subject for a landscape painting or drawing. Here the artist was attracted by the regular geometric lines of the building and has counterpointed these with the brick wall in the foreground. While the drawing is a faithful representation of the subject, the artist has deliberately stressed the strong parallels and, the repeated rectangles of the building's wall and the squares of the windows. At the same time, he has taken a viewpoint which eliminates most of the surrounding city-scape with its softer forms and trees which relieve the harshness and has played down those aspects of landscape which do intrude.

The artist worked very quickly, anxious to establish the broad areas of the drawing. He used colored pencils and lead pencils, handling them loosely and freely in order to get down as much information as possible in the short time available.

This is typical of the sort of information you should collect and the way you should use your sketchbook. It is an important part of your life and should always be with you. It is a diary of your day-to-day activities, a file of information, of details of architecture, for example, of light effects, of people and poses. It should be used every day. In this way you will improve your perceptive powers, your visual memory and your drawing skills.

EXPLORING PENCIL

Lead pencil can be used to create a wide and interesting range of effects. These illustrations show just a few. The type of mark made depends on both the degree of softness of the pencil and on how sharp the point is. Pencils are graded from 8B (the softest) through 7B, 6B, 5B, 4B, 3B, 2B, B, F, HB, H, 2H, 3H, 4H, 5H, 6H, 7H, to 8H (the hardest). The first set of marks was made with a 2B pencil. Below that you can see a graded tone created on a fairly smooth paper using a soft pencil (4B). The final picture shows how, using the same pencil, but a much rougher paper, a coarser, more textured effect is achieved. Pencil is a very flexible medium and should not be underestimated.

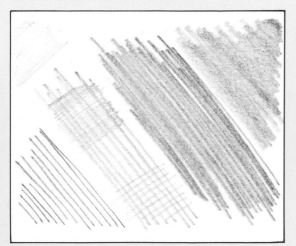

3 He uses a few colored pencils to record local color *above*. This will be useful if he should decide to use this subject in a painting.

1 The artist records everyday events, makes notes of subjects that interest him, evolves ideas and solves problems in his sketchbook *above* Here he addresses himself to a subject which might easily be overlooked but which is important to all city dwellers.

2 The artist works in pencil, drawing what he sees but simplifying the forms so that he can record his impressions quickly but accurately *above*. He was attracted by the strong verticals and horizontals and he makes these a feature of the sketch.

4 He applies the color with freely handled parallel strokes *right*. In the final picture *below*, blue has been scribbled into the sky, and this time the color is laid on much more loosely with strokes which vary in direction.

What the artist used

The artist used a sketch pad 7 x 10 inches, a B pencil and a set of colored pencils.

BLUE

LIGHT GREEN

DARK GREEN

YELLOW

LIGHT BROWN

DARK BROWN

PENCIL

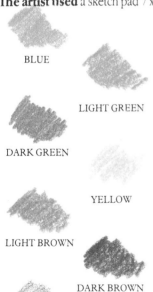

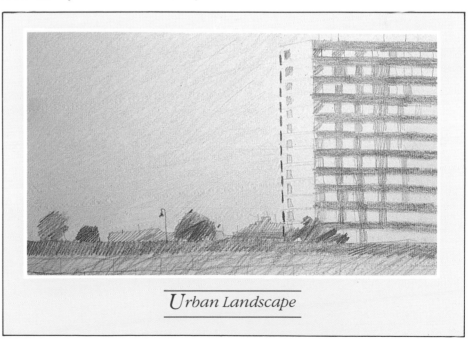

Urban Landscape

View across the Rooftops

FIBER PENS

The urban landscape provides the artist with many delightful views and just as many challenges. This view over the rooftops is a good example of the way in which the commonplace can set the artist a great challenge. You must look carefully and apply your knowledge of perspective in order to achieve a realistic representation. Roofs, especially tiled roofs, present a pleasing variety of pattern and color. In this view the large roof in the foreground acts as a foil to the buildings in the distance. These rapidly diminish in size, and the sudden change in scale helps to establish the spatial relationships creating a great sense of immediacy and, by contrast, a sense of distance.

Faced with such a complex subject you should dismiss these difficulties from your mind and look at the subject as if it were an abstract pattern rather than a series of 'things' to which you can put a name. Draw what you see, not what you know.

Here the artist started with a very general drawing. Allowing the shapes to emerge, he gradually followed each line, extending it, in his mind if not in reality, to see where it impinged on another object. He worked one object against another, checking the shapes between objects, and the angles lines made with one another.

If you think a subject is suitable for painting, you should make color notes on it, either by writing on it or by putting daubs of color on the paper. Working away from the subject, in the studio, has certain advantages because you are freer to interpret and can evolve your own color composition. You could also take a photograph so that you have something to check details against, or if the subject is nearby you can revisit the site with your notebook. If you do take a photograph you will find that the photograph looks insignificant compared to your drawing.

The artist has used a fiber pen. Pen and ink is delightful if you have found the nib that suits you, but the fiber pen does away with the need to transport a breakable and leaky ink bottle. Fiber tips are excellent for quick, immediate drawings, and they are capable of producing a reasonable variety of lines and are not as messy as charcoal. They are extremely flexible and can be used on almost any surface. Fiber pens do wear with use and lose the sharpness of their original line. The artist keeps a series of pens in various stages of wear so that he can create a range of lines, from sharp to soft.

1 Roofs always present the artist with an interesting subject.

FIBER PENS

The first pen has a flexible plastic nib and reproduces some of the qualities of a traditional dip pen or fountain-pen. The second pen is a very fine, fiber-tipped pen, which produces a hard, even line that has many of the qualities of a drafting pen. The third pen is a brush pen. The point consists of a bundle of loose synthetic fibers, rather like a paintbrush. The fourth pen is a felt-tip pen, a softer, coarser and cheaper product than the fiber-tipped pen. The pen soon wears down and old pens have a rather pleasing, soft quality. The last pen is designed for calligraphy and creates slab-shaped marks.

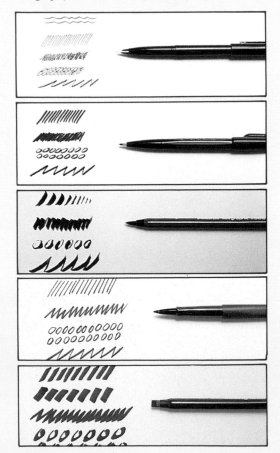

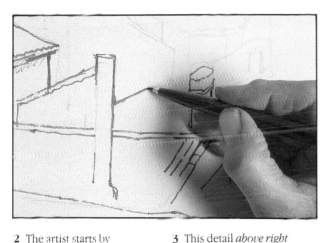

2 The artist starts by establishing the broad outlines of the subject in very faint pencil. He then changes to felt pen *above*. The uneven line of the pen responds well to the soft pastel paper. The artist starts by dropping perpendiculars, measuring each line against the next and amending construction lines.

3 This detail *above right* shows how the line is affected by the quality and texture of the pastel paper. The artist lets the pen trail over it so that it picks up the undulations of the paper and creates this softly muted area of shading. Compare this with the roofline and the solid black of the window.

4 The detail *right* illustrates yet another range of marks. These drawn shapes are made with a fairly new pen which still creates a sharp line. The artist does not draw every single roof tile but creates a pattern which suggests roof tiles. Notice how the quality of the line varies.

What the artist used

The artist used pink tinted pastel paper 10 x 15 inches and fiber tip pen.

5 This detail *above* is taken from an area further back in the picture and here the artist uses a much older pen which has lost its sharpness. He uses it for the background where less clarity is required. The final drawing *right* is a complex but effective pattern of shapes and illustrates the flexibility of felt pen.

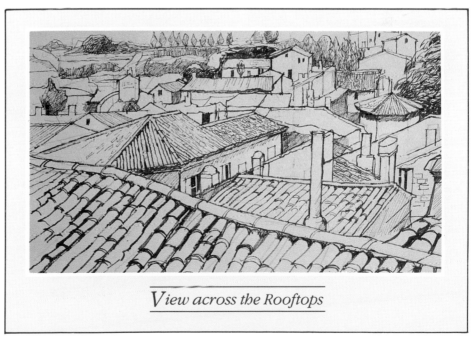

View across the Rooftops

Tombstones in Dappled Light

CHARCOAL

The dappled light filtering through the canopy of trees is an important feature of this entrancing scene. The artist made a quick sketch in which he analyzed the light and shade – the tonal qualities of the subject. The way the areas of tone are disposed across the surface of a painting is an important underlying current of any painting. One of the best ways to identify these areas of light and dark is to squint at the subject through half-closed eyes. You will see the subject reduced to very simple components so that it looks almost abstract. Sometimes the subject will be divided into a few large areas of light and dark, creating strong, simple images and a sense of calm and stillness. Other paintings are a mass of small elements which lead the eye in a more agitated way around and across the picture surface.

A subject can be analyzed by looking for the underlying geometry and for the directional lines. This underlying structure will be overlaid by many others which may work against it, creating an interesting internal dynamic.

Here the artist has first drawn the basic forms and has then blocked in the areas of darker tone, to see how they relate to the underlying geometry. He has used willow charcoal for the basic drawing. It is a pleasing, responsive medium which can be used broadly and responds to the urgency of the artist as he searches for the clues to the composition. He has made himself a holder of paper to prevent the work from getting too messy, but the finish of the drawing is much less important than what he discovers along the way. He has used the side of the charcoal to lay in the areas of dark tone, applying more or less pressure according to the degree of darkness he wants to achieve. He breaks the charcoal to an appropriate length for the size of mark required. With this large flat, drawing tool he draws the objects by establishing the background, so that the shapes of the objects emerge from the areas of tone. The sharp bits of charcoal are used to re-define these shapes and to create different textures and marks. The putty eraser, a particularly soft eraser, is used to lighten areas so as to indicate the highlights. By using charcoal the artist has been able to cover large areas of paper quickly and he has been forced to simplify and has thus concentrated on the main elements of the composition.

1 Sunlight falling through trees provided the artist with this delightful study in light and tone *right*. He made a quick sketch using charcoal because it offered him both line and solid blocks of tone.

EXPLOITING CHARCOAL

Willow charcoal is soft and springy with a pleasantly fluid feel. Pressed charcoal is square in section, much denser and less powdery than willow charcoal. Charcoal pencil is the hardest type of charcoal and is less messy to use than either willow charcoal or pressed charcoal. With pencil charcoal you cannot use the side of the charcoal.

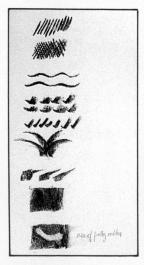

WILLOW CHARCOAL

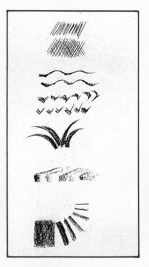

COMPRESSED CHARCOAL

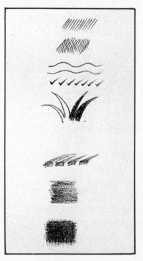

CHARCOAL PENCIL

2 The artist starts by laying in the main outline of the subject using a thin stick of willow charcoal *above*. He has made a holder from a rolled piece of paper.

3 A section has been broken from a stick of charcoal and with this the artist blocks in the darkest areas of tone – the deep shadows behind the tombstones – *above*.

4 Charcoal is a fairly messy medium – the image can easily be smudged. The artist blows the loose bits of charcoal off the paper and then fixes the drawing *above*.

5 The artist uses a small piece of charcoal *above* to make dashed marks which describe the foliage of the trees. The paper texture shows through the blended charcoal.

What the artist used

The artist used a soft, cream-colored paper, 14 x 20.5 inches, medium-grade willow charcoal and putty eraser.

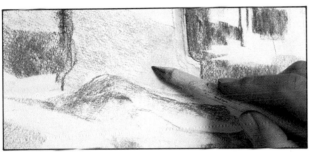

6 Using a torchon the artist works into the areas of mid-tone, blending and spreading the charcoal *above*. You can also blend charcoal with your finger or with a piece of tissue, but the torchon is a more accurate instrument. Torchons come in a range of sizes.

7 In the detail *right* the artist creates areas of highlight by removing charcoal with a soft putty rubber. Where a thin film of charcoal has been laid in it is possible to 'draw' into this with an eraser.

8 The artist adds a final detail *right*, using the linear quality of the charcoal to lay down small areas of deep black. In the final sketch *far right* we can see the subtle range of tones and marks that can be made with charcoal.

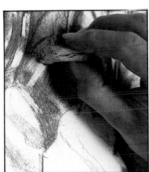

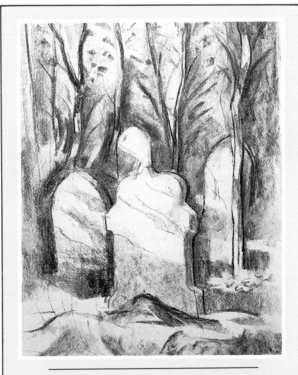

Tombstones in Dappled Light

185

Woodland Scene

DRAFTING PEN

The bare winter branches provided the artist with a linear subject ideally suited to the drafting pen. With its reservoir of ink, it is useful tool for working out of doors, especially on chilly winter days when hands, numb with cold, are not particularly adept at manipulating bottles of ink. The artist was interested in investigating the graphic details of this subject which required a high degree of definition. The drafting pen, which was designed as a technical tool, is capable of recording the small-scale details of the subject.

The artist used a gray pastel paper – its soft grainy texture, reduced the harshness of the line. A smoother paper would produce a very different quality of line.

The artist was interested in two aspects of the subject. He was concerned first of all with the spaces within the picture, the sense of depth and recession. Thus he has elected to allow the tree trunk in the foreground to break through the frame of the picture at top and bottom, and the branches break the frame to the left and right. This brings the image right up on to the picture plane, creating the impression of a tracery window through which the scene beyond is glimpsed. In this area the artist used thicker lines, created by going over the lines several times. In the background area he used finer broken lines to suggest objects viewed from a distance.

The artist used a cut-out frame to isolate the area in which he was interested. With such a complex subject it is difficult to decide just what areas of the subject are to be included. He then drew a penciled frame in the same proportions as the frame he was looking through to maintain the correct proportions.

The other aspect of the subject which appealed was the decorative qualities of the twisting forms of the trees as they spiraled skyward and the elaborate tracery of their branches and twigs. This has a slightly flattening effect and the way in which the space-negating qualities of the pattern contradicts the structural feel of the subject, creates an underlying tension which is compelling.

1 The complicated tracery of these bare winter branches provided the artist with an obviously linear subject *right*. He chose to sketch it with a drafting pen because it allowed him to work on a small scale.

DRAFTING PEN MARKS

Here we see some of the marks which the artist used to build up the variety of lights and darks, pattern and texture in his drawing. The artist has counteracted the rather mechanical quality of the line by working on a soft, pastel paper.

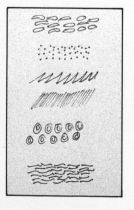

2 The artist chose a soft grainy pastel paper as his support – the texture of the paper softens the quality of the line and the gray color softens the black of the ink. The artist starts by sketching in the trunk of the foreground tree, using a single broken line *above*.

3 The artist works into the background *above*. He draws the foliage of the holly by repeating a shape which he has evolved to represent the leaf. He creates areas of darker tones by working into a small area, allowing the ink to flood the paper.

4 The outline of the tree trunk has been strengthened by going over the line several times so that a thicker, darker line is built up *above*. The artist has started to work into the background and now he creates a mid-tone where the trunk turns by laying down widely-spaced hatched lines.

5 The linear quality of the drafting pen is evident in the illustration *left*, where despite the hatching on the tree trunk there is, as yet, very little tone.

6 *Above* the artist uses a fine, broken, glancing mark to indicate the bare skeletal shapes of the trees in the distance. Solid lines would bring them too far forward.

7 The detail *right* shows some of the marks which the artist has developed to describe the texture of the bark of the tree. All texture and tone must be built up from lines or dots and here the artist has combined linear marks with stippling.

8 Drafting pens are designed to be accurate and unyielding. In this drawing the artist has devised a way of working with the pen which counteracts its natural characteristics. The quality of the paper contributes to this. The artist has managed to change the quality of the line by holding the pen loosely so that it skips over the support creating a broken line. In the detail *left* he has created dragged marks by holding the pen sideways.

What the artist used

The artist used a soft, gray-tinted pastel paper, 8 x 12 inches and a 0.6 drafting pen.

Woodland Scene

Glossary

ABSTRACT Relying on color and form rather than the realistic or naturalistic portrayal of subject matter.

ABSTRACTION The creation of an abstract image from a subject or other figurative reference.

ACRYLIC A comparatively new paint in which the pigment is suspended in a synthetic resin.

ADVANCING COLORS Colors which appear to stand out, either because they are brighter, stronger or denser than their neighbors.

AERIAL PERSPECTIVE The use of color and tone to denote space and distance.

ALLA PRIMA Direct painting in which the picture is completed in one session without any underpainting or underdrawing.

BINDER Any liquid medium which forms a paint when mixed with powder pigment.

BLENDING Merging colors together in such a way that the joins are imperceptible.

BLOCKING IN The initial stage of a painting when the main forms and composition are laid down in approximate areas of color and tone.

BROKEN COLOR Paint applied in its pure state rather than being mixed. This stiff paint is usually applied by dragging the brush across the surface, allowing layers of color underneath to show through.

CHIAROSCURO The exploitation of light and shadow within a painting. Both Caravaggio and Rembrandt were masters of the technique.

COLLAGE A picture made up from pieces of paper, fabric and other materials stuck on to canvas, paper or some other support.

COMPOSITION Arranging and combining different elements to make a picture.

COMPLEMENTARY COLORS Colors which appear opposite each other in the color circle. Hence, purple is complementary to yellow, green to red, and orange to blue.

COVERING POWER This refers to the opacity of a paint – its ability to obliterate the color underneath.

CROSS-HATCHING A method of building up areas of shadow with layers of criss-cross lines rather than areas of tone.

FIXATIVE Thin varnish which is sprayed on drawing media, especially charcoal and pastel, to prevent smudging and protect the paint surface.

FRESCO A wall-painting technique usually done with watercolor on damp plaster.

GLAZING Using a transparent film of color over another pigment.

GROUND A ground is used to make a surface suitable for painting on. With oil painting for instance, the ground is usually gesso or an oil-based mixture.

GUM ARABIC Gum taken from the acacia tree. It is used with inks and watercolors to give body and sheen.

HATCHING A shading technique using parallel lines instead of tone.

HUE A tint or shade.

IMPASTO The thick application of paint or pastel to the picture surface in order to create texture.

LEAN A term used to describe oil color which has little or no added oil. The term 'fat over lean' refers to the traditional method of using 'lean' color (paint thinned with turpentine) in the early stages of a painting and working over this with 'fat' or oily paint, as the painting progresses.

LINEAR PERSPECTIVE A system for drawing space and objects in space on a two-dimensional surface. It is based on the fact that parallel lines going in any one direction appear to meet at a point on the horizon. This point is referred to as the vanishing point.

LOCAL COLOR The actual color of the surface of an object without modification by light, shade or distance.

MASK A device used to prevent paint or any other medium from affecting the picture surface in order to retain the color of the support or the existing paint in a particular area.

MASKING The principle of blocking out areas of a painting to retain the color of the support or the existing surface. This is usually done with tape or masking fluid and leaves the artist free to paint over the masked areas. The masks are removed when the paint is dry to reveal the areas underneath.

MASKING FLUID A rubber solution which is painted on to a picture surface to retain the color of the paper or support. When the solution is dry, the artist can safely paint over the masked areas. The mask is removed by rubbing with an eraser or finger.

MEDIUM In a general sense the medium is the type of material used, such as oil paint or charcoal. More specifically, a medium is a substance mixed with paint or pigment for a particular purpose or to obtain a certain effect.

MIXED MEDIA The technique of using one or more established media, such as ink and gouache, in the same picture.

MONOCHROME A painting done using black, white and one other color.

NEGATIVE SPACE Drawing or painting the space around a subject rather than the subject itself.

OPACITY The ability of a pigment to cover and obscure the surface or color to which it is applied.

OPTICAL MIXING Mixing color in the painting rather than on the palette. For example, using dabs of red and yellow to give the illusion of orange rather than applying a pre-mixed orange.

PICTURE PLANE That area of a picture which lies directly behind the frame and separates the viewer's world from that of the picture.

PLANES The surface areas of the subject which can be seen in terms of light and shade.

PRIMARY COLORS In painting these are red, blue and yellow. They cannot be obtained from any other colors.

PRIMER The first coat on the support over which other layers – including the ground – are laid.

RENAISSANCE The cultural revival of classical ideals which took place in the 15th and 16th centuries.

RENDER To draw or reproduce an image.

SATURATED COLOR Color with a high degree of purity. The degree of saturation is assessed by comparing it with a colorless area of equal brightness.

SIZE A gelatinous solution such as rabbit skin glue which is used to prepare the surface of the canvas or board ready for priming and painting.

STENCIL A piece of card or other material out of which patterns have been cut. The pattern or motif is made by painting through the hole.

STIPPLE Painting, drawing or engraving using dots instead of line or flat color. A special brush is available for stippling paint.

SUPPORT A surface for painting on, usually canvas, board or paper.

TORCHON A stump used for blending charcoal and pastel. This is often made of rolled paper or chamois.

UNDERDRAWING Preliminary drawing for a painting, often done in pencil, charcoal or paint.

UNDERPAINTING Preliminary blocking in of the basic colors, the structure of a painting and its tonal values.

WASH An application of ink or watercolor, diluted to make the color spread transparently and evenly.

WET INTO DRY The application of paint to a completely dry surface causing the sharp overlapping shapes to create the impression of structured form.

WET INTO WET The application of paint to a surface which is still wet to create a subtle blending of color.

Index

Index

Credits

Contributing artists
pp *26, 28, 29 (left), 30 (right), 31 (top right, bottom left), 33 (right), 41 (center and bottom), 60-63, 96-7, 106-9, 146-7,* Stan Smith; pp *28 (right), 29 (right), 30 (left), 31 (top left, bottom right), 32, 33 (left), 41 (top), 72-7, 84-7, 110-15, 116-19, 120-3, 124-9, 130-3, 140-3, 162-7, 168-71, 172-5, 176-9, 186-7* Ian Sidaway; pp *39, 54-7, 68-71, 92-5, 148-51, 180-1, 182-3, 184-5* Gordon Bennett; pp *58-9, 64-7* Adrian Bartlett; pp *88-91* Mark Churchill; pp *144-5* Diana Armfield; pp *152-5* Mike Pope

Pictures on p 17 (bottom) and p 18 © DACS

Other illustrations
pp *7, 9, 10, 11, 13* The Bridgeman Art Library; p *39* Krystyna Weinstein; pp *42-7* Alastair Campbell, Mac Campeanu, John Coghill, Michael Monahan, Krystyna Weinstein; pp *72, 92, 186* Mac Campeanu; pp *84, 110, 124, 130, 140, 162, 172, 176* Ian Sidaway

QED would like to thank all those who have helped in the preparation of this book. Special thanks to Ian Sidaway for expert advice and the use of his studio, and to the staff of Langford and Hill Ltd, London, for their patience and generosity in lending materials and items of equipment.